A DAVID & CHARLES BOOK
Copyright © David & Charles Limited 2006

David & Charles is an F+W Media Inc. company
4700 East Galbraith Road
Cincinnati, OH 45236

First published in 2006
Reprinted 2007, 2008, 2010 (Twice), 2011
Originally published as *Drawing Problems and Solutions* (2001)
and *Watercolour Problems and Solutions* (2002) by David & Charles

Text and illustrations copyright © Trudy Friend 2006

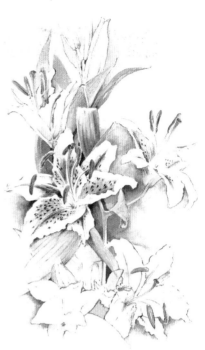

ISBN-13: 978-0-7153-2321-2 paperback
ISBN-10: 0-7153-2321-0 paperback

Printed in Singapore by KHL Printing Co Pte Ltd
for David & Charles
Brunel House, Newton Abbot, Devon

David & Charles publish high quality books on a wide range of subjects.
For more great book ideas visit: **www.rubooks.co.uk**

This book is based on Trudy Friend's popular 'Problems and Solutions'
series in *Leisure Painter* magazine. For subscription details and other
information, please contact: The Artists Publishing Company Ltd,
Caxton House, 63–65 High Street, Tenterden, Kent TN30 6BD,
tel: 01580 763315, website: www.leisurepainter.co.uk

Contents

Drawing

Watercolour

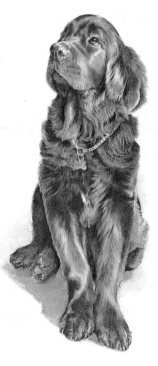

Drawing

Introduction

With this book I will be helping you …
to love your art,
to live your art
and see the world go by
as colour, texture, line and form
and with an 'artist's eye'.

The drawing section of this book is intended to help beginners who, inspired by a subject, are unsure where or how to put marks in order to create a recognizable impression.

Many beginners try to copy exactly what they see, whether from a photograph (if they cannot work from life) or something set in front of them, as with still-life or flower studies. When presented with a distant view this can be very daunting. You may be unaware that it is not only what you put into your drawing, but what you choose to leave out, that is important. You may find it difficult to be selective.

In this section there are 12 themed sections about different subjects. Each contains some typical learner's mistakes on one page, with suggested methods to overcome these problems on the facing page. The most important advice, however, is to remember the three 'P's that are essential for all beginners – Practice, Patience and Perseverance.

Practice

If you can find time on a daily basis (even if only ten minutes) to practise a few marks, you will be learning. Try looking closely at your surroundings and drawing small details and studies, rather than always thinking of making a picture. Sometimes just practise making marks for their own sake – these 'constructive doodles' can be invaluable.

Patience

Patience is an extremely important aspect of learning to draw. By this I mean patience with yourself, at the stage you have reached so far. Try not to compare your present level of achievement with that of others, even if they are beginners too. You are being very unfair to yourself if you judge your efforts too harshly. Self-criticism is an important part of learning, but do beware of putting yourself down. Use constructive criticism, but try to acknowledge that you may need to be told, shown and have things explained in detail in order to understand. This is all part of the natural learning process.

Perseverance and pride

When explaining perseverance, I refer to the fact that we all experience low periods – times when everything seems to go wrong for us. This may be easier to accept when it is related to everyday life, but it will occur with your artwork as well. It happens to us all at some time, whatever level we have achieved, but it probably seems worse to a beginner. So persevere and try not to become despondent. If you have a bad art day leave your drawing for a while, or perhaps just practise making marks, returning to it later with a fresh eye. In many cases this is all that is required in order for your progress to continue.

You should always take a pride in the way you prepare your drawing materials and your work surface. If you do not wish to invest in a table easel, obtain a rigid piece of plywood approximately 35 x 48 cm (14 x 19 in) and raise it to an angle from the table with the aid of books or a block of wood. Ensure this is stable and will not move.

Erasing

I do not advocate the use of an eraser when trying out the exercises in this section. It is of greater benefit to you to see your mistakes – and how you correct them – rather than by erasing an error that may inadvertently be made again in the same place. Sometimes a drawing is more exciting when we are able to see the artist's original lines and how they have been changed and corrected throughout the work. This method also encourages the use of varied pencil pressure on the paper's surface, as the image can be suggested by light pressure at first (with 'wandering' lines) over which more pressure is asserted on subsequent lines, until the final, contrasting tones bring it to life.

Techniques

A number of specific drawing techniques are referred to and are illustrated through-out ; these are incorporated to give you confidence to make marks on paper with-out even intending to erase any mistakes, and allowing you literally to 'feel' your way across your drawing as you progress.

Beginners may find it difficult to understand that we are able to make marks on the paper that express what we feel about what we see, as well as what we actually see. In addition to this, we may choose to build the drawing upon marks that are made very lightly on the paper and are subsequently changed and corrected, yet all are left in place throughout the drawing, as mentioned

above. Perhaps surprisingly, we do not always require lines in order to establish form. Instead, learn to think of drawing in a 'painterly' way, that is, being more concerned with tonal blocks and their relationships than with pure linear drawing. The exercises in this book also bring in the importance of drawing light against dark (or 'dark behind'), for instance by illustrating a solid object with dark massed foliage behind and shadow area on grass at the base.

To take one example, the demonstration on page 17 brings a number of techniques into consideration. It uses 'directional' strokes that describe the form – think of these as 'finding out' lines, as they enable you to find out the shape of the form. A continuous heavy line, applied with a zigzag movement, gives the impression of a mass radiating from a central area. Flat areas of tone suggest a backdrop and the surface on which the subject rests.

This drawing also gives you opportunities to show reflected light on curved surfaces by shading an intensely dark area a little away from the shadow side of the form. In addition, in this drawing there are lines that 'follow the form' as well as tonal lines and 'lost' lines. A 'lost' line is an area where the subject is the same tone as its background, therefore no mark is made on the paper at that point.

Developing a personal style

You can follow the solutions pages to draw familiar subjects that perhaps you have not studied closely before. Then try others, of your own choice, giving them the same amount of care and consideration.

Everyone sees things differently, and each artist has their own personal approach. Transformation takes place by understanding the subject, its structure and the best way of depicting it. Trial and error studies will help you discover how to 'see' the subject and how to portray it to your own satisfaction.

Drawing Materials

You can draw with anything that will make a mark on any suitable surface that will take a mark. Whatever you decide to use, spend some time just making marks and becoming familiar with using your art materials. The marks below are made with materials used for the exercises throughout the book, and show just a few of the endless possibilities.

If you are using a pencil you must be able to sharpen it properly, and the illustration opposite shows you how to do so to best effect. Once it is sharpened you can shape the point to a chisel edge, useful for producing a 'tonal mass' or range of tones.

Choose your materials to suit your subjects. Page 10 shows a variety of effects that can be achieved with different types of coloured pencils. In certain instances – for example, when using soft pencil or charcoal – you will need to fix the medium by using a fixative spray or diffuser, which can be obtained from an art shop.

Some media may fade in the sunlight, while others may crumble off the surface you have chosen, if unsuitable. Make sure, therefore, that you use use good quality materials that will 'work' well upon the chosen support, be it paper, card or board. Consider the texture of the paper carefully, too.

For practice, however, beginners will find that a pack of copier paper from an office shop and a couple of good pencils will afford many hours of constructive doodling and 'trial and error' studies.

Pencils and pens

Graphite pencils are available from 9H (the hardest 'lead') to 9B (the softest), with H, HB and B in mid-range. Profipens can be used to make strong linear marks.

B graphite pencil

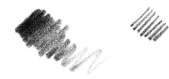

9B graphite pencil

(a) *(b)*

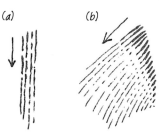

Profipen

(a) and (b) above are directional on/off pressure strokes

How to sharpen a pencil

The best tool for sharpening pencils is a utility knife rather than a pencil sharpener or craft knife. The aim is to create a good point by angling the blade to such an extent that it glides over the wood. Try to remove slivers rather than chips.

Pull the pencil towards the blade

The hand holding the knife does nothing else. It just holds the knife to allow the other hand to operate. This, and the acute angle at which the knife is held, prevents the blade cutting into the wood too sharply and removing too much wood with the stroke

Turn the pencil as it is being sharpened (imagine that you are trying to roll a small piece of tissue between your finger and thumb). This turning movement is to ensure even sharpening

How to use the pencil

If you learn when to turn the pencil while you are working (with practice this will become a natural habit), you can use just one pencil, turned as necessary, for areas of contrasting tonal and linear application, without having to sharpen it repeatedly.

The point created on the opposite side of the lead will be sharp enough to draw very fine lines

By making a number of strokes with a soft pencil, the lead will wear down to a chisel shape. The more you apply, the wider the chisel shape becomes and the more surface area is covered by each stroke. This will allow you to tone areas rapidly with side-by-side strokes

Coloured pencils

Modern coloured pencils are available in many different forms: standard, water-soluble, thick- and thin-leaded, and pastel pencils.

They produce a wide variety of expressive marks which can be used in your work – see below for a selection of these.

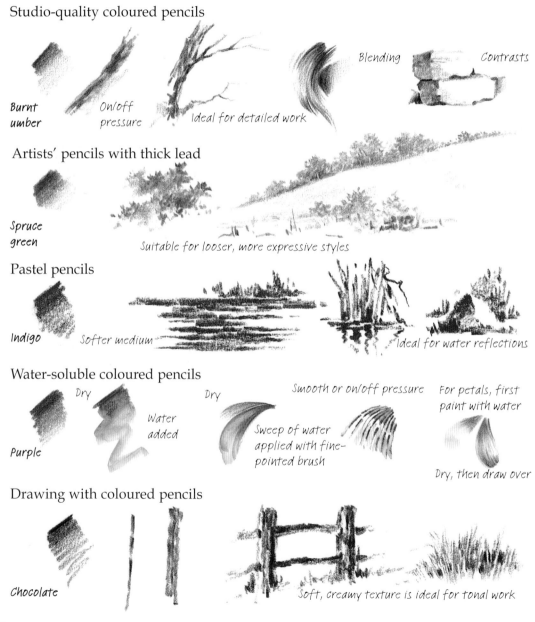

Studio-quality coloured pencils

Burnt umber

On/off pressure

Ideal for detailed work

Blending

Contrasts

Artists' pencils with thick lead

Spruce green

Suitable for looser, more expressive styles

Pastel pencils

Indigo

Softer medium

Ideal for water reflections

Water-soluble coloured pencils

Dry

Dry

Smooth or on/off pressure

For petals, first paint with water

Water added

Sweep of water applied with fine-pointed brush

Purple

Dry, then draw over

Drawing with coloured pencils

Chocolate

Soft, creamy texture is ideal for tonal work

Using textured surfaces

Using drawing surfaces that are textured can add an extra dimension to your work, particularly in landscape subjects. You can buy offcuts or sample swatches of paper or card from art shops, and practise creating textures on these.

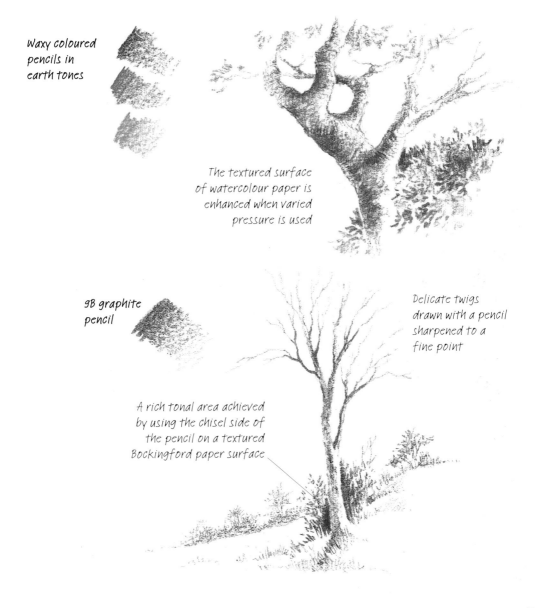

Waxy coloured
pencils in
earth tones

The textured surface
of watercolour paper is
enhanced when varied
pressure is used

9B graphite
pencil

Delicate twigs
drawn with a pencil
sharpened to a
fine point

A rich tonal area achieved
by using the chisel side of
the pencil on a textured
Bockingford paper surface

Constructive Doodles

In the rush to produce 'complete' drawings, it is all too easy to forget the importance of the basic marks you are using. Constructive doodles can be made any time you have a pencil and paper – try them to learn how to use simple marks to create complex effects.

Gently touch *Press and travel* *Gently lift*

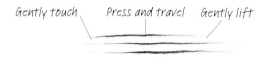

One stroke from left to right

Gently touch – press more firmly – lift

One stroke across – return immediately (covering the first line), widening the central area

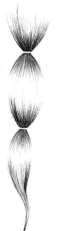

This effect is created by a series of down strokes with varying pressure

Gently touch

Press and travel

Lift, but remain in contact as you continue to travel

Re-assert pressure

Gently lift off

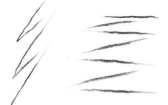

Try different strokes in a variety of directions, always varying pressure and maintaining contact with the paper

Varying pressure

Use simple, constructive doodle marks to draw a hank of hair with tight bands at intervals along its length. The darkest area will be near the bands, and light between them.

1. Draw the band.

2. Holding the pencil in an upright position, push stroke out from band.

3. Use 'directional' strokes to describe the form with firm pressure near the band, flicking up and away.

Practising doodles

All these exercises need to be practised again and again to improve your skill and techniques. Analyse your work and ask yourself questions such as 'Why does that line appear too heavy?'

The answer may be as simple as needing to sharpen your pencil. Repeat the exercises, applying them to different subjects, and remember the three 'P's.

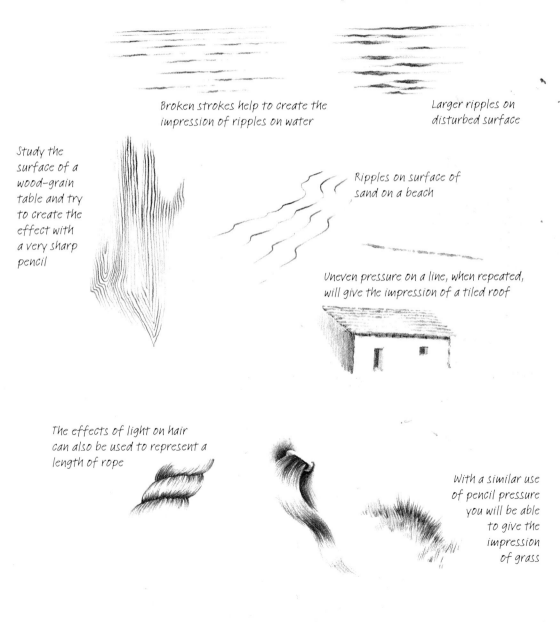

Broken strokes help to create the impression of ripples on water

Larger ripples on disturbed surface

Study the surface of a wood-grain table and try to create the effect with a very sharp pencil

Ripples on surface of sand on a beach

Uneven pressure on a line, when repeated, will give the impression of a tiled roof

The effects of light on hair can also be used to represent a length of rope

With a similar use of pencil pressure you will be able to give the impression of grass

Using a 'Wandering Line'

'Wandering lines' is a phrase that describes purely linear marks on paper or card, which are created by placing the tip of a sharpened pencil on to paper and using even pressure to create a line or shape. Because this is light, it can be treated as a starting point, and can then be strengthened or added to by other techniques, as in the exercise below.

1. Don't lift your pencil from the surface of the paper until you have drawn a number of stones of varying shapes and sizes. This will give the impression of a section of a stone wall.

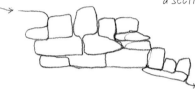

2. To strengthen your line, look for shapes between the stones, either as shadow shapes or shadow lines, and fill in with a dark tone.

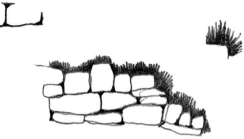

3. With repeated up-and-down strokes, starting from the top of each stone on the top of the wall, create a medium to dark tonal mass.

4. Once you have placed this dark tone behind the top stones, fan out slightly with lighter pressure.

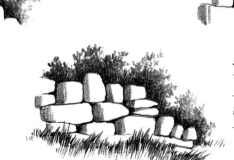

5. Create a shadow side to the stones by downward strokes applied with lighter pressure using a chisel-shaped lead.

Varying Pencil Pressure

In the exercise opposite, the unvarying pressure of the wandering line was added to by subsequent toning and shading. Where there will be no background for a study, you can reduce pressure on the pencil at certain points and increase it at others to avoid a hard, diagrammatic outline that may flatten the effect of your work.

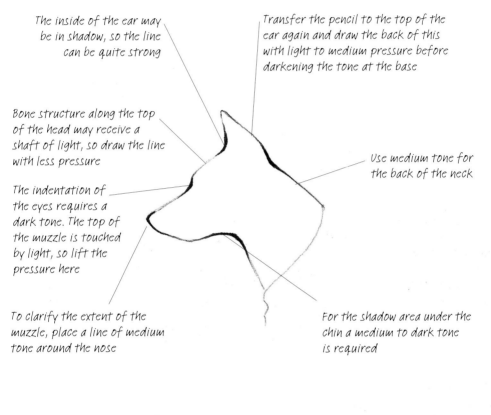

The inside of the ear may be in shadow, so the line can be quite strong

Transfer the pencil to the top of the ear again and draw the back of this with light to medium pressure before darkening the tone at the base

Bone structure along the top of the head may receive a shaft of light, so draw the line with less pressure

Use medium tone for the back of the neck

The indentation of the eyes requires a dark tone. The top of the muzzle is touched by light, so lift the pressure here

To clarify the extent of the muzzle, place a line of medium tone around the nose

For the shadow area under the chin a medium to dark tone is required

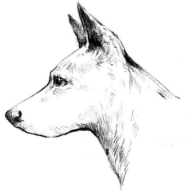

Add an eye and nose and a few lines to suggest hair that follows the form, and you have drawn a dog's head rather than a diagram of one.

Drawing in a 'Painterly Way'

Making linear marks and wandering lines is fine for depicting subjects lit by a fairly regular, even source. But there will be times when you want to suggest sharp contrasts, and creating tonal areas from the start, as painters do, can be the answer.

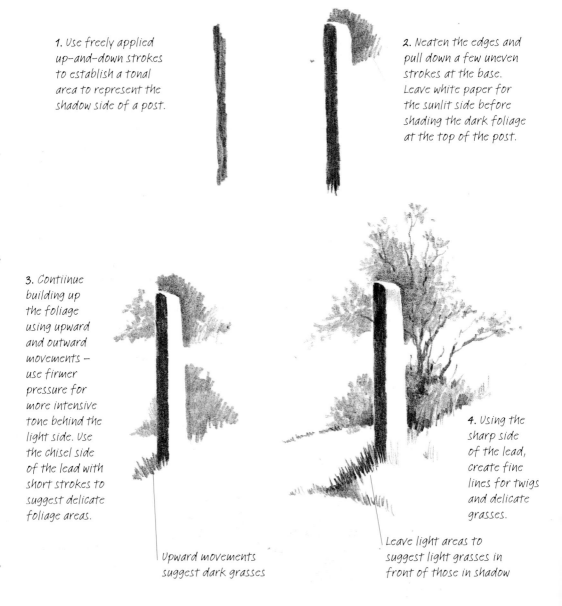

1. Use freely applied up-and-down strokes to establish a tonal area to represent the shadow side of a post.

2. Neaten the edges and pull down a few uneven strokes at the base. Leave white paper for the sunlit side before shading the dark foliage at the top of the post.

3. Contiinue building up the foliage using upward and outward movements — use firmer pressure for more intensive tone behind the light side. Use the chisel side of the lead with short strokes to suggest delicate foliage areas.

4. Using the sharp side of the lead, create fine lines for twigs and delicate grasses.

Upward movements suggest dark grasses

Leave light areas to suggest light grasses in front of those in shadow

Directional Strokes

Once you have described the outline of an object using a wandering line, you can use purely linear strokes to give it form. In this exercise, all the outlines used to draw the mushroom are absorbed into its tonal areas to finish the piece.

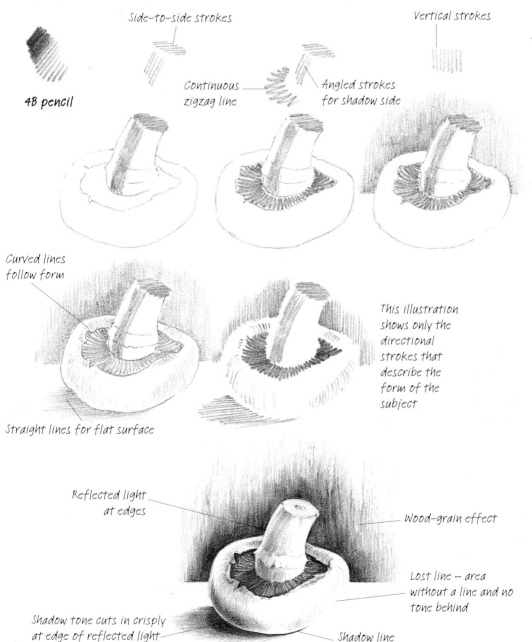

Side-to-side strokes

Vertical strokes

4B pencil

Continuous zigzag line

Angled strokes for shadow side

Curved lines follow form

This illustration shows only the directional strokes that describe the form of the subject

Straight lines for flat surface

Reflected light at edges

Wood-grain effect

Lost line – area without a line and no tone behind

Shadow tone cuts in crisply at edge of reflected light

Shadow line

Trees and Woodland

Drawing trees and woodland or forests creates its own particular problems. 'You can't see the trees for the wood' would sum up many of the pitfalls you can experience when trying to differentiate one tree from others, let alone finding out how to suggest the rest of the trees in the scene.

I often use a soft-grade pencil, 6B or 8B, when drawing trees. After a chisel shape has been created, the flat side of the lead quickly covers the shadow side of the tree when I apply up-and-down strokes. By turning the pencil round to the sharper point, you can use a delicate and interesting line to define the light side of the trunk.

You can switch to a harder-grade pencil, such as a 2B, to produce directional strokes on exposed roots, and to make a wandering line that establishes form for any part of your subject. The softer marks made by a graphite pencil of the same grade are good for making small studies of roots or grass banks – choose whatever will suit your own style as well as the subject, and take the time to understand what each medium can do, and how you can best utilize it.

One point that recurs in this section is that you must take as much care over the trees that make up the mass of the woodland as the foreground ones that are your main concern.

Typical Problems

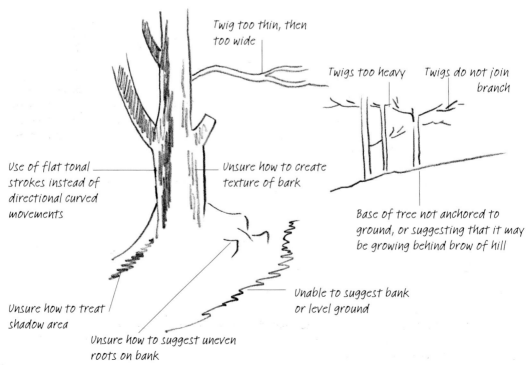

Twig too thin, then too wide

Twigs too heavy

Twigs do not join branch

Use of flat tonal strokes instead of directional curved movements

Unsure how to create texture of bark

Base of tree not anchored to ground, or suggesting that it may be growing behind brow of hill

Unsure how to treat shadow area

Unsure how to suggest uneven roots on bank

Unable to suggest bank or level ground

Solutions

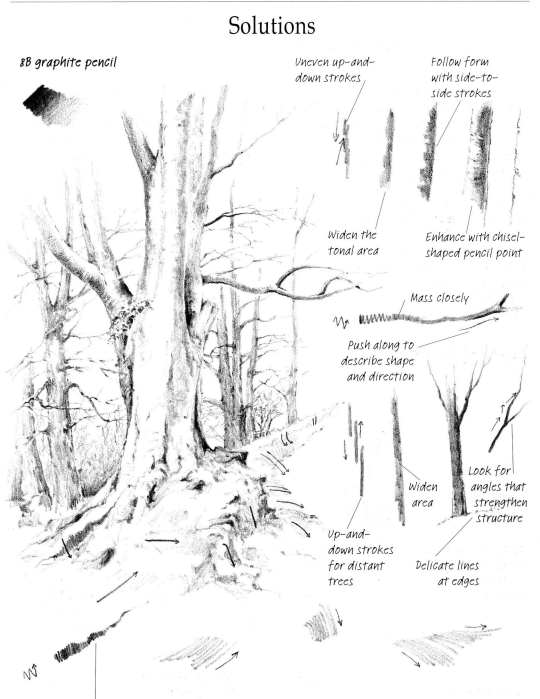

8B graphite pencil

Uneven up-and-down strokes

Follow form with side-to-side strokes

Widen the tonal area

Enhance with chisel-shaped pencil point

Mass closely

Push along to describe shape and direction

Widen area

Look for angles that strengthen structure

Up-and-down strokes for distant trees

Delicate lines at edges

Look for connection between shadow area and other directional tones

Directional strokes follow the form of areas toned to suggest shadow sides and curved banks

Typical Problems

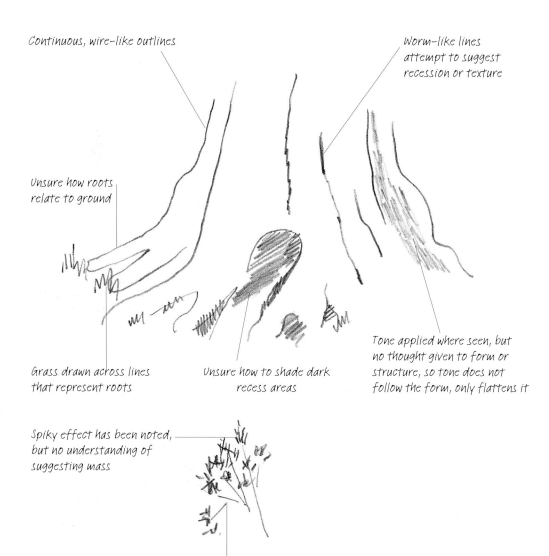

Continuous, wire–like outlines

Worm-like lines
attempt to suggest
recession or texture

Unsure how roots
relate to ground

Grass drawn across lines
that represent roots

Unsure how to shade dark
recess areas

Tone applied where seen, but
no thought given to form or
structure, so tone does not
follow the form, only flattens it

Spiky effect has been noted,
but no understanding of
suggesting mass

Twigs do not join
main structure

Solutions

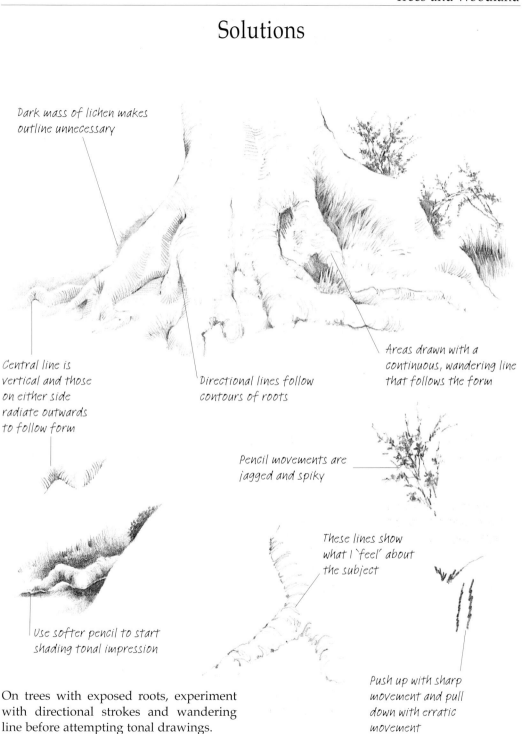

Dark mass of lichen makes outline unnecessary

Central line is vertical and those on either side radiate outwards to follow form

Directional lines follow contours of roots

Areas drawn with a continuous, wandering line that follows the form

Pencil movements are jagged and spiky

Use softer pencil to start shading tonal impression

These lines show what I `feel' about the subject

Push up with sharp movement and pull down with erratic movement

On trees with exposed roots, experiment with directional strokes and wandering line before attempting tonal drawings.

21

Typical Problems

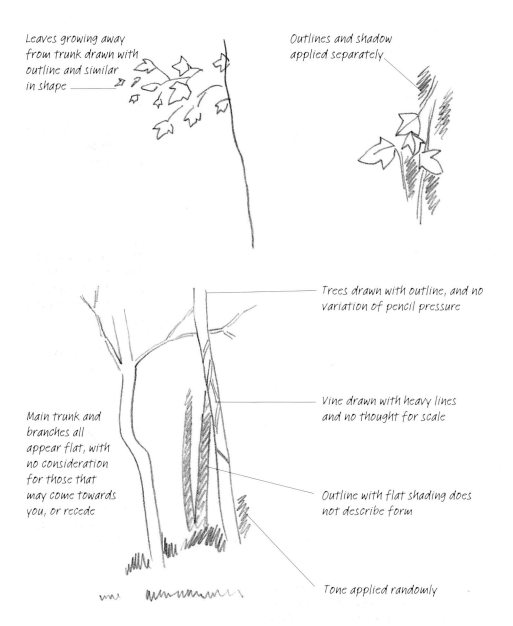

Leaves growing away from trunk drawn with outline and similar in shape

Outlines and shadow applied separately

Trees drawn with outline, and no variation of pencil pressure

Vine drawn with heavy lines and no thought for scale

Main trunk and branches all appear flat, with no consideration for those that may come towards you, or recede

Outline with flat shading does not describe form

Tone applied randomly

Solutions

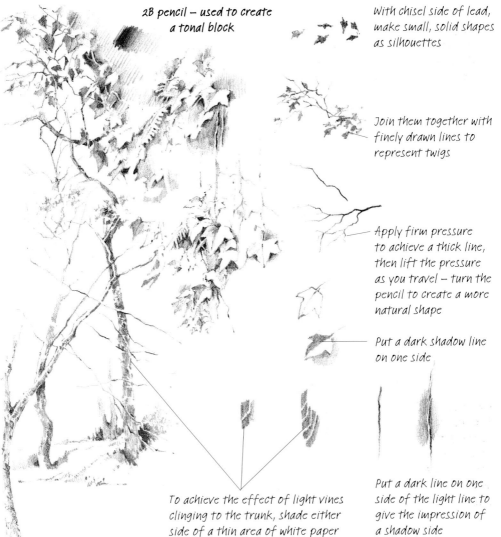

2B pencil – used to create a tonal block

With chisel side of lead, make small, solid shapes as silhouettes

Join them together with finely drawn lines to represent twigs

Apply firm pressure to achieve a thick line, then lift the pressure as you travel – turn the pencil to create a more natural shape

Put a dark shadow line on one side

Put a dark line on one side of the light line to give the impression of a shadow side

To achieve the effect of light vines clinging to the trunk, shade either side of a thin area of white paper

For the trees in the foreground, try the wandering line again, changing from the silhouette approach to finding form

Typical Problems

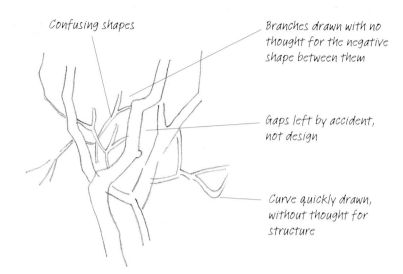

Confusing shapes

Branches drawn with no thought for the negative shape between them

Gaps left by accident, not design

Curve quickly drawn, without thought for structure

All lines drawn with same pressure on pencil

Smaller twigs are not growing from angles

This mass started with observation of ivy leaf shapes, but ended with shapes not resembling the leaf at all

These small squiggles representing leaves are drawn with no thought for how to show a mass by using the shapes between the leaves

Solutions

8B graphite pencil

Draw negative shape between
branches to help place them
correctly

As twig passes behind
branch, there is no need
for an outline

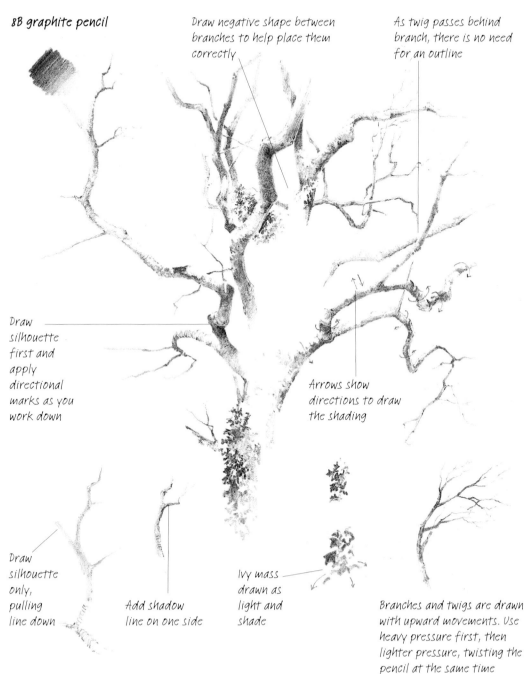

Draw
silhouette
first and
apply
directional
marks as you
work down

Arrows show
directions to draw
the shading

Draw
silhouette
only,
pulling
line down

Add shadow
line on one side

Ivy mass
drawn as
light and
shade

Branches and twigs are drawn
with upward movements. Use
heavy pressure first, then
lighter pressure, twisting the
pencil at the same time

Demonstration

Draw a rough pencil sketch to position trees and path

Suggest main branches with short, erratic strokes

Notice where shadows fall across the trunks

Leave areas of white paper for leaves coming towards you

Use directional strokes to describe undulations in the path

Decide where strong, dark tones will be used to enhance the light areas

To create a feeling of light penetrating dense foliage, I started my drawing with Vandyke brown and May green, over which the other colours were worked

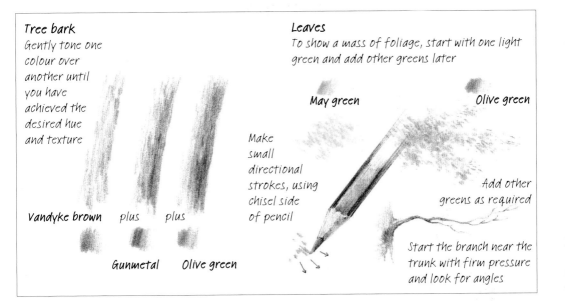

Tree bark
Gently tone one colour over another until you have achieved the desired hue and texture

Vandyke brown plus plus

Gunmetal Olive green

Leaves
To show a mass of foliage, start with one light green and add other greens later

May green Olive green

Make small directional strokes, using chisel side of pencil

Add other greens as required

Start the branch near the trunk with firm pressure and look for angles

TRUDY FRIEND

It is important to decide where light paper will remain untouched. The build-up of colours is gradual, starting with gentle pressure on the pencil.

Cool Gunmetal is used within the shadow areas

27

Open Landscapes and Skies

In addition to looking at the open country-side, this theme emphasizes the importance of choosing the correct materials to suit the subject and techniques used.

A smooth white drawing paper provides an ideal surface when used with a hard-grade pencil, such as HB, to create controlled effects on clouds and sky. In contrast to this, use a soft pencil, such as 7B, to create textures using varied pressure; you can increase your options by also using a textured, rougher paper or card. This is ideal when using the chisel side of the lead (produced by rubbing to create the tonal mass).

In contrast to concentrating on the details and single bulk of trees, in this theme forests and woods are likely to be part of the middle or far distance. However, the principles for drawing them remain – use a variety of pencils to create leaf, bark and foliage mass effects with the directional strokes that are so important in drawing.

Typical Problems

Distant trees drawn in outline, though actually seen as tonal mass

Grass too heavy and high

Odd squiggles

Leaves of dandelion spread out unnaturally

Lines do not suggest flat field surface – too dark for distance

Pencil strokes suggesting shadow are similar to those used to depict grass

Solutions

5B graphite pencil

1. For distant trees and bushes on a hill, draw basic constructive doodle lines using the chisel side of the pencil.

2. Then, still using the chisel side, start massing tone upwards from the line (incorporating the line within your mass). Make the top shapes irregular for a natural effect.

For lower hedgerows reduce height, but use same method

Vary pressure for different tonal effects within mass to suggest shadow areas

Make suggestions of grass in the distance smaller and paler, and those in the foreground larger and darker

Dandelion appears very large (because nearer to us) against terrier

Use shadow shapes to anchor subject

To achieve grass effect, place shapes as positives

Fill in negative spaces with dark tone

Typical Problems

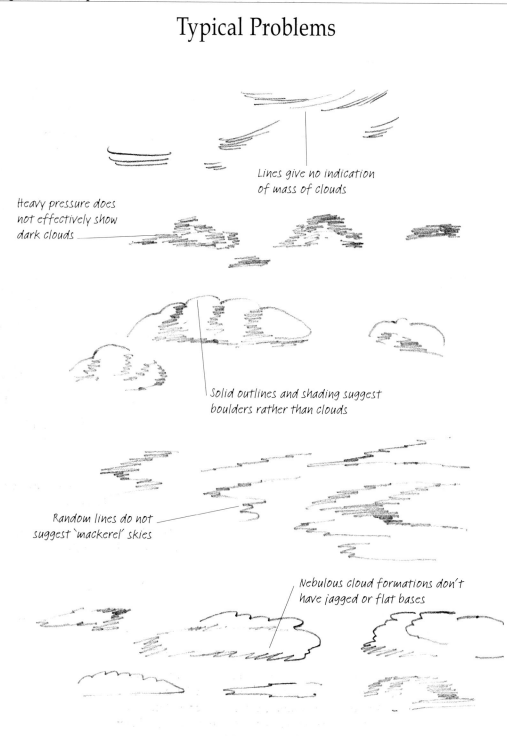

Lines give no indication
of mass of clouds

Heavy pressure does
not effectively show
dark clouds

Solid outlines and shading suggest
boulders rather than clouds

Random lines do not
suggest 'mackerel' skies

Nebulous cloud formations don't
have jagged or flat bases

Solutions

HB graphite pencil

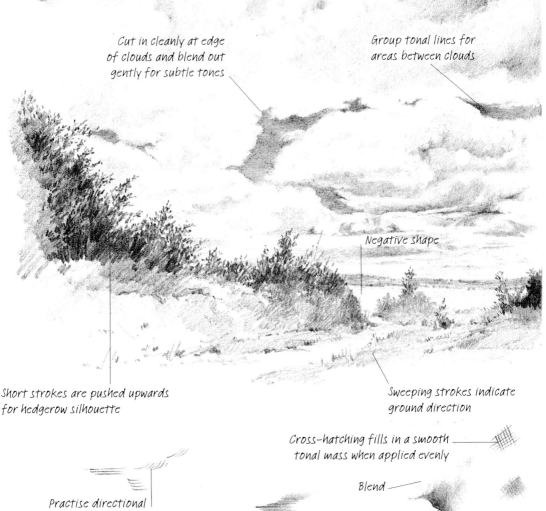

Cut in cleanly at edge
of clouds and blend out
gently for subtle tones

Group tonal lines for
areas between clouds

Negative shape

Short strokes are pushed upwards
for hedgerow silhouette

Sweeping strokes indicate
ground direction

Cross-hatching fills in a smooth
tonal mass when applied evenly

Practise directional
strokes in a
diagrammatic way

Blend

Cut in

I chose a sky with plenty of cloud to show
how recession and distance can be created at
the base by shading closer together. Take your
time – the tonal masses are built up, layer
upon layer, with even pencil pressure.

Typical Problems

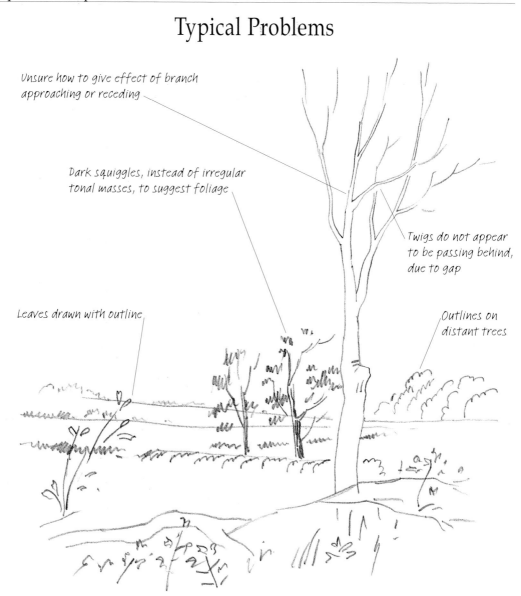

Unsure how to give effect of branch approaching or receding

Dark squiggles, instead of irregular tonal masses, to suggest foliage

Twigs do not appear to be passing behind, due to gap

Leaves drawn with outline

Outlines on distant trees

Many beginners experience problems with the use of tone, so tend, therefore, to depict everything with the use of an outline. I used a very soft pencil for the drawing on page 33, which shows how varied pressure can produce interesting textures on shapes. An outline is not necessary. Light, uneven lines may be used on sunlit surfaces and dark shadow lines will form a contrast as a tonal mass.

Solutions

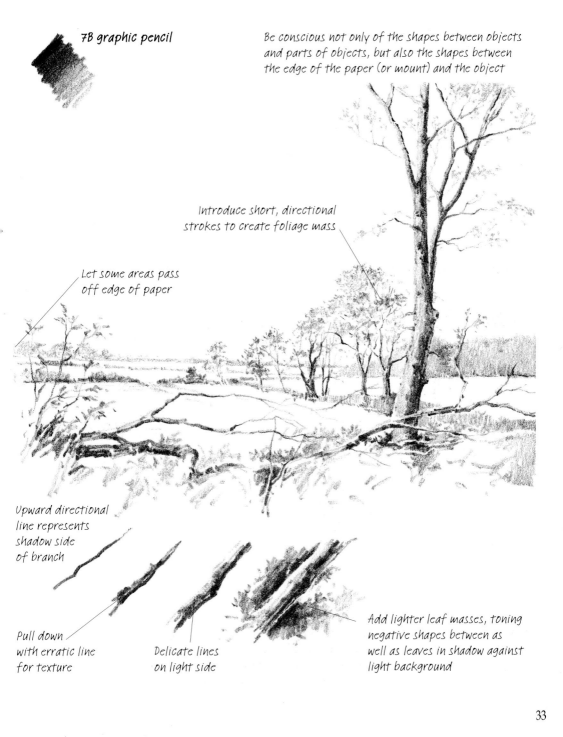

7B graphic pencil

Be conscious not only of the shapes between objects and parts of objects, but also the shapes between the edge of the paper (or mount) and the object

Introduce short, directional strokes to create foliage mass

Let some areas pass off edge of paper

Upward directional line represents shadow side of branch

Pull down with erratic line for texture

Delicate lines on light side

Add lighter leaf masses, toning negative shapes between as well as leaves in shadow against light background

Typical Problems

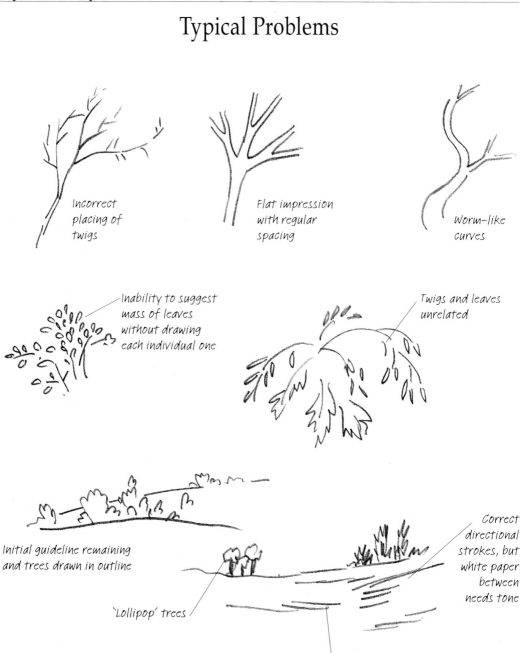

Incorrect
placing of
twigs

Flat impression
with regular
spacing

Worm-like
curves

Inability to suggest
mass of leaves
without drawing
each individual one

Twigs and leaves
unrelated

Initial guideline remaining
and trees drawn in outline

Correct
directional
strokes, but
white paper
between
needs tone

'Lollipop' trees

All same intensity of application

Solutions

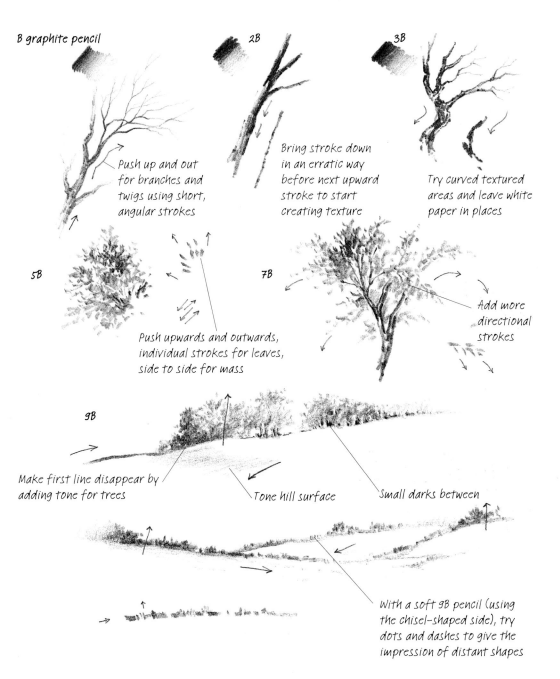

B graphite pencil

2B

3B

Push up and out
for branches and
twigs using short,
angular strokes

Bring stroke down
in an erratic way
before next upward
stroke to start
creating texture

Try curved textured
areas and leave white
paper in places

5B

7B

Push upwards and outwards,
individual strokes for leaves,
side to side for mass

Add more
directional
strokes

9B

Make first line disappear by
adding tone for trees

Tone hill surface

Small darks between

With a soft 9B pencil (using
the chisel-shaped side), try
dots and dashes to give the
impression of distant shapes

Demonstration

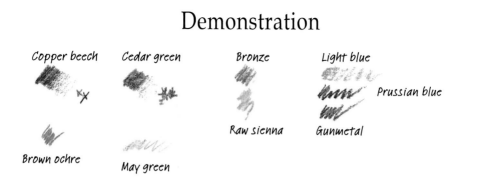

Copper beech

Cedar green

Bronze

Light blue

Prussian blue

Raw sienna

Gunmetal

Brown ochre

May green

Here is an opportunity to use brushes and water alongside pencils, using pencil strokes in a similar way to brush techniques. As drawing and watercolour painting are so closely linked you will find water-soluble pencils the ideal medium for the transition between the two methods.

The choice of watercolour pencil hues for this view of open landscape with straw bales is shown above. Not only do the round bales provide contrasting shapes within the composition, but they also help to achieve the sense of strong perspective I felt was needed here.

Dry pencil on paper

Water added to this half of the study

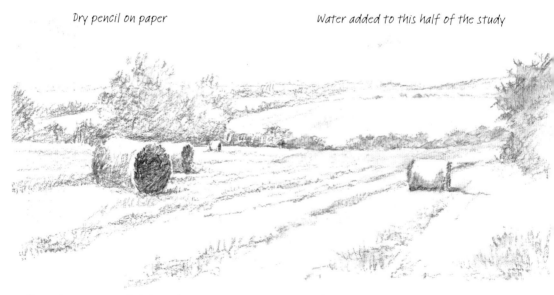

1. Draw the scene very lightly in Copper beech and Cedar green, paying attention to the feeling of recession.

2. Gently apply Bronze, Raw sienna and Brown ochre to the surface to achieve the textured masses.

The rough surface of watercolour paper helps the textured effect, and the 300 gsm (140 lb) paper allows easy blending when water is added.

The jagged edge of the bales is achieved by making a mass of crosses. When water is later added the colour changes

The effect of the tree masses is achieved in exactly the same way as with the graphic pencil exercises

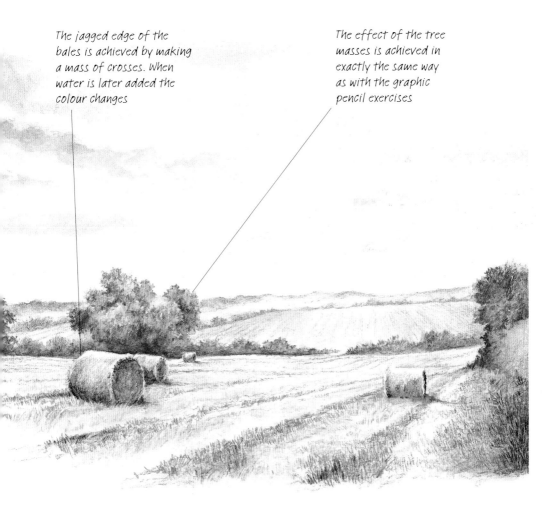

3. Gently brush clean water over the surface of the paper. This causes the pigments to dilute and produces slightly textured washes. When dry, apply detailed drawing over the washed areas, using directional pencil strokes to suggest growth of new grass amongst the stubble.

4. Add more layers of water to your work and, when dry, apply pencil drawing until you are satisfied that the desired effect has been achieved. All these pencil movements are the same as those used with ordinary graphic pencils.

Water in Landscapes

Water moves in response to how it is disturbed – it is only very rarely that you see a completely placid, still expanse – so each of the examples in this theme demonstrates how the surface of water is influenced by the factors and objects around it. Beginners may not wish to attempt to draw birds or bridges, but do practise the darks and lights of the ripples and notice the shapes between.

Another vital point to remember is that, with the exception of muddied waters, water takes its colour from reflections above or beside it, or from what is beneath and in it.

Because of this, it is worth paying attention to shadows created by reflected objects.

If a subject appears to be complicated, look at small areas at a time, perhaps using a viewfinder. Analyse what you see and think of it in a diagrammatic way in order to understand the shapes, notice how they are formed, and practise them.

It is also a good idea to take photographs of scenes that feature water; the demonstration and solutions in this section will be easier if you have references – but remember that there is no substitute for direct observation.

Typical Problems

Worm-like strokes

Roughly scribbled tonal mass

Up-and-down movements on side-to-side strokes that are unrelated to each other

Zigzags are the basis for some reflections and only require a little more understanding of the subject to be used successfully

Solutions

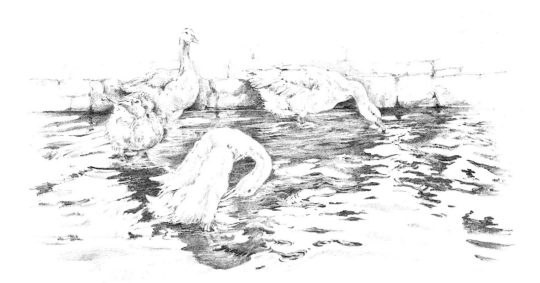

9B graphite pencil

This produces more texture on delicate areas than may be required, but is ideal for strong, sweeping strokes

Practice marks

It is a good idea to practise a variety of marks suggesting movement with varied pressure on the pencil, to see which effects you prefer

B graphite pencil

For less texture, where gradation is required

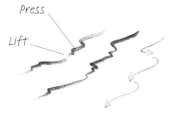

Press

Lift

Arrows show pencil movement

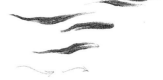

Using a 9B pencil on a pad of paper (which absorbs some of the pressure), you will achieve rich, dark sweeping strokes. Do not be afraid to press down really hard before lifting again. Look closely at some of the areas within the above study and try to achieve some of the undulations you can see here.

Typical Problems

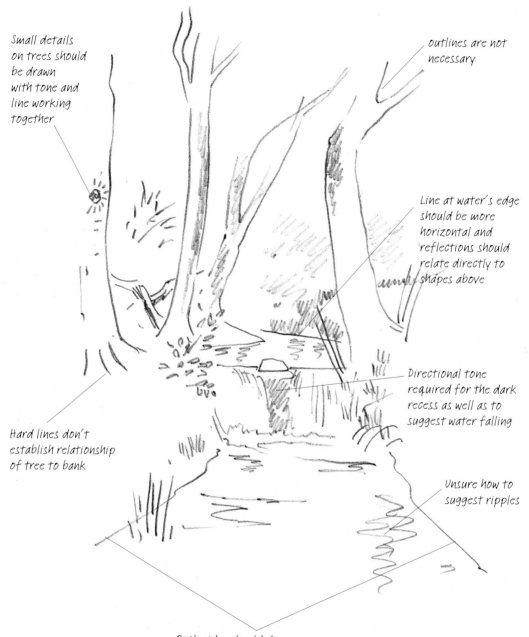

Small details on trees should be drawn with tone and line working together

outlines are not necessary

Line at water's edge should be more horizontal and reflections should relate directly to shapes above

Hard lines don't establish relationship of tree to bank

Directional tone required for the dark recess as well as to suggest water falling

Unsure how to suggest ripples

Both sides should diverge more, as less surface is visible when the stream is viewed from this angle

Solutions

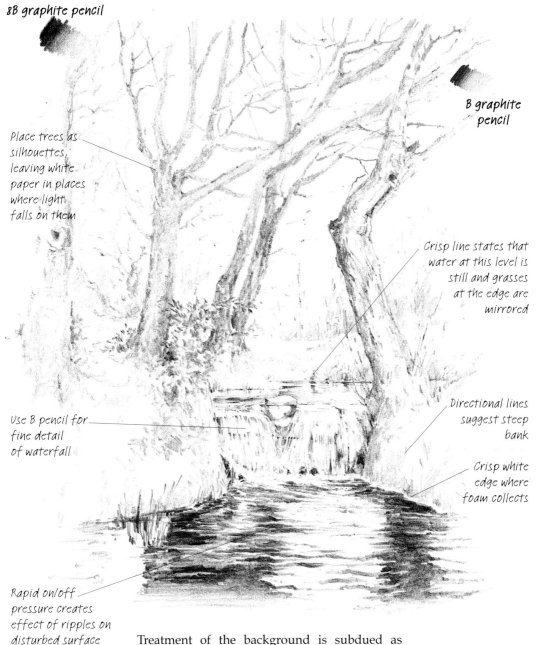

8B graphite pencil

Place trees as silhouettes, leaving white paper in places where light falls on them

B graphite pencil

Crisp line states that water at this level is still and grasses at the edge are mirrored

Use B pencil for fine detail of waterfall

Directional lines suggest steep bank

Crisp white edge where foam collects

Rapid on/off pressure creates effect of ripples on disturbed surface

Treatment of the background is subdued as the drawing focuses on the treatment of water. Note the use of contrasts and the way light cuts into dark, and dark into light, areas.

Typical Problems

A subject like this requires the use of tonal areas to give impact, and beginners often experience problems with tone when trying to show movement. I would advise close observation of water surfaces from life and from photographs.

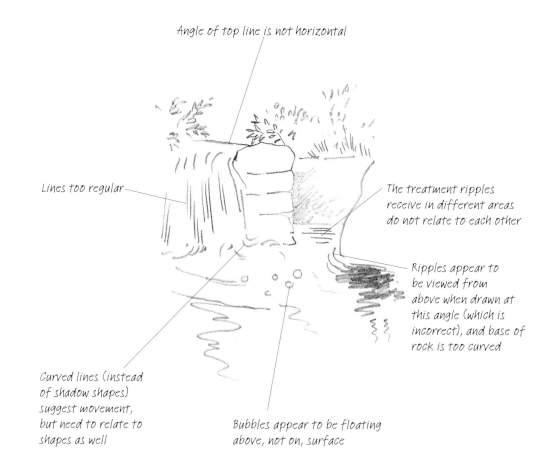

Angle of top line is not horizontal

Lines too regular

The treatment ripples receive in different areas do not relate to each other

Ripples appear to be viewed from above when drawn at this angle (which is incorrect), and base of rock is too curved

Curved lines (instead of shadow shapes) suggest movement, but need to relate to shapes as well

Bubbles appear to be floating above, not on, surface

Solutions

Often when we view a scene we see reflections and/or shadows within the area to be drawn that do not relate to what we see around them, but to something that is beyond and out of the picture. So, in this drawing I have added dark reflections in the foreground water that relate to trees above the small area that is depicted.

Start with horizontal line, then place rock and bank, using gentle tone at first

Pull down dark areas visible on either side of falling water, leaving light strips of water untouched

Put extra dark tone in small gaps between water

Put a few lightly drawn tonal lines down length of water area

Apply light tone around oval shapes of partially submerged leaves and debris

Place dark behind any stretch that requires contrast

Practise:

(a) Downward wiggles

(b) Making the shape wider and very dark

(c) Joining the shapes in places

(d) Delicate shapes, with a very fine pencil point

Typical Problems

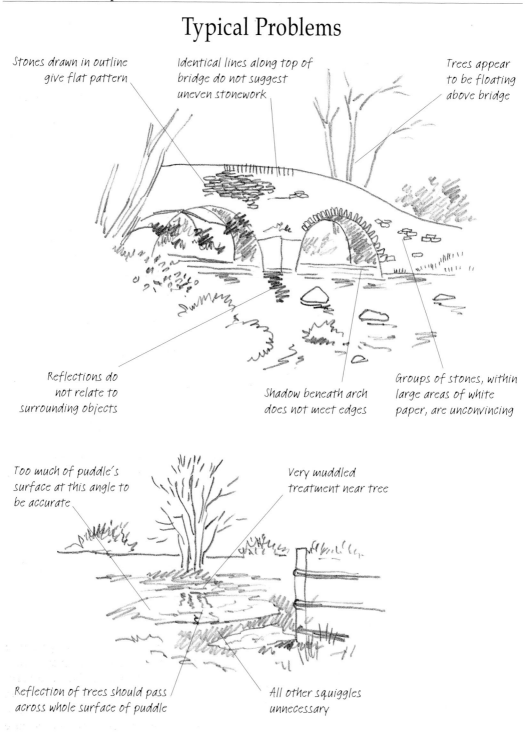

Stones drawn in outline give flat pattern

Identical lines along top of bridge do not suggest uneven stonework

Trees appear to be floating above bridge

Reflections do not relate to surrounding objects

Shadow beneath arch does not meet edges

Groups of stones, within large areas of white paper, are unconvincing

Too much of puddle's surface at this angle to be accurate

Very muddled treatment near tree

Reflection of trees should pass across whole surface of puddle

All other squiggles unnecessary

Solutions

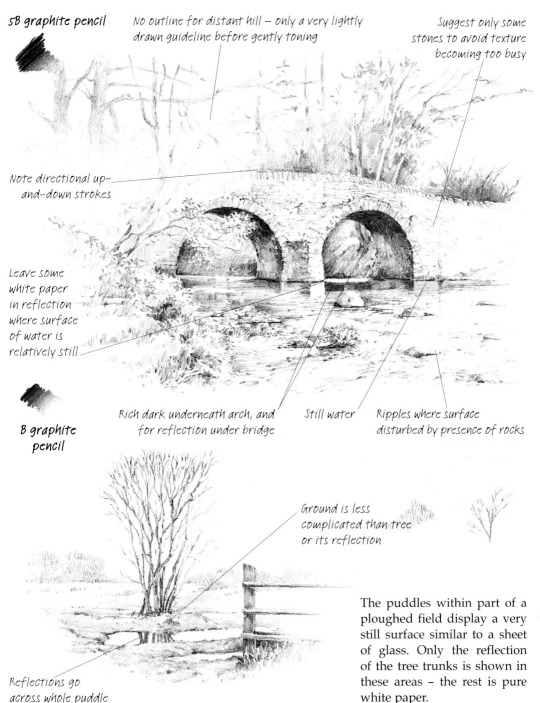

5B graphite pencil

No outline for distant hill – only a very lightly drawn guideline before gently toning

Suggest only some stones to avoid texture becoming too busy

Note directional up-and-down strokes

Leave some white paper in reflection where surface of water is relatively still

B graphite pencil

Rich dark underneath arch, and for reflection under bridge

Still water

Ripples where surface disturbed by presence of rocks

Ground is less complicated than tree or its reflection

Reflections go across whole puddle

The puddles within part of a ploughed field display a very still surface similar to a sheet of glass. Only the reflection of the tree trunks is shown in these areas – the rest is pure white paper.

45

Demonstration

B graphic pencil

Twist pencil as you travel to achieve delicate twig effects, lifting gently off while twisting

Irregular pressure, downward line

Repeat and work on this (with varied pressure) to achieve effect of bark

Treat bank with directional strokes before adding grass

Tick and flick for grass. The same in pastel as pencil

Keep water reflections horizontal

Practise a mass of twig lines, then fill in between them with your sky colour

Add crisp dead-leaf effect with 'pushing out' movement, then place sky colour behind

Add other greens and light hues. Shadow areas will contain cooler colours

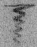

Use a constructive doodle as a base stroke. Increase pressure then lift off gently

Bring in light sky reflection colours at edges of dark tree reflection

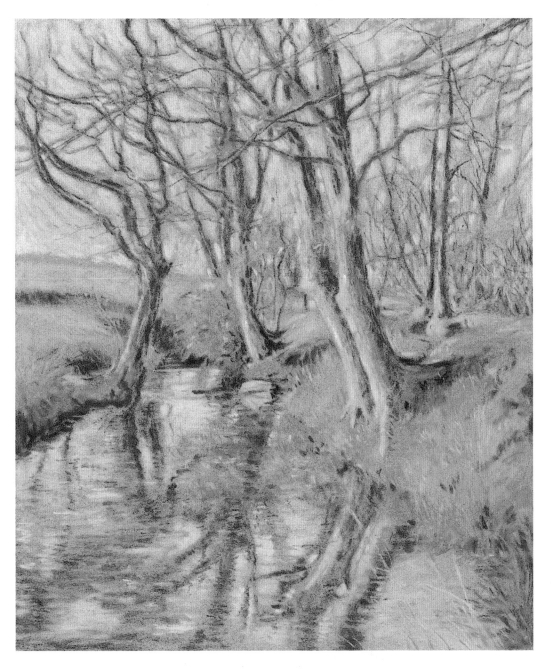

This is worked in pastel pencils on pastel board, and the softness of the medium suits the tranquil subject. The treatment is identical to the pencil methods. A coloured ground makes full use of the white and lighter pastel pencil colours.

Buildings in Landscapes

Barns and houses in the countryside – whether they are in good condition and occupied or derelict and crumbling – offer a wealth of subject matter for the artist, and can be found in countries all over the world.

The combination of natural landscape and man-made architecture is an appealing one, and provides you with many choices. Do you want to view the building from afar as part of the countryside, get in close to frame it as your focal point, or even concentrate on details that are unique to it? This is when carrying a viewfinder can come in very useful – take time to look at the buildings from as many angles as possible until you are satisfied that the viewpoint you have chosen is interesting and achievable.

Another point to note is that, unlike the situation in villages, town and cities, where buildings can crowd upwards as well as sideways, the sky plays as much of a part as the ground around the building. Look at the previous themes, and bring what you have learned from them to this theme.

Typical Problems

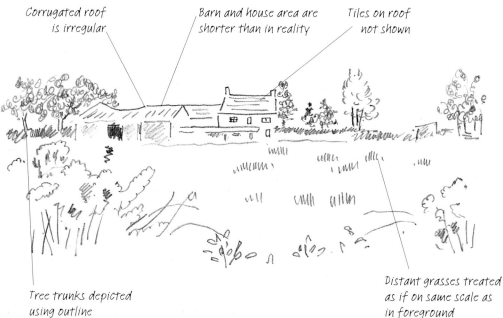

Corrugated roof is irregular

Barn and house area are shorter than in reality

Tiles on roof not shown

Tree trunks depicted using outline

Distant grasses treated as if on same scale as in foreground

Solutions

B graphite pencil

Keep sky simple with light, sweeping
strokes of chisel side of lead

Trunk and branches are
silhouettes at this distance
with gaps for foliage

Note important shadow
shapes on adjoining surfaces

Place dark, irregular mass of tone either side of a thin strip
of white paper to show light grasses against a dark recess

Start trees on left of barn using
up-and-down (continuous)
movements, then mass them

A series of
directional
strokes is
required for
the corrugated
barn roof

A simple, irregular line
is repeated, starting
with the top ridge
and working down, to
suggest a tiled roof

Note how the slender grasses in the field are not drawn in detail until they are in the foreground. For distant grasses, light, side-to-side strokes (made with an up-and-down movement) suggest shadows across the surface of the field.

Typical Problems

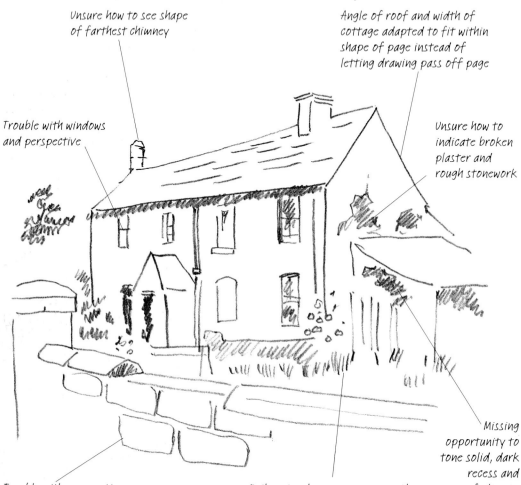

Unsure how to see shape
of farthest chimney

Angle of roof and width of
cottage adapted to fit within
shape of page instead of
letting drawing pass off page

Trouble with windows
and perspective

Unsure how to
indicate broken
plaster and
rough stonework

Trouble with perspective
of stone wall

Failure to place grasses correctly
in relation to stone wall

Missing
opportunity to
tone solid, dark
recess and
failing to
define edges

The problems here have arisen because the
house is drawn in the form of an outline rather
than working from within and relating positions
of windows, porch, chimneys and so on. Using
guidelines and shapes between would help.

Solutions

3B graphite pencil — *A 3B pencil achieves rich, dark areas of tone, while still enabling a fine line to be drawn after a chisel shape is used*

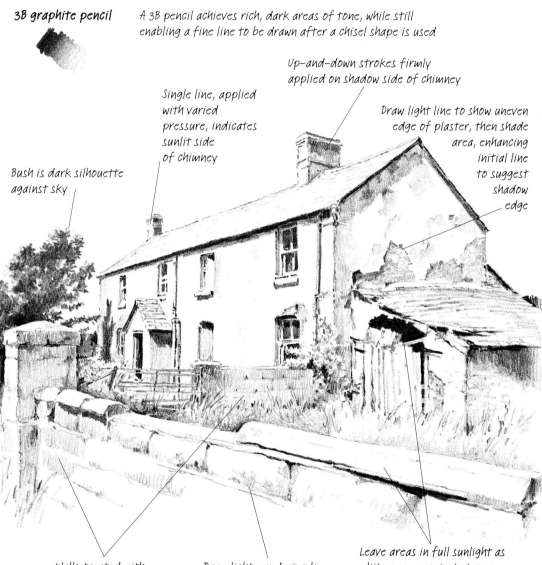

Up-and-down strokes firmly applied on shadow side of chimney

Single line, applied with varied pressure, indicates sunlit side of chimney

Draw light line to show uneven edge of plaster, then shade area, enhancing initial line to suggest shadow edge

Bush is dark silhouette against sky

Walls treated with up-and-down strokes

Draw light wandering line first before adding tone

Leave areas in full sunlight as white paper against strong contrast of dark recesses

Driving through the countryside you may be lucky enough to discover a derelict farmhouse with outbuildings that is an absolute gift to the artist. On the day I came across this building it was in bright sunlight, affording me the opportunity to use dark and light contrasts to full effect, and also many different textured surfaces.

Typical Problems

Close observation, perhaps with the aid of a few detailed studies, is advisable before starting the main drawing.

Difficulty in indicating the steep slope of tiled roof above eye level

Treatment of stonework surface shows lack of understanding of perspective

Opportunity for capturing dark, negative shapes, created by position of the open gate, has not been used to advantage

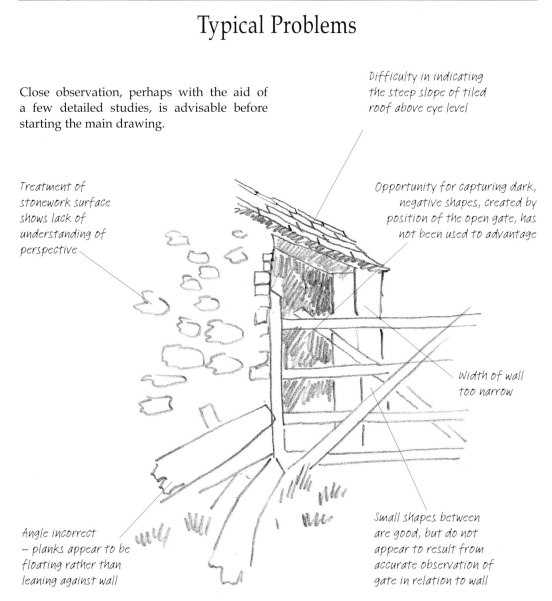

Width of wall too narrow

Angle incorrect – planks appear to be floating rather than leaning against wall

Small shapes between are good, but do not appear to result from accurate observation of gate in relation to wall

A drawing from an unusual angle can encourage the beginner to concentrate more on the shapes between than the actual outline of the forms. Learning to forget what the subject actually is, while placing elements accurately with the aid of guidelines, is a great advantage.

Solutions

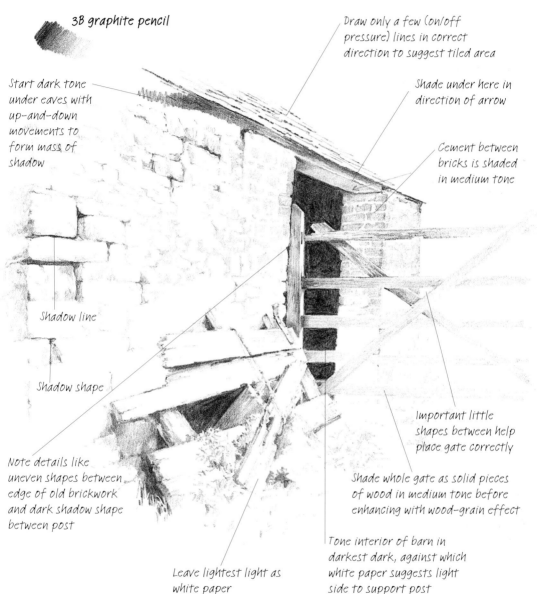

3B graphite pencil

Draw only a few (on/off pressure) lines in correct direction to suggest tiled area

Shade under here in direction of arrow

Start dark tone under eaves with up-and-down movements to form mass of shadow

Cement between bricks is shaded in medium tone

Shadow line

Shadow shape

Important little shapes between help place gate correctly

Note details like uneven shapes between edge of old brickwork and dark shadow shape between post

Shade whole gate as solid pieces of wood in medium tone before enhancing with wood-grain effect

Leave lightest light as white paper

Tone interior of barn in darkest dark, against which white paper suggests light side to support post

Practise your scales:

Tone the darkest dark as dense as possible

Just as a musician requires notes in order to play a tune, you need your tones to create a drawing. Try to use a variety of tones.

Typical Problems

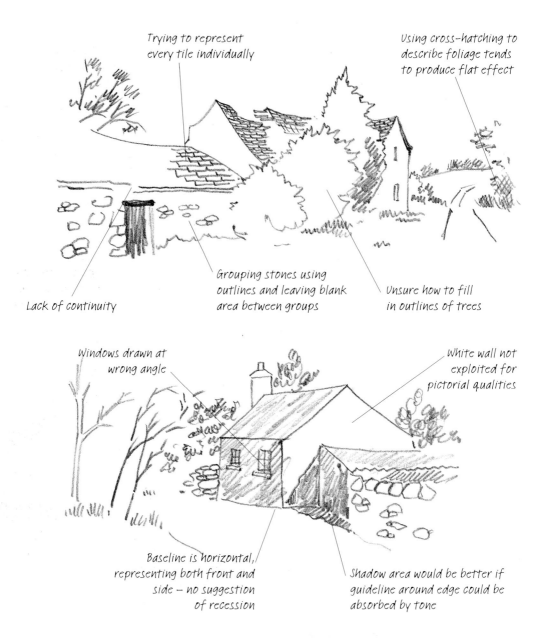

Trying to represent
every tile individually

Using cross-hatching to
describe foliage tends
to produce flat effect

Grouping stones using
outlines and leaving blank
area between groups

Unsure how to fill
in outlines of trees

Lack of continuity

Windows drawn at
wrong angle

White wall not
exploited for
pictorial qualities

Baseline is horizontal,
representing both front and
side – no suggestion
of recession

Shadow area would be better if
guideline around edge could be
absorbed by tone

However detailed and carefully drawn
an area may be, if the perspective is
wrong, the drawing will not work.

Solutions

These two studies show how much white paper may be left untouched by the pencil when depicting trees, walls of buildings, sky and ground.

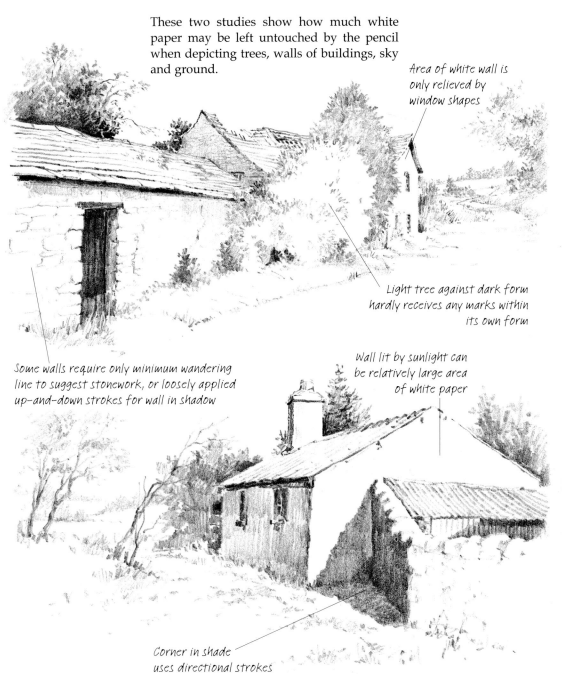

Area of white wall is only relieved by window shapes

Light tree against dark form hardly receives any marks within its own form

Some walls require only minimum wandering line to suggest stonework, or loosely applied up-and-down strokes for wall in shadow

Wall lit by sunlight can be relatively large area of white paper

Corner in shade uses directional strokes

Demonstration

This demonstration is worked with a coloured Derwent drawing pencil with a soft, creamy texture that provides a velvety finish. The extra-thick strip requires sharpening to a fine point for the delicate linear work on twigs and branches, but for most of this drawing the chisel side and point are used alternately.

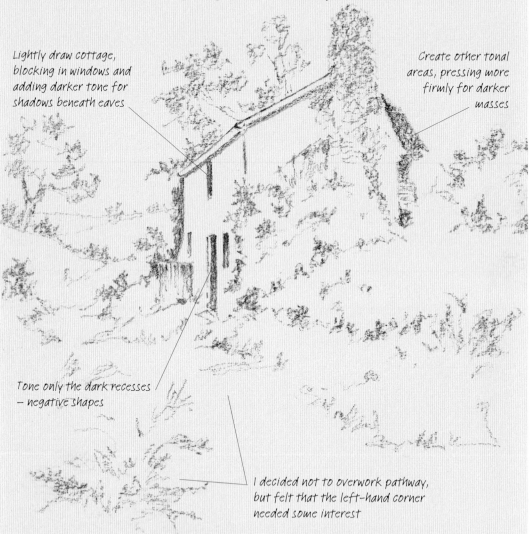

Lightly draw cottage, blocking in windows and adding darker tone for shadows beneath eaves

Create other tonal areas, pressing more firmly for darker masses

Tone only the dark recesses – negative shapes

I decided not to overwork pathway, but felt that the left-hand corner needed some interest

To add more textural interest, I worked on a rough surface – a tinted Bockingford water-colour paper. In many instances, just working with the texture of the paper can help you achieve exciting effects.

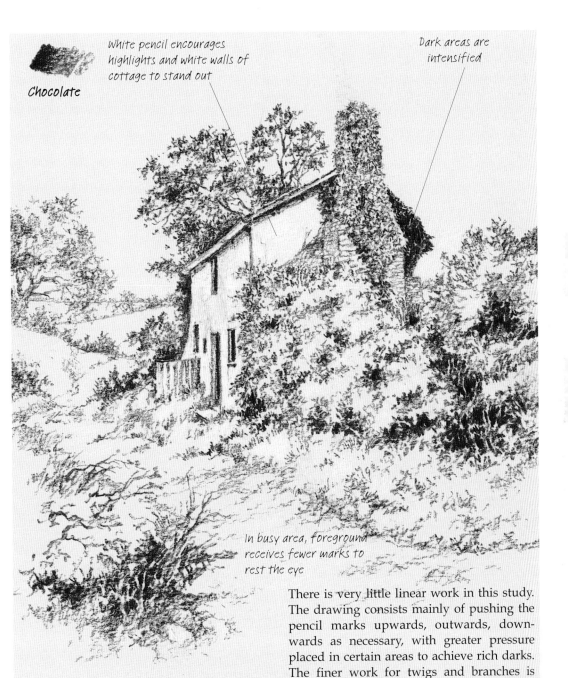

White pencil encourages highlights and white walls of cottage to stand out

Dark areas are intensified

Chocolate

In busy area, foreground receives fewer marks to rest the eye

There is very little linear work in this study. The drawing consists mainly of pushing the pencil marks upwards, outwards, downwards as necessary, with greater pressure placed in certain areas to achieve rich darks. The finer work for twigs and branches is achieved by twisting the pencil to give interest of line.

Village Houses and Cottages

Once you leave behind solitary buildings in the countryside and start looking for subjects in villages and small towns, your concerns may begin to change a little.

In addition to more perspective angles being necessary – especially in old streets with houses built in different eras – you may have to make some decisions about what to include in your drawing from the scene in front of you, and what to leave out.

This theme looks closely at perspective and reinforces the value of guidelines and shapes. Emphasis is also placed throughout on the importance of learning to observe closely the subject you choose to draw, noticing tiny details that are of great help within your work – such as the textures of thatched roof, stone walls, uneven tiles, grass and foliage. If you are lucky enough to find cobbled streets and flagstoned paths, these make excellent studies in their own right.

With this in mind, the studies of the buildings in this theme have been broken down in places to details in order to encourage close observation and the development of understanding and personal drawing skills. I hope this approach will help you understand the basic theory and allow you to use a more 'free' style confidently, if you wish, once it has become established.

Typical Problems

Unsure how to suggest texture of thatched roof

Although top of chimney is above eye level, it is drawn as if on eye level

Suggestion of foliage could be placed crisply up to edge to make building appear in front

All drawn along same line, with no thought for perspective

Path drawn as if house is at top of steep bank

Porch drawn as if cottage is viewed from an angle, but windows drawn as if looking straight at building

Solutions

2H pencil **B pencil**

Sky darker than light chimney

Dark tone behind light thatch brings side of cottage forward

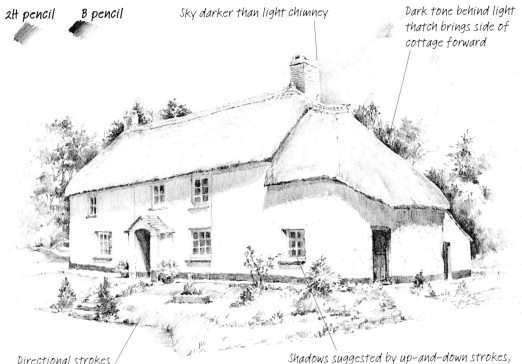

Directional strokes suggest sloping bank

Shadows suggested by up-and-down strokes, as in dark door and inside of windows

Thatch shadow lines follow form

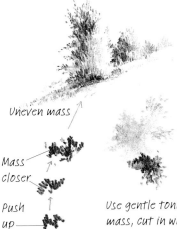

Uneven mass

Mass closer

Push up

Use gentle toning for light mass, cut in with dark area underneath

Practise tonal blocks and lines applied with erratic pressure. See how many tonal variations you can create with both pencils. Use softer pencil for all the rich darks

Typical Problems

These careless drawings can be easily corrected with closer observation. Allow yourself 'thinking time' before starting to draw, so that you can observe closely how elements fit together in relationship to one another.

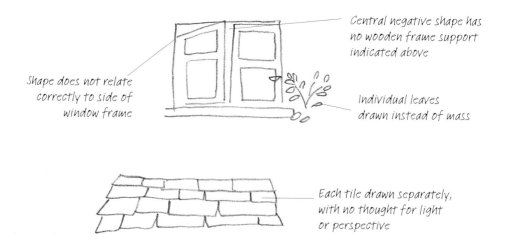

Central negative shape has no wooden frame support indicated above

Shape does not relate correctly to side of window frame

Individual leaves drawn instead of mass

Each tile drawn separately, with no thought for light or perspective

Stonework of wall too spaced out, with no consideration for relationships between stones

Stones placed as the scales of a fish, usually when you travel too quickly, placing one stone after another without thinking

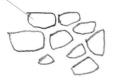

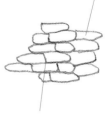

Grasses placed one after the other, either massed or individually, with no regard for tonal values

Curved sides followed by straight sides, and all stones drawn with even pressure, producing wire-like outlines

Solutions

8B pencil

(large tonal areas)

B pencil

(fine lines)

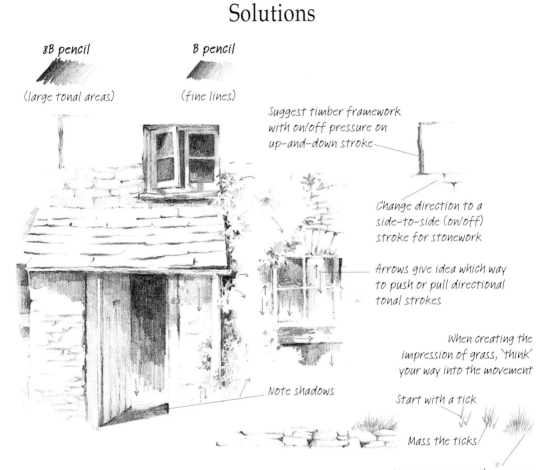

Suggest timber framework
with on/off pressure on
up-and-down stroke

Change direction to a
side-to-side (on/off)
stroke for stonework

Arrows give idea which way
to push or pull directional
tonal strokes

When creating the
impression of grass, 'think'
your way into the movement

Start with a tick

Mass the ticks

Vary pressure so they are no
longer recognizable as ticks

Note shadows

Start the open window by using
the most important shapes

Draw around
panes of glass

Fill in dark tone,
leaving light bars

The on/off pressure used for depicting stones is
similar to that for roof tiles over the porch. Lift
pressure completely off the paper at times to
suggest strong light, causing shadows between
tiles to almost disappear

Typical Problems

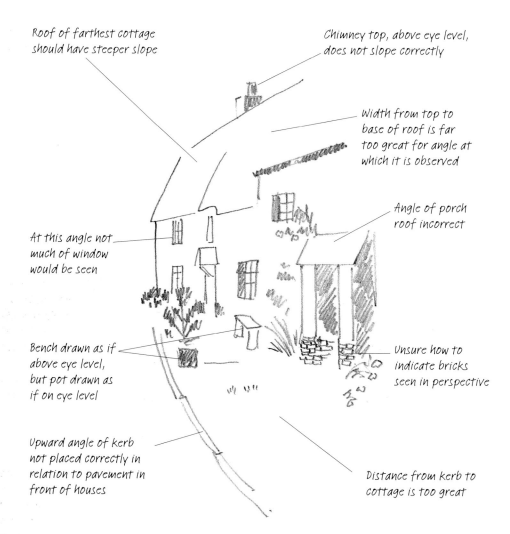

Roof of farthest cottage should have steeper slope

Chimney top, above eye level, does not slope correctly

Width from top to base of roof is far too great for angle at which it is observed

Angle of porch roof incorrect

At this angle not much of window would be seen

Bench drawn as if above eye level, but pot drawn as if on eye level

Unsure how to indicate bricks seen in perspective

Upward angle of kerb not placed correctly in relation to pavement in front of houses

Distance from kerb to cottage is too great

This is a difficult viewpoint for beginners to draw unless each part of the buildings is seen in relation to the next and observed as a shape (with the aid of vertical and horizontal guidelines). If you are using a photograph as reference, hold a straight edge against each part of the subject to check its dimensions. When drawing from life, hold a pencil in front of you, vertically or horizontally, relating this to the angles.

Solutions

HB pencil 2H graphic
pencil

Shading applied
with vertical
strokes

Start the initial drawing with a 2H pencil,
both for the tonal masses and linear work

Draw extent
of cast
shadow lightly first,
with downward
strokes shaded up
to, and including,
guideline

Use HB pencil
for darker areas
and shadow lines
between tiles
with on/off
pressure applied
to a continuous
stroke

Eye level

Draw a horizontal line
on eye level. Radiate
lines from it to
help place chimneys,
windows, porches and
the acute slope of the
thatched roofs

Delicate line drawn
with very sharp 2H
pencil adds crispness
to edge and
emphasizes contrast

Draw bricks as toned
blocks over toned area

A village street demonstrates simple
perspective as the cottages are built on a hill,
which offers interesting shapes. You may find
a detailed drawing like this rather daunting
at first. Do not try to copy it – just observe
and practise the individual aspects.

Start the mass of leaves
and flowers as a light tone,
emphasizing shadow areas.
Subsequent applications of
tone will add depth. Areas of
white paper will represent white
flowers or light on leaves

Typical Problems

Angle of this roof is almost correct, but others get worse

Unsure how to indicate surface is sloping away

Cottage almost faces viewer

Difficulty in drawing tiles – top ones, farther away, should be drawn closer together

Windows face viewer

Various 'almost horizontal' lines used (at different levels), but only eye level would be horizontal – all others would be angled

No eye-level line was used to help with perspective

Guidelines would help to solve problem of showing foreshortened area

Top and base of container appear flat, and bands around container do not indicate curved surface

With old cottages, much of the wall area may be covered in ivy or other creepers. Use the Trees and Woodland and Gardens themes to help you understand how to draw these surfaces.

Solutions

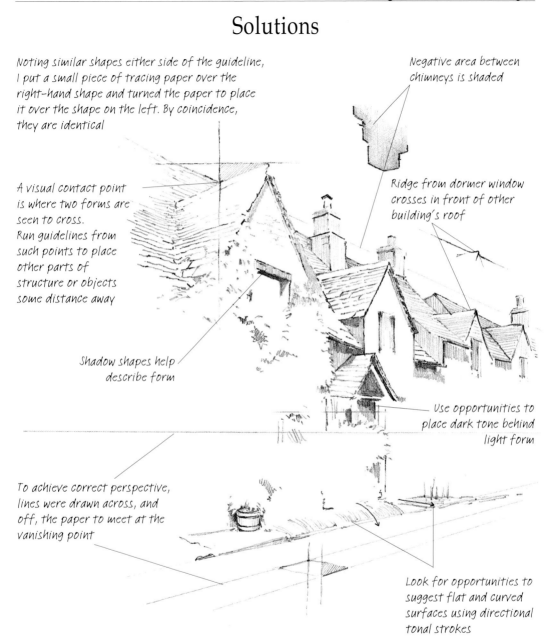

Noting similar shapes either side of the guideline, I put a small piece of tracing paper over the right-hand shape and turned the paper to place it over the shape on the left. By coincidence, they are identical

Negative area between chimneys is shaded

A visual contact point is where two forms are seen to cross.
Run guidelines from such points to place other parts of structure or objects some distance away

Ridge from dormer window crosses in front of other building's roof

Shadow shapes help describe form

Use opportunities to place dark tone behind light form

To achieve correct perspective, lines were drawn across, and off, the paper to meet at the vanishing point

Look for opportunities to suggest flat and curved surfaces using directional tonal strokes

Just as there is a similarity in shape between the guidelines and the edge of the roof, the central area here is separated by two guidelines. Look also at the two smaller shapes between relating to the guidelines in the centre area.

Demonstration

This demonstration shows the importance of guidelines to place a structure correctly. From these, look for shapes between to help achieve correct angles.

The areas blocked in red are some of the small shapes that are not negative but are between a guideline and part of an object. Get these right, and the rest will follow.

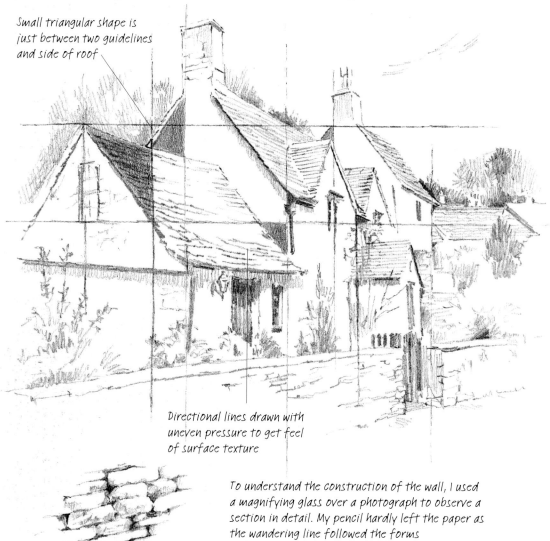

Small triangular shape is just between two guidelines and side of roof

Directional lines drawn with uneven pressure to get feel of surface texture

To understand the construction of the wall, I used a magnifying glass over a photograph to observe a section in detail. My pencil hardly left the paper as the wandering line followed the forms

You can learn a great deal by using photographs. They can help you see how the use of guidelines creates shapes between that assist with accurate placing of angles. Before working in pen and ink, plan your drawing in pencil. You can then draw over the pencil with ink before erasing it and adding the finer details.

Foliage

1. Start with an uneven line, pushing strokes upwards.

2. Pull down to form a mass.

3. Push tiny strokes (as individual marks) upwards.

4. Combine the two to form a mass with small marks at edges, suggesting individual leaves.

5. Add curved directional lines to add interest.

Tiles

Up-and-down application of directional lines can be used to suggest shadow areas on a flat surface and, when intensified, a dark recess

This line is applied with uneven pressure, backwards and forwards, to achieve the undulating effect of the tiles

Look closely at the angles to achieve correct perspective

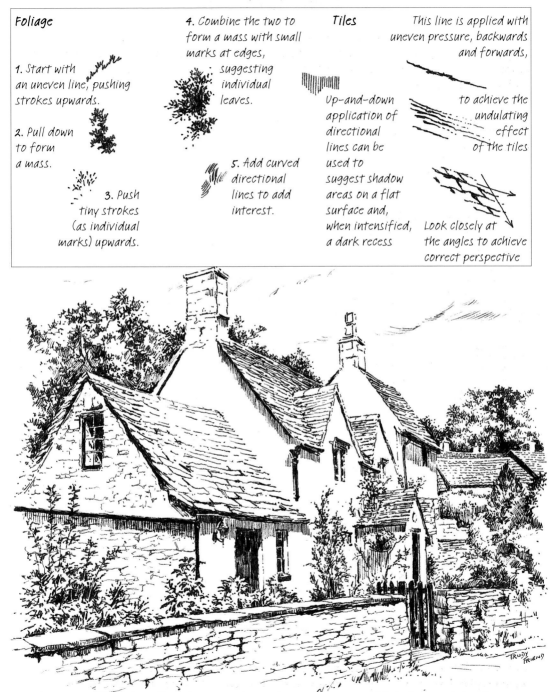

Suggest stones in the wall in places to indicate that you are aware of light hitting the surface. It is not necessary to draw every stone in detail – learn to simplify

Gardens

From tiny, one-person town enclosures to vast public areas that are tended by many hands, gardens offer artists a true wealth of subjects for drawing and painting. And it's worth considering at this point what makes a garden – plants, trees and flowers alone are only a part of the whole, and it is the planning mind of humanity, whether regularizing a garden or leaving as a wilderness, that makes the space a special one.

Some of the best garden subjects are, in fact, the man-made objects that are found in

them, from classical, monumental statuary and elaborate pots and containers to humble park benches and civic fountains. Combining the natural and the artificial is a particular challenge, and requires you to use most of the techniques in the preceding themes.

Because many gardens have tall trees in a relatively enclosed space, the quality of light you are working in may be made more interesting – and more difficult – to draw by the effect of dappled sunlight. As always, observation is the key to success.

Typical Problems

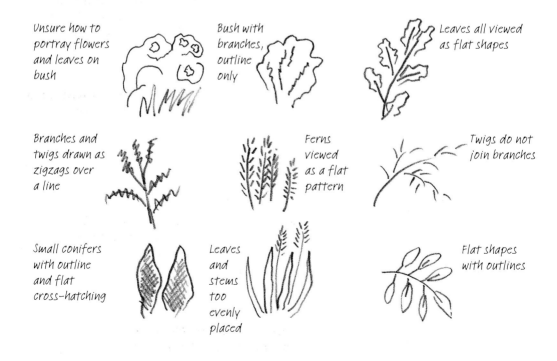

Unsure how to portray flowers and leaves on bush

Bush with branches, outline only

Leaves all viewed as flat shapes

Branches and twigs drawn as zigzags over a line

Ferns viewed as a flat pattern

Twigs do not join branches

Small conifers with outline and flat cross-hatching

Leaves and stems too evenly placed

Flat shapes with outlines

Solutions

3B pencil

Make a chisel-shaped lead by toning, then keep the pencil in the same position within your fingers and push the lead up and down to create a tonal block in the shape of a leaf silhouette. Twist the pencil slightly to locate the pointed side of the lead and pull a short line down from the base of the leaf to indicate a twig. Do the same again, adding leaf after leaf. Remember that leaves will come from the twigs at different angles. Try not to lift your pencil off the paper while working – just lift the pressure.

Pull down delicate lines for twigs and branches

Push short upward strokes again and again and mass them, letting individual ones become more apparent at edge of mass

Dark tonal mass behind top of hedge

Dark mass behind light outcrop of foreground foliage

Leaves and stems silhouetted for foreground mass of larger forms

Gentle toning from side to side to suggest flat surface of path

Typical Problems

Worm-like twigs do
not join main stem

Ellipse drawn incorrectly

Cross-hatching because
unsure how to create tonal
area suggesting foliage

No sense of perspective

Area backing stand does not
look as if it passes behind

Shadow applied
without thought for
shape of pedestal

Continuous line around
leaves is too diagrammatic

Each plant treated
in separate way and
unrelated to its neighbour

Even pressure with
similar strokes does
not represent
mass of grass

Each leaf too evenly
spaced with similar
area of tone in
between

Look closely at how plants relate to one another.
When leaves come towards you, try to leave
their shape as white paper. You can draw the
shapes very lightly and tone behind.

Solutions

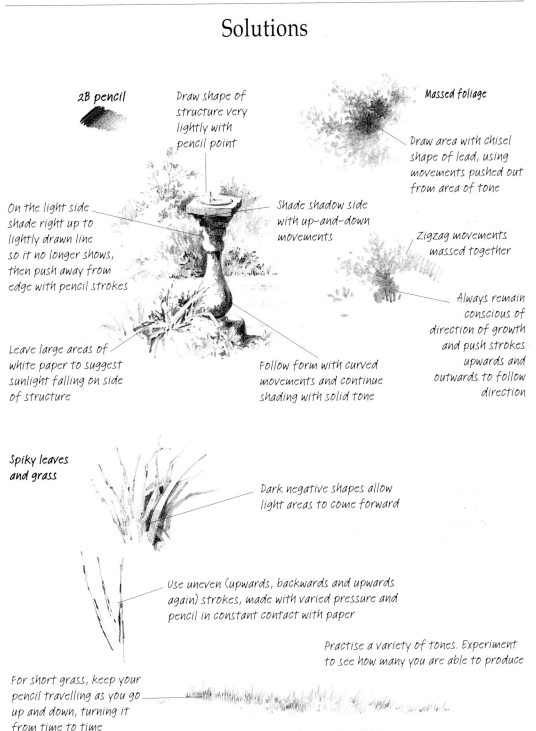

2B pencil

Draw shape of structure very lightly with pencil point

Massed foliage

Draw area with chisel shape of lead, using movements pushed out from area of tone

On the light side shade right up to lightly drawn line so it no longer shows, then push away from edge with pencil strokes

Shade shadow side with up-and-down movements

Zigzag movements massed together

Always remain conscious of direction of growth and push strokes upwards and outwards to follow direction

Leave large areas of white paper to suggest sunlight falling on side of structure

Follow form with curved movements and continue shading with solid tone

Spiky leaves and grass

Dark negative shapes allow light areas to come forward

Use uneven (upwards, backwards and upwards again) strokes, made with varied pressure and pencil in constant contact with paper

Practise a variety of tones. Experiment to see how many you are able to produce

For short grass, keep your pencil travelling as you go up and down, turning it from time to time

Typical Problems

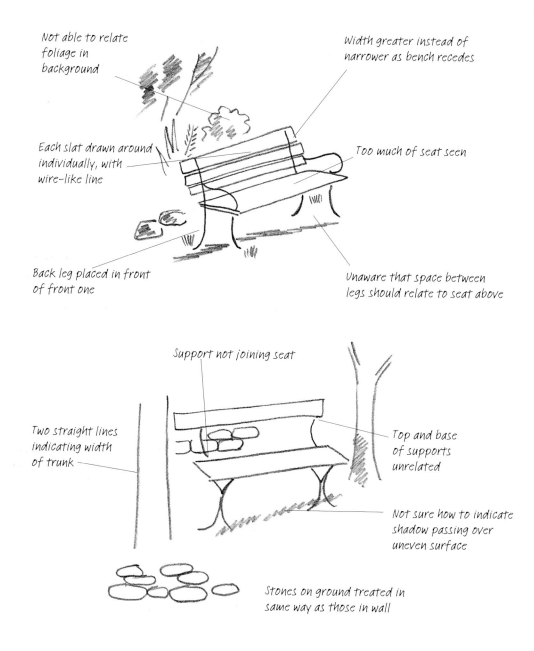

Not able to relate
foliage in
background

Width greater instead of
narrower as bench recedes

Each slat drawn around
individually, with
wire-like line

Too much of seat seen

Back leg placed in front
of front one

Unaware that space between
legs should relate to seat above

Support not joining seat

Two straight lines
indicating width
of trunk

Top and base
of supports
unrelated

Not sure how to indicate
shadow passing over
uneven surface

Stones on ground treated in
same way as those in wall

Solutions

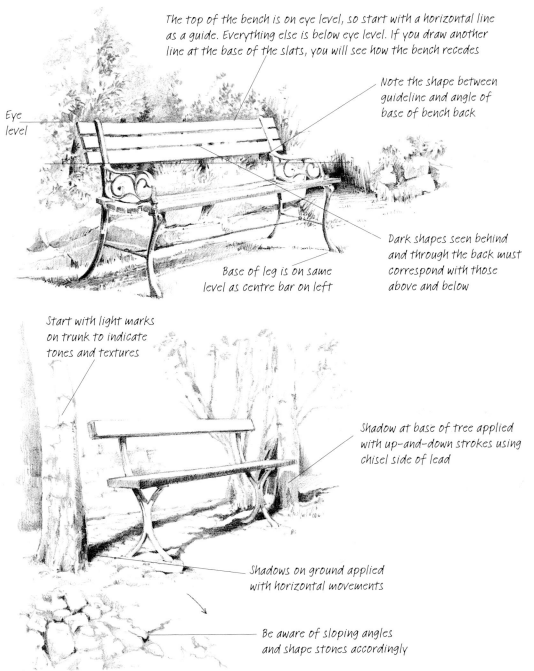

The top of the bench is on eye level, so start with a horizontal line as a guide. Everything else is below eye level. If you draw another line at the base of the slats, you will see how the bench recedes

Note the shape between guideline and angle of base of bench back

Eye level

Dark shapes seen behind and through the back must correspond with those above and below

Base of leg is on same level as centre bar on left

Start with light marks on trunk to indicate tones and textures

Shadow at base of tree applied with up-and-down strokes using chisel side of lead

Shadows on ground applied with horizontal movements

Be aware of sloping angles and shape stones accordingly

Typical Problems

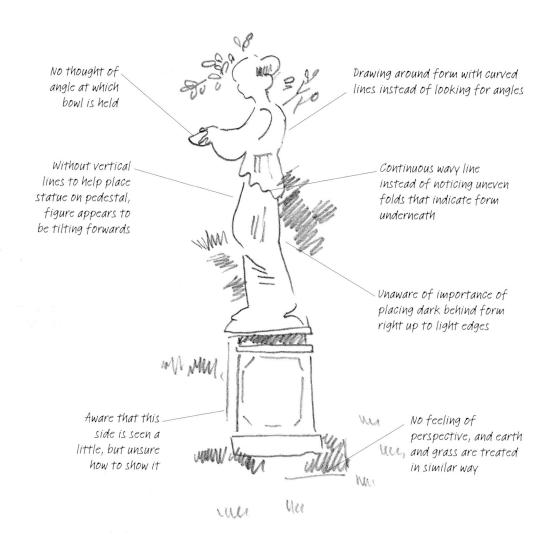

No thought of angle at which bowl is held

Drawing around form with curved lines instead of looking for angles

Without vertical lines to help place statue on pedestal, figure appears to be tilting forwards

Continuous wavy line instead of noticing uneven folds that indicate form underneath

Unaware of importance of placing dark behind form right up to light edges

Aware that this side is seen a little, but unsure how to show it

No feeling of perspective, and earth and grass are treated in similar way

Although there are no negative shapes within the statue itself, the shape between the chin, neck and outstretched arm is a very important area where you can use both horizontal and vertical guidelines.

Solutions

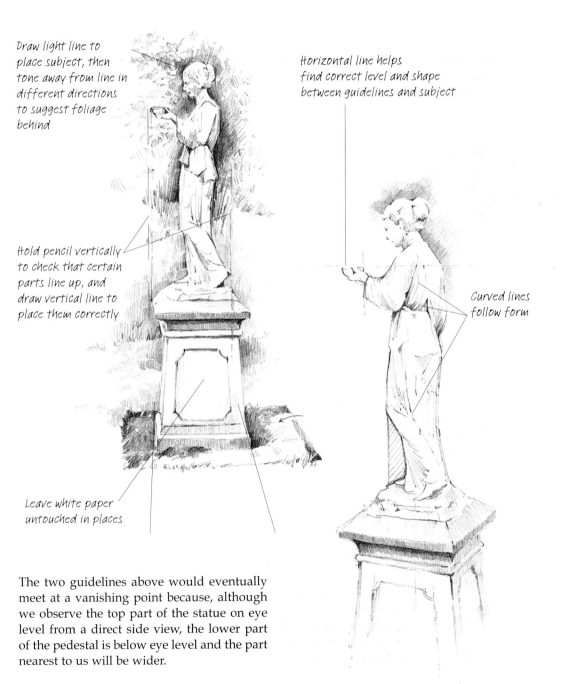

Draw light line to place subject, then tone away from line in different directions to suggest foliage behind

Horizontal line helps find correct level and shape between guidelines and subject

Hold pencil vertically to check that certain parts line up, and draw vertical line to place them correctly

Curved lines follow form

Leave white paper untouched in places

The two guidelines above would eventually meet at a vanishing point because, although we observe the top part of the statue on eye level from a direct side view, the lower part of the pedestal is below eye level and the part nearest to us will be wider.

Demonstration

I chose a little statue in the corner of a garden as a focal point. If you find the statue too complicated, you could substitute the sundial for it on page 71, set at eye level.

Make a rough sketch to position the figure and decide where to place the important dark areas behind. These will make the structure stand forward

Using uneven pressure, and slightly erratic movements, draw leaves freely in green coloured pencil

If you use strong side light, draw dark masses behind the light side of the form and light areas as contrast behind dark (shadow) side

Using another colour or graphite pencil, shade in negative shapes between stalks and leaves

Lightly draw the subject and then work around it using directional strokes

Decide which drawing materials will suit your subject. I chose an illustration cartridge, a line surface paper that is ideal for pen and ink drawing. It also produces a pleasing texture when pencil (coloured or graphite) is used.

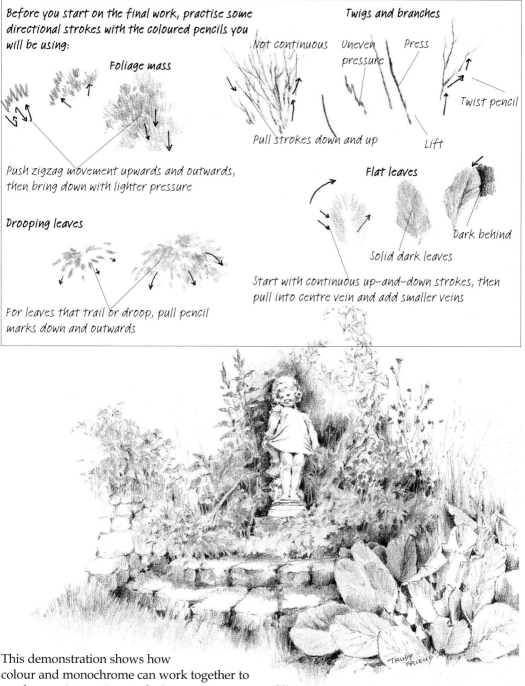

Before you start on the final work, practise some directional strokes with the coloured pencils you will be using:

Foliage mass

Push zigzag movement upwards and outwards, then bring down with lighter pressure

Drooping leaves

For leaves that trail or droop, pull pencil marks down and outwards

Twigs and branches

Not continuous

Uneven pressure

Press

Twist pencil

Pull strokes down and up

Lift

Flat leaves

Dark behind

Solid dark leaves

Start with continuous up-and-down strokes, then pull into centre vein and add smaller veins

TRUDY FRIEND

This demonstration shows how colour and monochrome can work together to produce an interesting study. It is not necessary to fill every corner of your picture – untouched white paper can enhance your drawing.

Plants and Flowers

In the themes up to now, I have looked at plants and flowers as part of the landscape, and have treated them more as masses of shape and colour than as individual objects. This theme moves the emphasis from drawing landscapes to still lifes, and enables you to observe flowers in detail and gain the confidence to draw them accurately.

It is always helpful to draw the negative shapes, whatever the subject, when placing objects or parts of objects in relation to each other. I also look for what I call the other 'shapes between' – in some cases, they are shapes between part of an object and a guideline, rather than negative shapes.

You may find it helpful to work from a photograph in order to understand where to place guidelines. With practice, however, you can learn how to hold your pencil in the air in front of a view or objects and imagine where the vertical and horizontal guidelines would be placed.

Typical Problems

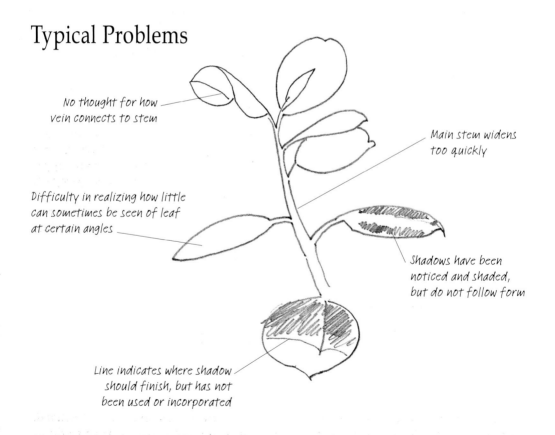

No thought for how vein connects to stem

Main stem widens too quickly

Difficulty in realizing how little can sometimes be seen of leaf at certain angles

Shadows have been noticed and shaded, but do not follow form

Line indicates where shadow should finish, but has not been used or incorporated

Solutions

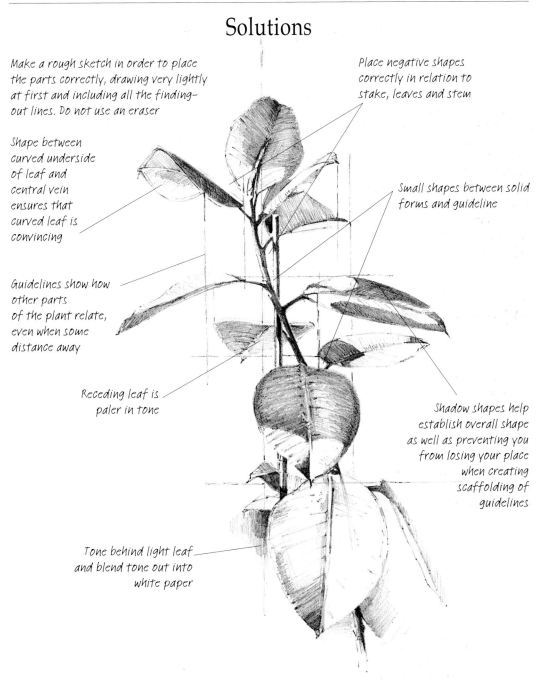

Make a rough sketch in order to place the parts correctly, drawing very lightly at first and including all the finding-out lines. Do not use an eraser

Shape between curved underside of leaf and central vein ensures that curved leaf is convincing

Guidelines show how other parts of the plant relate, even when some distance away

Receding leaf is paler in tone

Tone behind light leaf and blend tone out into white paper

Place negative shapes correctly in relation to stake, leaves and stem

Small shapes between solid forms and guideline

Shadow shapes help establish overall shape as well as preventing you from losing your place when creating scaffolding of guidelines

I do not use angled guidelines, as they may be incorrect – all are vertical or horizontal and can be checked with a set square if necessary.

Practise drawing all guidelines freehand. They may run the length of your study or remain short to compare close relationships.

Typical Problems

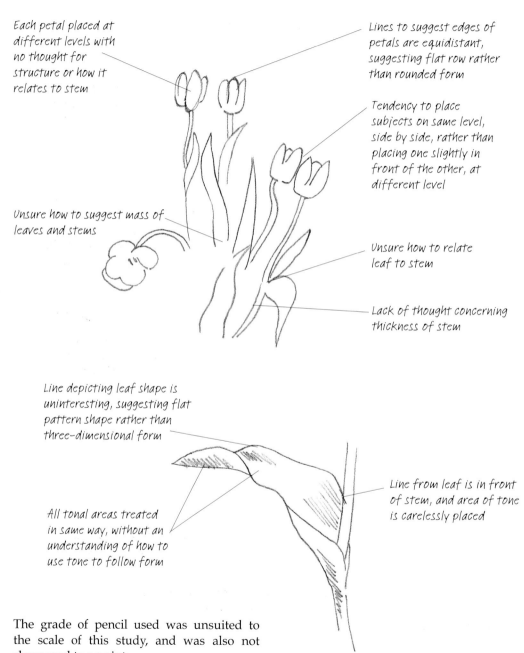

Each petal placed at different levels with no thought for structure or how it relates to stem

Lines to suggest edges of petals are equidistant, suggesting flat row rather than rounded form

Tendency to place subjects on same level, side by side, rather than placing one slightly in front of the other, at different level

Unsure how to suggest mass of leaves and stems

Unsure how to relate leaf to stem

Lack of thought concerning thickness of stem

Line depicting leaf shape is uninteresting, suggesting flat pattern shape rather than three-dimensional form

Line from leaf is in front of stem, and area of tone is carelessly placed

All tonal areas treated in same way, without an understanding of how to use tone to follow form

The grade of pencil used was unsuited to the scale of this study, and was also not sharpened to a point.

Solutions

Tulip

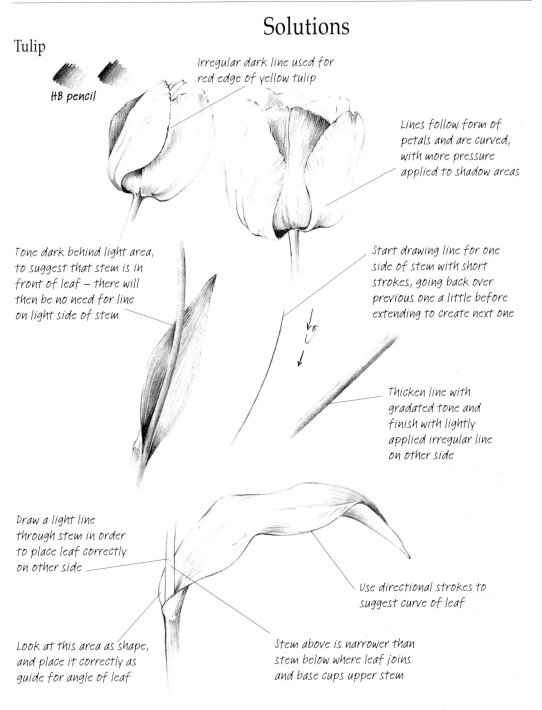

HB pencil

Irregular dark line used for
red edge of yellow tulip

Lines follow form of
petals and are curved,
with more pressure
applied to shadow areas

Tone dark behind light area,
to suggest that stem is in
front of leaf – there will
then be no need for line
on light side of stem

Start drawing line for one
side of stem with short
strokes, going back over
previous one a little before
extending to create next one

Thicken line with
gradated tone and
finish with lightly
applied irregular line
on other side

Draw a light line
through stem in order
to place leaf correctly
on other side

Use directional strokes to
suggest curve of leaf

Look at this area as shape,
and place it correctly as
guide for angle of leaf

Stem above is narrower than
stem below where leaf joins
and base cups upper stem

Typical Problems

Outer casing butts
on to inner form
instead of giving
impression that
one is enclosed
within other

Wire-like lines surround image,
like lead on stained-glass window

Lines of veins drawn with no
consideration for form

Intricacies of uneven edge
have been overlooked

Continuous curve does
not take account of
intricate angles

Line should have started
curving by now to suggest
perspective as it cups
form within

Stem drawn at
wrong angle

Folds drawn with three
very similar lines

Within the form of an Iris you will find many
aspects to learn from. Study small areas,
practising line and tone variations (with on/off
pressure of your pencil) before drawing the
flower in its entirety.

Solutions

Iris

B graphite pencil

Start with a small shape, then another, larger shape. Move on to next shape, relating each one to other and using fine veins as lines to find form

In some places you will be able to see through translucent areas

Practise different line formations within shape of flower

Cut in crisply with tone to make light areas stand forward

Note details, such as succulent bud enclosed within translucent, finely veined cover

Always think of what is enclosed and, with your knowledge of what happens, you will make your drawing convincing

Practise details in order to understand how each part is made up, and work line and tone together

For dense shading, start with very light application (using chisel side of pencil) and gently work over and over same area to build tone up to desired intensity

The pencil should hardly leave the surface of the paper at all when drawing. The tip of the pencil is a fine point that travels over the paper's surface, lightly changing direction as necessary to describe the contours.

Typical Problems

A flower of this nature is delicate so, when making a drawing that is the actual size of the plant, many people resort to outline only.

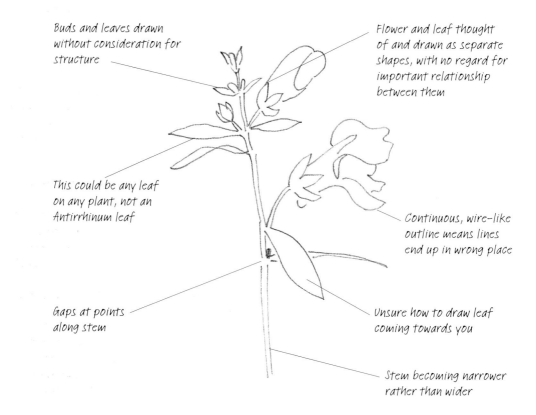

Buds and leaves drawn without consideration for structure

Flower and leaf thought of and drawn as separate shapes, with no regard for important relationship between them

This could be any leaf on any plant, not an Antirrhinum leaf

Continuous, wire-like outline means lines end up in wrong place

Gaps at points along stem

Unsure how to draw leaf coming towards you

Stem becoming narrower rather than wider

While learning to draw plants, it is sometimes helpful if you gently remove some of the flower heads to enable you to see the remaining ones clearly. This also makes it easier to observe the structure of stem and leaf placing. By removing a couple of larger blooms, you may be able to use clear negative spaces to advantage.

Solutions

Antirrhinum

Making tone and line work together:

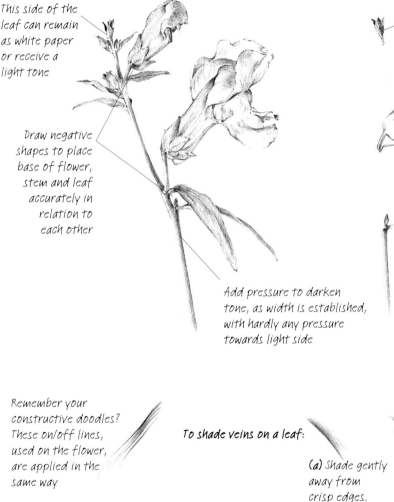

This side of the leaf can remain as white paper or receive a light tone

This side is just a dark shape

Draw negative shapes to place base of flower, stem and leaf accurately in relation to each other

Start here and draw shape with downward curved line on into stem

To draw the stem:

(a) Establish the bud shape in relation to the adjoining leaf.
(b) Draw a downward line firmly. This will be the shadow side of the stem.
(c) Make the line wider (on the left side), gradually reducing pressure to lighten tone.

Add pressure to darken tone, as width is established, with hardly any pressure towards light side

Remember your constructive doodles? These on/off lines, used on the flower, are applied in the same way

To shade veins on a leaf:

(a) Shade gently away from crisp edges.

(b) Place another crisp edge a small distance away from the first, and gently shade out from there.

Choose any flower that you consider complicated to draw. You will need to observe it far more carefully if you are unfamiliar with the shape and form, especially the negative shapes and other shapes between, to enable you to be accurate.

Demonstration

The Iris is one of the most helpful plants to draw when looking for shapes and form. Here is an open bloom, following on from the bud on page 83. This page shows how the first drawing develops and, in this instance, how the first shape drawn is at the top.

1. *Draw the shape, and tone it, with directional strokes (as it appears in shadow).*

2. *Add the larger shape.*

3. *Slowly a relationship develops between the petals and, with the aid of directional strokes to follow the form, work down.*

A wandering line (with on/off pressure) finds the edge of the petal and relates to the undulations within

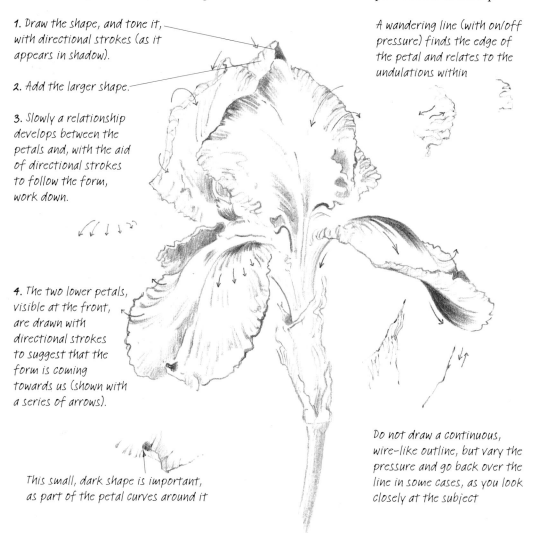

4. *The two lower petals, visible at the front, are drawn with directional strokes to suggest that the form is coming towards us (shown with a series of arrows).*

This small, dark shape is important, as part of the petal curves around it

Do not draw a continuous, wire-like outline, but vary the pressure and go back over the line in some cases, as you look closely at the subject

At all times check and double-check the tiny undulations at the edges of petals, relationships between the petals and directional strokes suggesting form. In this case I held the flower in one hand – alongside the drawing – and continuously looked from one to the other. Always keep checking for accuracy in order to develop drawing and observation skills.

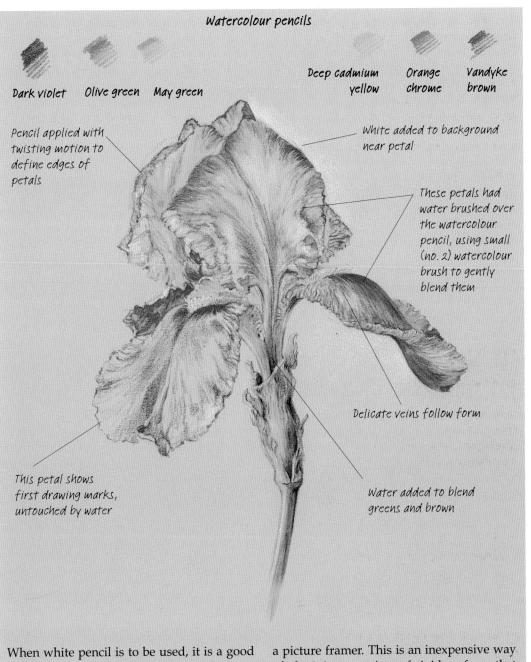

Watercolour pencils

Dark violet Olive green May green

Deep cadmium yellow Orange chrome Vandyke brown

Pencil applied with twisting motion to define edges of petals

White added to background near petal

These petals had water brushed over the watercolour pencil, using small (no. 2) watercolour brush to gently blend them

Delicate veins follow form

This petal shows first drawing marks, untouched by water

Water added to blend greens and brown

When white pencil is to be used, it is a good idea to work on a tinted surface. I used a piece of mounting card purchased as an offcut from a picture framer. This is an inexpensive way of obtaining a variety of rigid surfaces that do not require stretching.

Vegetables

Vegetables and fruit, although they may be still-life subjects that we do not normally think of drawing, provide us with marvellous opportunities to observe structure and form, and the examples in this theme show in particular how reflected light enhances form in drawing.

I never tire of drawing mushrooms, for instance, as they give opportunities for line and tone to work together to describe form and encourage the use of contrasts. Many vegetables and fruits show similarities with other totally different subjects, and allow you to make use of shadow shapes and shadow lines in drawings.

It is important to choose the right materials to work together for certain subjects. The chunky feel of the mushrooms can encourage you to use a soft pencil, and to work on rough-textured (and possibly off-white or tinted) paper in order to achieve more texture. A smooth paper is more suitable for delicate work on subjects such as tomato stalks and peas or beans.

Typical Problems

Viewed out of context, the familiar loses its identity:

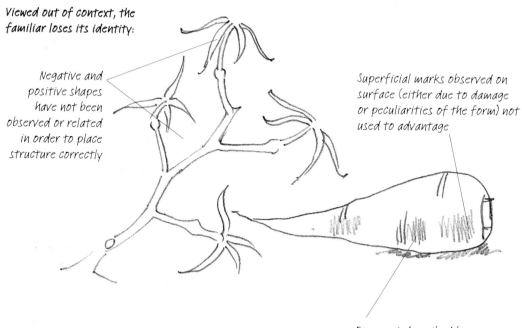

Negative and positive shapes have not been observed or related in order to place structure correctly

Superficial marks observed on surface (either due to damage or peculiarities of the form) not used to advantage

Form not described by directional strokes

88

Solutions

Observing structure and form

I could not resist drawing this tomato stalk as an example of structure:

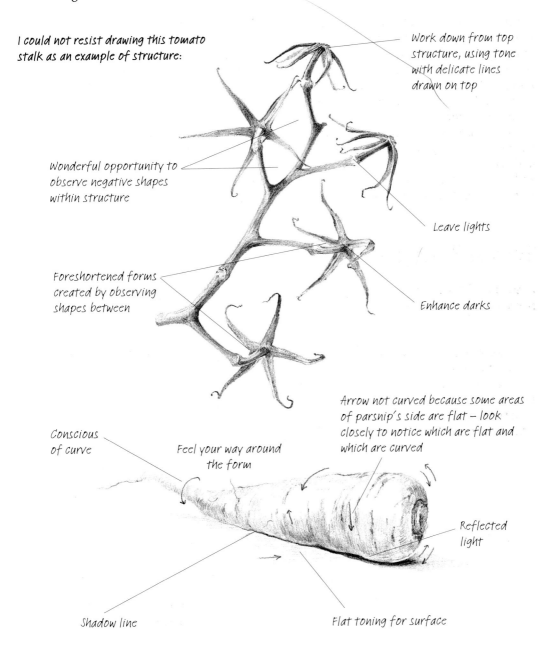

Work down from top structure, using tone with delicate lines drawn on top

Wonderful opportunity to observe negative shapes within structure

Leave lights

Foreshortened forms created by observing shapes between

Enhance darks

Arrow not curved because some areas of parsnip's side are flat – look closely to notice which are flat and which are curved

Conscious of curve

Feel your way around the form

Reflected light

Shadow line

Flat toning for surface

Typical Problems

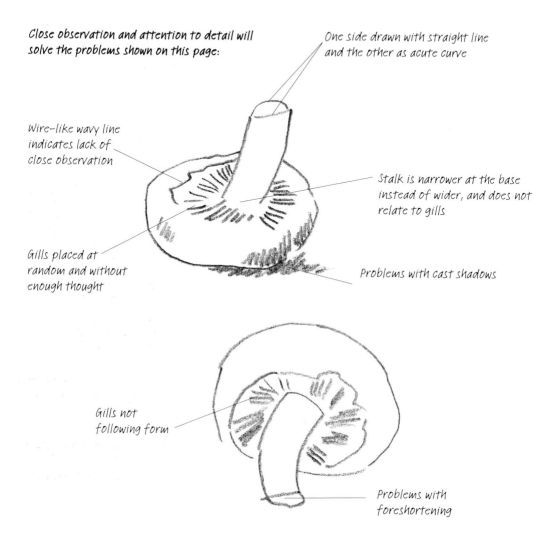

Close observation and attention to detail will solve the problems shown on this page:

One side drawn with straight line and the other as acute curve

Wire–like wavy line indicates lack of close observation

Stalk is narrower at the base instead of wider, and does not relate to gills

Gills placed at random and without enough thought

Problems with cast shadows

Gills not following form

Problems with foreshortening

Many problems may be due to not knowing how to tone around the form. Try to imagine a little spider walking over the surface – it would follow the direction of the arrows shown on page 91. If, as you look at the mushroom in front of you, you can imagine the tiny creature's progress (and let your pencil wander in the same directions), you will find you are beginning to use a wandering line to describe form.

Solutions

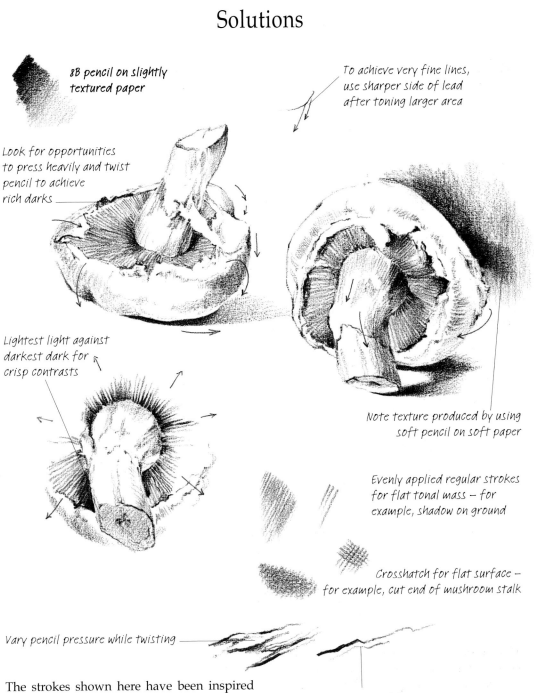

8B pencil on slightly textured paper

To achieve very fine lines, use sharper side of lead after toning larger area

Look for opportunities to press heavily and twist pencil to achieve rich darks

Lightest light against darkest dark for crisp contrasts

Note texture produced by using soft pencil on soft paper

Evenly applied regular strokes for flat tonal mass – for example, shadow on ground

Crosshatch for flat surface – for example, cut end of mushroom stalk

Vary pencil pressure while twisting

The strokes shown here have been inspired by surface textures on a mushroom, but they can also be applied to many other subjects.

Twist as you travel for thick and very thin lines

Typical Problems

Many vegetables, when cut or opened out to reveal seeds within, can be used as subjects worthy of our close observation, allowing us to understand form and texture.

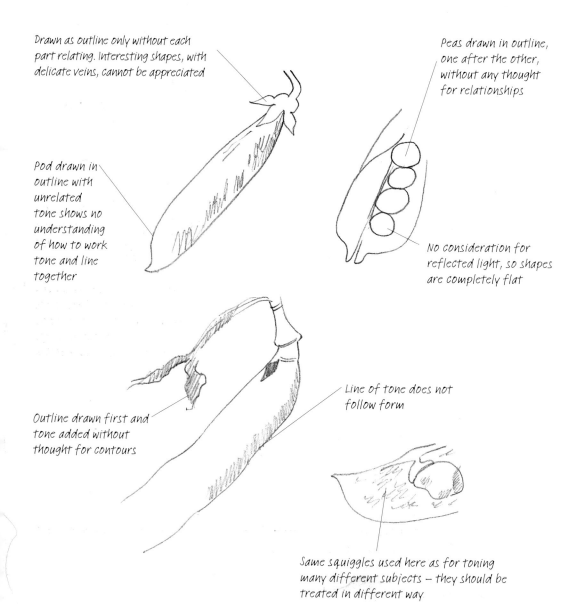

Drawn as outline only without each part relating. Interesting shapes, with delicate veins, cannot be appreciated

Peas drawn in outline, one after the other, without any thought for relationships

Pod drawn in outline with unrelated tone shows no understanding of how to work tone and line together

No consideration for reflected light, so shapes are completely flat

Outline drawn first and tone added without thought for contours

Line of tone does not follow form

Same squiggles used here as for toning many different subjects — they should be treated in different way

Solutions

B graphite pencil

You can learn something
from every subject. I
found one pea pod at the
greengrocer's with a leaf
still attached, and felt
that the delicacy of this in
relation to the heavier
pod was worth
recording:

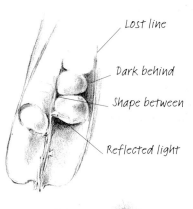

Lost line

Dark behind

Shape between

Reflected light

Reflected light

Draw semicircle
and tone behind

Tone
within,
leave light
area–near
edge

The lines used on parts
of the mushroom
drawing on page 91 are
used to represent a
different form here

This little exercise will help you
understand how light reflects back
from a surface. Achieving this
effect will help give your drawings
a three-dimensional impression

Crisp, dry leaves
in contrast to pod
filled with beans

Make a tonal mass by
gently shading for a few
moments in one area,
then turn the pencil to
use the point that has been
created on the other side and
draw fine lines across the tone

Delicate lines

Soft texture

Reflected light

Demonstration

The wax content of the artists' pencils used here causes them to travel smoothly over the textured paper surface. Few colours are used, and all the initial drawing is done in Chocolate.

Arrange the vegetables to guide the eye into the composition and establish interesting shapes between. The block of wood behind the leek is actually beyond another small block on which the onion and potato rest. It is placed at an angle, and follows the line of the leek.

The positions of the various vegetables are established with the use of guidelines (a couple of which I have emphasized, to show how they were placed in relation to visual contact points)

Most of the guidelines are drawn so lightly that they are not obvious in the finished work, but I did place much darker tones for the tiny shapes between, which I felt to be so vital within this composition

Sunset gold

Terracotta

Chocolate

May green

Moss green

The group, placed on a slate floor tile, has a piece of wood at the back with a noticeable grain. This dictated the up-and-down strokes used on that surface. All pencil strokes on the toned areas are directional to follow the form

Place the warm colours first and then introduce the greens of the leek. White is used gently for the highlights

Demonstration

For this group, I chose a slightly textured, tinted paper, intending to use its colour and allowing it to be part of the overall effect and to influence the way light areas were treated.

Mushroom
To attain the correct angle of stalk, a guideline is drawn in order to use the shape between

Freely drawn little roots

Onion
The dead skin twists and turns and is drawn in one colour only at first

Up-and-down strokes indicate grain of wood in background

Potato
Crosshatching is used to build the contours

Note light in front of dark and dark in front of light

Similar movement to ripples upon water surface and wood-grain effect

Curved lines follow form

Veins on onion and leek help you achieve direction

Slate floor tile

Carrot

Leek

Textures

Whatever your chosen subject, if you wish to make intricate, detailed drawings, one of the best ways to learn is to look closely at, and practise drawing, textured surfaces.

Try to observe and produce a variety of effects. Even sitting at a table made of pine or another wood with an interesting grain, or studying a piece of wood offcut, will provide interesting textures. By attempting to draw a small section, looking closely at the grain, you can produce a series of studies from which you can learn many techniques.

The same applies to pieces of stone of all sizes. In the following pages I suggest a few warm-up exercises to try with the pencil before you start work in earnest.

Items of clothing, either worn by a person, placed on a surface or hanging from a hook, provide interesting subjects for learning studies, and still-life studies often have cloth within them or as a background. You can set up endless still-life arrangements using everyday objects, all of which will have a slightly different surface texture.

Typical Problems

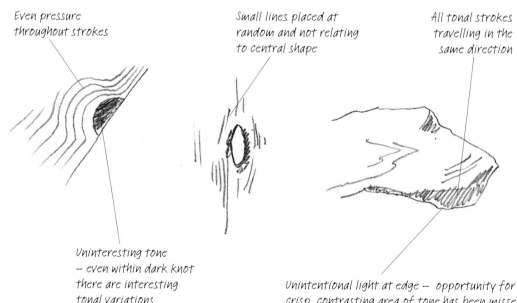

Even pressure throughout strokes

Small lines placed at random and not relating to central shape

All tonal strokes travelling in the same direction

Uninteresting tone – even within dark knot there are interesting tonal variations

Unintentional light at edge – opportunity for crisp, contrasting area of tone has been missed

Solutions

Wood

2B pencil

`Furry´ texture caused by being roughly sawn

On/off pressure line, drawn using very sharp point, follows curve of knot in wood's surface

Crisp edge of sawn timber

Observing the end of a block, you can see a series of tiny dots creating the texture

Wood and stone may receive the same treatment, but note the subtle nuances and try to suggest the softer feel of wood in contrast to the hard, brittle, sharp-edged surface of stone

Not all wood knots are flush with the surface. This study is taken from part of a round fence post, and the centre area, being raised, catches the light, so remains as white paper. This is an opportunity to use a rich, dark contrasting tone along the edges

Stone

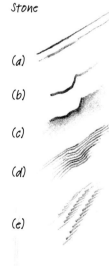

(a)

(b)

(c)

(d)

(e)

Try these exercises as a warm-up:
(a) On/off line.
(b) Uneven curve.
(c) Tone one side of curve.
(d) Series of very fine contoured lines.
(e) Contoured lines achieved by a series of individual short lines.

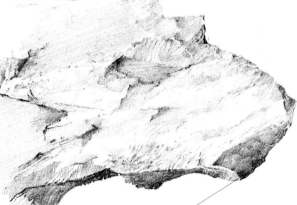

Go for rich darks when you have the opportunity

Make up your own exercises of constructive doodles, suggested by close observation of textured surfaces.

Typical Problems

The chance to observe a number of textures within one study has been missed. Look at the smooth, hard, shiny surface of the hook, in contrast to the smooth fabric used as tape, against the rough texture of the pile of the dressing gown. The fabric-covered button (where tightly stretched cloth offers an opportunity to crosshatch) contrasts with the small area of decorated braid that follows the form.

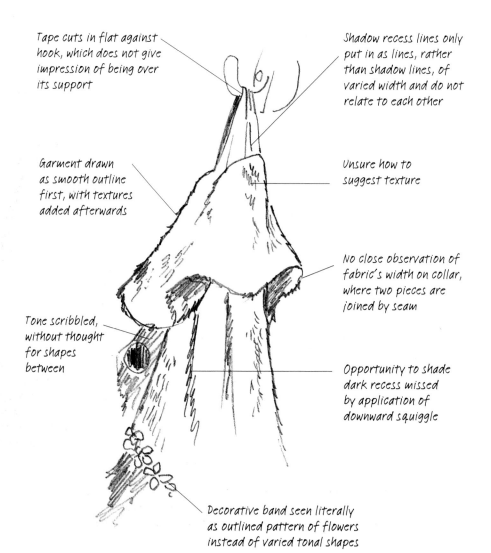

Tape cuts in flat against hook, which does not give impression of being over its support

Shadow recess lines only put in as lines, rather than shadow lines, of varied width and do not relate to each other

Garment drawn as smooth outline first, with textures added afterwards

Unsure how to suggest texture

No close observation of fabric's width on collar, where two pieces are joined by seam

Tone scribbled, without thought for shapes between

Opportunity to shade dark recess missed by application of downward squiggle

Decorative band seen literally as outlined pattern of flowers instead of varied tonal shapes

Solutions

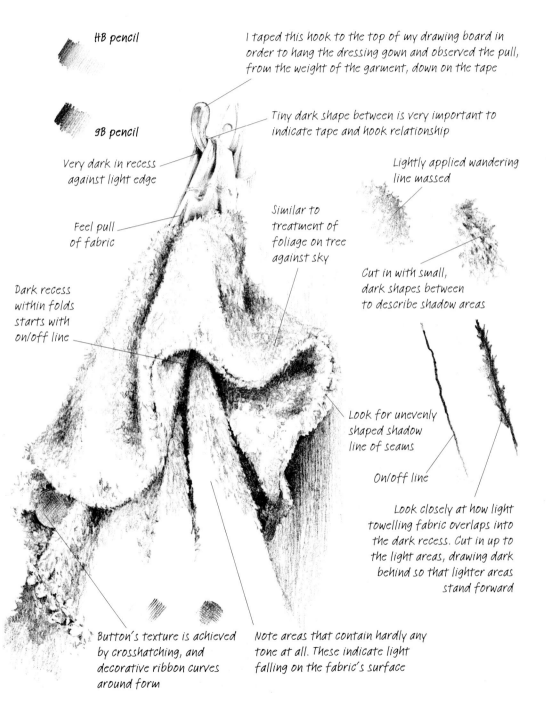

HB pencil

I taped this hook to the top of my drawing board in order to hang the dressing gown and observed the pull, from the weight of the garment, down on the tape

9B pencil

Tiny dark shape between is very important to indicate tape and hook relationship

Very dark in recess against light edge

Lightly applied wandering line massed

Feel pull of fabric

Similar to treatment of foliage on tree against sky

Cut in with small, dark shapes between to describe shadow areas

Dark recess within folds starts with on/off line

Look for unevenly shaped shadow line of seams

On/off line

Look closely at how light towelling fabric overlaps into the dark recess. Cut in up to the light areas, drawing dark behind so that lighter areas stand forward

Button's texture is achieved by crosshatching, and decorative ribbon curves around form

Note areas that contain hardly any tone at all. These indicate light falling on the fabric's surface

Typical Problems

Many beginners experience problems with fabric when trying to give the impression of folds. They draw lines and add areas of tone, only to find that they do not work together, producing a series of marks rather than the feel of folded cloth.

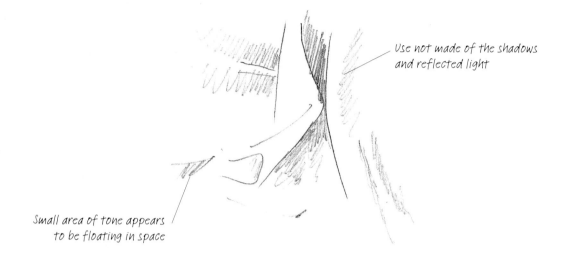

Use not made of the shadows and reflected light

Small area of tone appears to be floating in space

Problems with creating recess

Tone is a very important part of this type of drawing. I always work my line and tone together in order to create crisp contrasts at the edges and gentle blending on the contoured and curved surfaces

There is no need to practise larger areas than those on page 101 when you are at first learning to look. If one study goes wrong, just leave it and start another. Try not to be tempted to erase and correct the study – it is better to leave your mistakes in order to learn from them. Compare the two and observe your progress.

Solutions

Folds

9B pencil

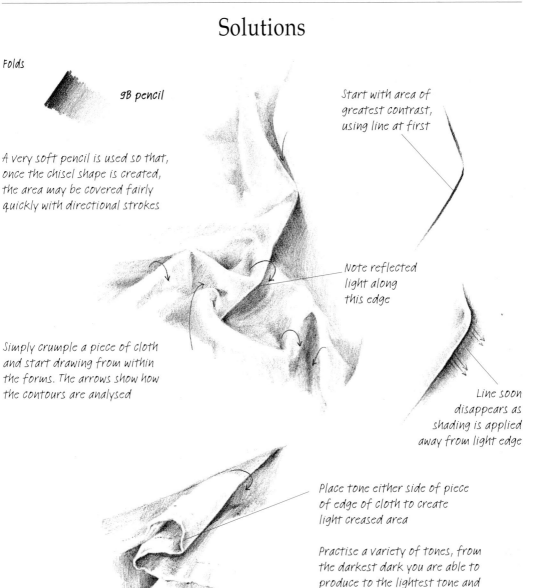

A very soft pencil is used so that, once the chisel shape is created, the area may be covered fairly quickly with directional strokes

Start with area of greatest contrast, using line at first

Note reflected light along this edge

Simply crumple a piece of cloth and start drawing from within the forms. The arrows show how the contours are analysed

Line soon disappears as shading is applied away from light edge

Place tone either side of piece of edge of cloth to create light creased area

Practise a variety of tones, from the darkest dark you are able to produce to the lightest tone and blending into white paper

Looking at pieces of cloth and the way the folds cause shadows is a good way to practise toning. Remember to follow the form.

Demonstration

I chose a simple coffee cup and saucer for this demonstration, but added other items to cut across forms in order to help explain shadow shapes, the effective use of grid and guidelines, relationships, contrasts and darks behind.

I started by placing the spoon in relationship to the ellipse of the cup, paying particular attention to the shape between and the shadow shape reflected on the inner surface. I then worked down the right side to place the handle in relationship to any background seen behind or through the form. Starting to work across, on the curve of the dark band, I was intrigued by the shapes between the base of the cup and the saucer upon which it rests. Horizontal and vertical guidelines assisted with accurate placing of overlapping forms.

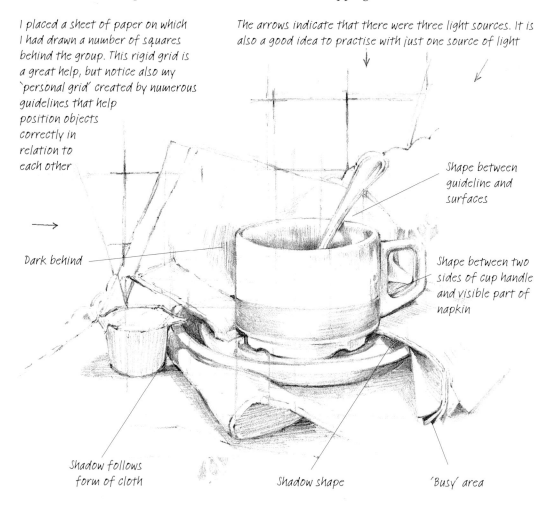

I placed a sheet of paper on which I had drawn a number of squares behind the group. This rigid grid is a great help, but notice also my 'personal grid' created by numerous guidelines that help position objects correctly in relation to each other

The arrows indicate that there were three light sources. It is also a good idea to practise with just one source of light

Shape between guideline and surfaces

Dark behind

Shape between two sides of cup handle and visible part of napkin

Shadow follows form of cloth

Shadow shape

'Busy' area

Demonstration

There were two stages to this study. In my initial rough drawing I drew as many guidelines as were needed in order to place objects correctly. Then I attached the rough to a window pane, using masking tape, and placed a separate sheet of paper over it. The main lines were clear to see and I traced the basic outlines, not as continuous, diagrammatic lines, but in a gentle way, as if drawing them for the first time. Sitting again in front of the still-life group, I then added colour and tone. I kept the rough drawing to hand and referred to it from time to time.

Mixed textures

A limited coloured range was chosen, using Derwent Studio coloured pencils, which are ideal for blending and mixing for overworking shadows and highlights

Gunmetal used for spoon, cup, doily and cloth

Red napkin is reflected in surface of cup

Gentle toning of darker area behind cup brings form forward

Gentle blending builds up layers of tone and colour

Effect is very similar to that achieved when toning dark on either side of light veins in leaf

Variety of shadow shapes as well as coloured shapes add interest to this area

Areas of white paper can be effective within areas of colour and tone

Crisp contrasts

Pets

Whether making quick sketches of pets from life, or more detailed drawings with the aid of photographs, your primary considerations should be close observation and a feeling for the subject. On location, I spent much more time observing the dogs on the opposite page than I did drawing them – and these are only a few of the studies that I made that day!

It is also my previous knowledge and understanding of the subject, achieved by a lifelong interest in animals, that influences the way I interpret them in their various stances. If your interest lies with animal drawing, it could well be because the animals themselves mean so much to you. This feeling will help you enormously.

If you apply the methods of drawing and observation covered in this book (especially the three important 'P's – Practice, Patience and Perseverance) and combine them with an instinctive knowledge of animals, you will discover your talents emerging.

As with most subjects, particularly ones that are everyday or familiar to you, try not to judge yourself too harshly or to look for rapid progress. Take your time and notice your improvements (however small) – and be encouraged by them.

Typical Problems

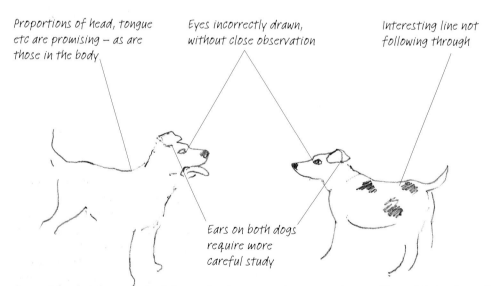

Proportions of head, tongue etc are promising – as are those in the body

Eyes incorrectly drawn, without close observation

Interesting line not following through

Ears on both dogs require more careful study

As quick sketches worked by a beginner, these make a good start, and the problem areas can be addressed by developing a deeper understanding of the subject (looking at and thinking about it for some time) before starting to draw.

Solutions

For the top left-hand drawings I started with the dog's eye. On the middle one, it was the relationship of the ears – toned as solid shapes – before using a wandering line to find form around the neck and on into the shoulders and body.

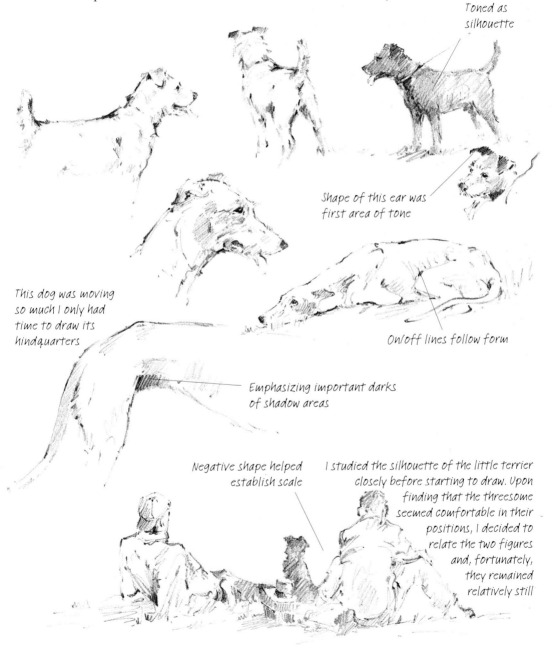

Toned as silhouette

Shape of this ear was first area of tone

This dog was moving so much I only had time to draw its hindquarters

On/off lines follow form

Emphasizing important darks of shadow areas

Negative shape helped establish scale

I studied the silhouette of the little terrier closely before starting to draw. Upon finding that the threesome seemed comfortable in their positions, I decided to relate the two figures and, fortunately, they remained relatively still

Typical Problems

As with the dog drawn by a beginner on page 28, there is a lack of understanding of how to depict the dog's eyes from an unfamiliar angle.

A useful tip is to try not to draw around the eye in one or two strokes. Instead, look for angles and draw bit by bit, observing relationships of one side to the other at every stage. See also the solutions to drawing a pony's eye on page 117.

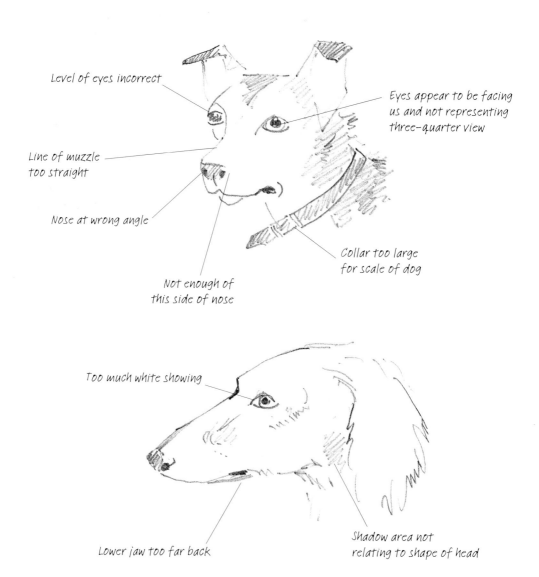

Level of eyes incorrect

Eyes appear to be facing us and not representing three-quarter view

Line of muzzle too straight

Nose at wrong angle

Not enough of this side of nose

Collar too large for scale of dog

Too much white showing

Lower jaw too far back

Shadow area not relating to shape of head

Solutions

HB graphite pencil

This side of head shows
first stage of drawing,
where small shapes
between are considered
carefully

Kipper – a mixed breed.
A photograph depicting a
three-quarter view provided
ideal reference for me to
cover this angle

Firm directional strokes on
collar indicate the way it curves

I have not drawn
arrows to indicate
directional strokes.
Instead, the actual strokes
are heavier in the lower part of
the portrait for you to see how I
decide in which direction to tone
the hair

Angus – a standard long-haired Dachshund

Contact point – a good place
from which to drop guideline

This aristocratic profile shows how I started my first rough.
Using guidelines to help place indentations and changes of
hair growth direction, I looked closely for any small nuances
to help place these correctly

Typical Problems

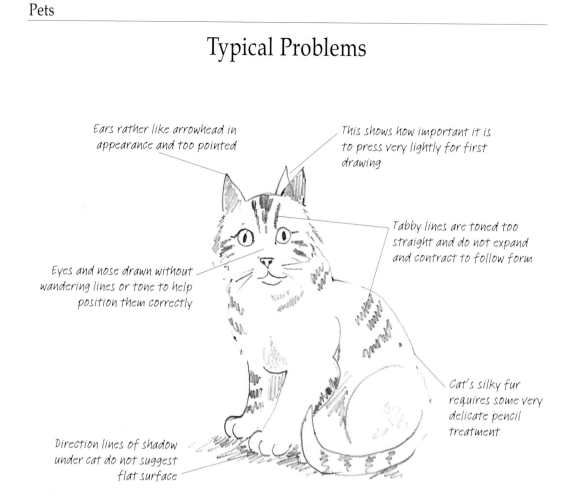

Ears rather like arrowhead in appearance and too pointed

This shows how important it is to press very lightly for first drawing

Tabby lines are toned too straight and do not expand and contract to follow form

Eyes and nose drawn without wandering lines or tone to help position them correctly

Cat's silky fur requires some very delicate pencil treatment

Direction lines of shadow under cat do not suggest flat surface

This is the way some beginners depict cat paws. I hope the drawing on page 109 shows how little outline is actually necessary

Solutions

I chose to draw a tabby cat. The markings are achieved by a similar method as that used for grass – that is, cutting in with a dark behind.

HB graphite pencil

(a)

(b)

Try this exercise:
(a) Make an uneven tonal mass in the form of a stripe.
(b) Extend certain areas with a very sharp point and gentle strokes away from the dark mass.

Take your time and first create a detailed rough with guidelines to help you achieve the correct proportions. Then gently trace the main outline and tone in lightly

Gentle strokes away from form for furry edge, which is why the initial outline needs to be drawn very lightly

The arrows show how I think about the shapes. The tail is thought of in a similar way to the branch of a tree, with lines that follow the form

Side-to-side strokes for flat ground

Rich darks behind the light forms make them stand forward

Demonstration

This portait is of a Jack Russell terrier. When portraying a particular dog, it is a good idea to draw a few details at the side of your first rough drawing. If the dog has passed away and you have to rely solely upon your memories and photographic reference, it is important to get the character details correct.

Very distinctive eye shape, giving particular character of dog

She often had a wisp of hair passing in front of her eye

Mouth has little black mark and distinguishable shape, surrounded by longer hair

Guidelines are invaluable when working from a photograph. Line up parts of the body and notice the shapes between

The arrows show how I think of the dog's form, imagining I am curving my hand around that form. This tells you in which direction to use tone

Work out angles of legs and relationships of paws to ground

For a small drawing, about 7.5 x 7.5 cm (3 x 3 in), use a hard pencil (HB), sharpened to a fine point

Beginners will find it beneficial to practise working on small studies in addition to the larger work they produce. It is a discipline that encourages concentration, close observation and exacting skills.

Meldreth

HB graphic pencil on
smooth cartridge paper

Achieving the darks for the ear:

(a) (b) (c)

(a) Draw the curved shadow shape where
the ear rests against the head.
(b) Pull down your pencil strokes,
allowing some light areas to remain.
(c) Finish with other tones.

Longer hair on the muzzle:

First strokes

Cut in with darks
behind to bring
out light hair

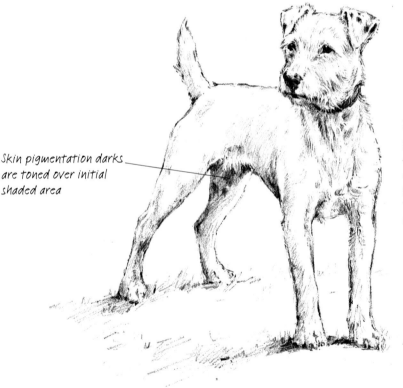

Skin pigmentation darks
are toned over initial
shaded area

The tick and flick
pencil exercises
shown for giving the
impression of grass on
page 61 are very similar
to those used when
representing hair

Always be conscious of the form and direction of hair growth.
Avoid a hard outline. When a white dog is depicted against a
white background, you need edges, but make them interesting
with on/off pressure and the use of toned areas where possible.

Horses and Ponies

The importance of detailed studies as part of a learning process continues with this theme, which considers the specific problems encountered in drawing horses and ponies. Even the largest breeds of dogs are small in relation to a standard pony – let alone a fully grown horse – and this can lead beginners to assume that the extra surface area can be depicted as flat or blank. To avoid this it is helpful to work from within the form, noticing the undulations and curving your pencil strokes to follow the contours.

When drawing animals and human beings it is vital to bear in mind the correct anatomy. The exercises here show how to depict the raised surface of veins, the strength of the muscles and bone structure under the surface of skin, and the relationship of hair to hoof.

Making a detailed rough helps if you prefer a loose approach to your final artwork. This choice tends to be a personal preference but try not to allow a loose style to become careless in application as this will inhibit your progress and improvement.

Typical Problems

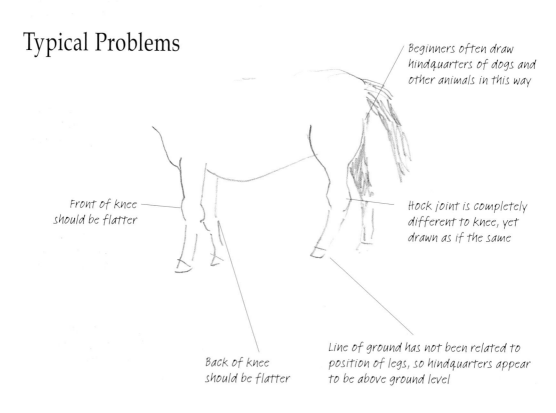

Beginners often draw hindquarters of dogs and other animals in this way

Front of knee should be flatter

Hock joint is completely different to knee, yet drawn as if the same

Back of knee should be flatter

Line of ground has not been related to position of legs, so hindquarters appear to be above ground level

Solutions

Legs

5B graphite pencil
on copier paper

Using a clear black-and-white photograph and producing a photographic representation is a good way to gain an understanding of form and to learn how to tone up to, and around, light areas.

Exercises:

(a) Areas of smooth tone either side of a white strip.

(a)

(b) Tone with flat, then curved strokes.

(b)

(c)

(c) Combine the two smoothly.

(d) For the shadow side of leg, define the shape, then gently shade away.

(d)

(e) An exercise to help understand hoof structure.

(e)

Guidelines dropped from contact points ensure that lower parts of legs are placed correctly

The small arrows indicate the consideration given to the direction of form

Negative shapes are as important as legs themselves

Drawing shows how first rough sketch is laid out

Dark grass behind encourages light forms to stand forward

Think your way through the hoof/hair structure of the foal's foot in a similar way to that used for the mushroom cap/stalk on page 17.

Typical Problems

Drawing details gives an opportunity to look into the subject more deeply and to work out how line and tone may be developed together. Look closely and try to give an impression of all the 'ins and outs'. Your first attempts may not appear accurate, but, with practice, patience and perseverance – and determination – they will improve.

The nostril has been reduced to a simple oval – since this area is so complex it is a good idea to practise drawing it alone, noting all the intricacies

Lines do not relate to shape of nostril – and are usually lower

An attempt has been made to correct first shape, but both have been drawn heavily – if first attempt had been drawn very lightly, alterations could have been made over top with more pressure

Noseband drawn as if it cuts in to bone, not resting on it

Bit does not appear to be in horse's mouth

Solutions

Noses

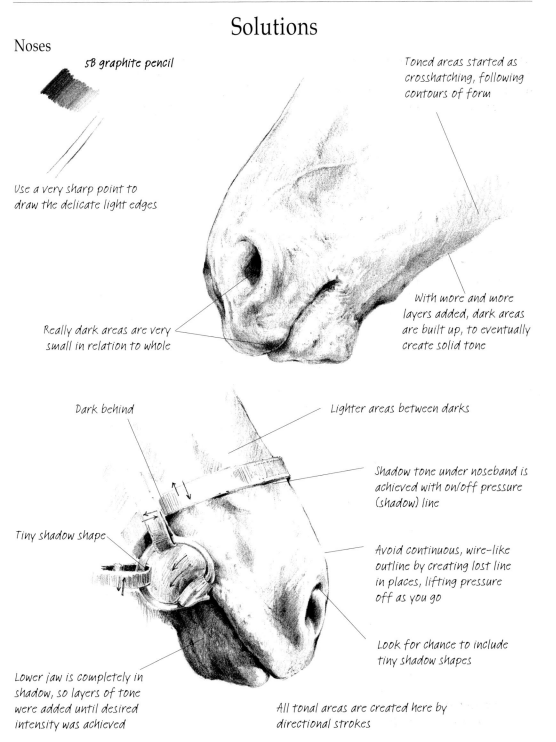

5B graphite pencil

Toned areas started as crosshatching, following contours of form

Use a very sharp point to draw the delicate light edges

With more and more layers added, dark areas are built up, to eventually create solid tone

Really dark areas are very small in relation to whole

Dark behind

Lighter areas between darks

Shadow tone under noseband is achieved with on/off pressure (shadow) line

Tiny shadow shape

Avoid continuous, wire-like outline by creating lost line in places, lifting pressure off as you go

Look for chance to include tiny shadow shapes

Lower jaw is completely in shadow, so layers of tone were added until desired intensity was achieved

All tonal areas are created here by directional strokes

Typical Problems

Some attempt at directional toning, but pencil pressure is too even

Delicate tip of ear, which faces the direction of sound, has been lost

Ear shape too even, and no thought given to hairs within

Many angles that form shape of eye not noticed or drawn

Foal's head drawn as outline, with tone filled in within ears and no sense of foreshortening

Hair direction has been noted, but, when treated in this way, does not describe form

On page 117, I have drawn the foreshortened ear as a rough, with guidelines and other lines that indicate what I *feel* about what I see. My roughs tend to be a mass of thought lines as well as the lines and tonal shapes that build form. Try *thinking* your way into your drawings, rather than just copying an image.

Solutions

Heads

Horses' ears are very flexible, turning towards the source of sound as well as responding to mood and temperament

When you draw ears it is important to relate one to the other, even if they are facing in different directions

Working from a photograph, I show below how we still use the guidelines and shapes between – in this instance to help indicate a foreshortened ear

Look for angles

These lines on a rough indicate flat surface

Always look closely at the eye and look for angles, rather than just drawing around the entire shape with a line

Look at an eye in a photograph and see how many angles you can find, then you will know where to place them in your drawing. The arrows here show the angles I have noticed

Guidelines help correct position

Draw directional lines to suggest form by imagining what it would feel like to pat this foal on the forehead

Demonstration

Pages of my sketchbooks have drawings of horses and ponies taken from life. Some are details of heads, legs and so on – whatever part I could put on paper before the animal moved.

For this study, however, I used photographic reference alongside my sketches. It is gratifying when the animal looks up at the camera when the rest of its body is in a pleasing stance.

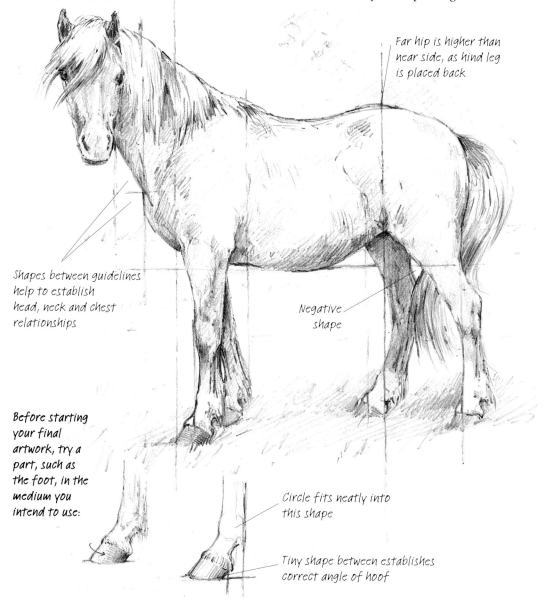

Far hip is higher than near side, as hind leg is placed back

Shapes between guidelines help to establish head, neck and chest relationships

Negative shape

Before starting your final artwork, try a part, such as the foot, in the medium you intend to use:

Circle fits neatly into this shape

Tiny shape between establishes correct angle of hoof

Chestnut mare

Copper beech watercolour pencil

Exercises for hair of mane:

(a) Strokes applied with dry pencil on dry surface.

(b) Water added to dilute pigment (when thoroughly dry, other strokes may be added on top).

Stages of development:

1. Make as many rough sketches as you need to get the drawing right.
2. Transfer basic lines to quality paper and, with light pressure, start building your drawing.
3. Using a good-quality watercolour brush that gives a fine point, gently blend the drawing, allowing your brushstrokes to follow form.
4. When the image is dry, darks may be enhanced by the addition of more pencil strokes.

After producing the rough drawing on page 118, I traced the basic lines gently on to tinted Bockingford watercolour paper using a coloured watersoluble pencil. Then, using the rough as a guide (as well as a photograph), the drawing was developed with very light pressure. If you need to erase any areas, this will be possible if you press lightly at first

Portraits

For nearly all of us, the human face is one of the things we see most in our daily life, and is certainly what we use – from a very early age – to identify individuals and recognize them subsequently. Despite this, many beginners (and even some quite experienced artists) find drawing faces difficult and prone to causing problems. This is frequently because they try to bring out the character in a face without first observing it, both as a whole and in detail, and regarding it in the same way as a landscape or a still life, as a selection of lines, shapes and forms. Once again, practice, perseverance and patience are the guides.

In this theme I have chosen to cover angles, guidelines and the relationships with shapes between forms, rather than concentrating on individual features. The former has been the main consideration of my methods throughout this book, and it is important to understand how they may also be applied to the subject of the human face.

Depicting human features is best approached in the same way as drawing the features of animals – both involve close observation, thought and consideration of how to achieve an understanding of the form before you start to draw. Using angles and guidelines, you can position the features accurately in relation to each other, in the same way as other relationships. It is this aspect of placing the features correctly that is concentrated on, encouraging the observation of shapes between guidelines as well as negative shapes.

Typical Problems

The following are some of the problems that may present themselves to a beginner when attempting to draw from models (whether from life or using photographic reference) in poses similar to those on page 121:

1. Level of eyes. The cross superimposed on each study shows how you can overcome the problem of positioning eyes.

2. This also applies to the ears. Pay close attention to the angle at which the ears relate to the head of your particular model, as this is part of the person's character.

3. Use the vertical guidelines to position shadow lines between the teeth in relation to other features above – for example, nostril, part of eye, and so on.

4. Background. You will need to decide whether to use plain white paper or to tone behind. The latter may be done quite freely in order to allow the lighter form to stand forward.

5. It is probably better to understate eyebrows rather than make them too heavy – observe how they follow form and relate to the position of the eyes.

Solutions

 B graphite pencil

These two sketches show slightly different angles and allow us to analyse the differences:

Less hair, more forehead, visible

Note direction and position of nose in relation to lips

Looking directly at mouth, note curve of top lip

Less forehead, more hair, visible

Note direction and position of nose in relation to lips

Looking down at mouth, note curve of top lip

On my first rough sketches I look closely at all the relationships and will use many more guidelines than you see here in order to find shapes between that will help achieve the correct angles.

Typical Problems

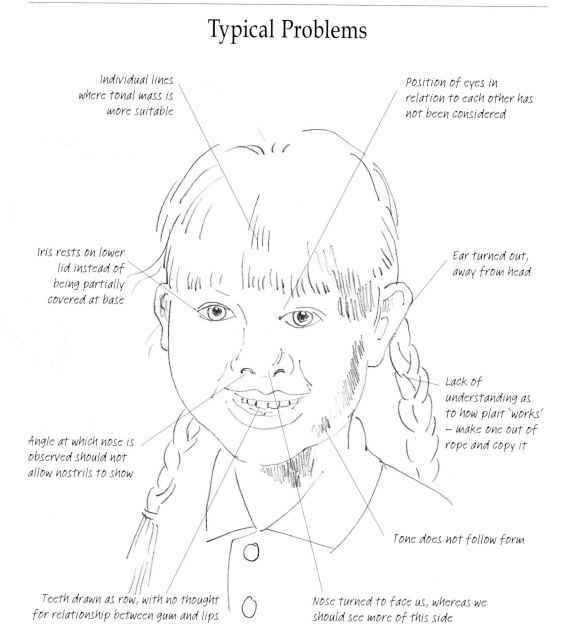

Individual lines where tonal mass is more suitable

Position of eyes in relation to each other has not been considered

Iris rests on lower lid instead of being partially covered at base

Ear turned out, away from head

Lack of understanding as to how plait 'works' – make one out of rope and copy it

Angle at which nose is observed should not allow nostrils to show

Tone does not follow form

Teeth drawn as row, with no thought for relationship between gum and lips

Nose turned to face us, whereas we should see more of this side

The positive shapes have been drawn rather than the negatives and other shapes between, which would have been far more helpful towards accurate placing – for example, between the side of the head/neck and the plait.

Solutions

 HB graphite pencil

Leave some areas of untouched white paper to indicate the lightest highlights

Areas of rich dark tone suggest recesses

I started this portrait with the left (model's right) eye. To achieve the correct angle I drew horizontal and vertical lines:

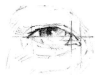

I noticed the white shape above my line and how the iris touched the horizontal line on the other side. That allowed me to lower the white area visible on the right and this established the correct angle. I placed the other eye, then related the nose to the eyes and the mouth to the nose and eyes, then worked outwards

 Zigzag centre line

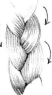 Directional strokes

If you can place one of the smaller (yet most important) areas correctly you can then use guidelines from that area outwards into the rest of the portrait. Notice all the tiny (yet vital) shapes between – including them in your drawing will help you place areas correctly.

Typical Problems

Both studies are of the same person, but not enough care has been taken over certain characteristics, so they look like different people. With just a few guidelines (horizontal and vertical) to help, greater accuracy could have been achieved with the main features.

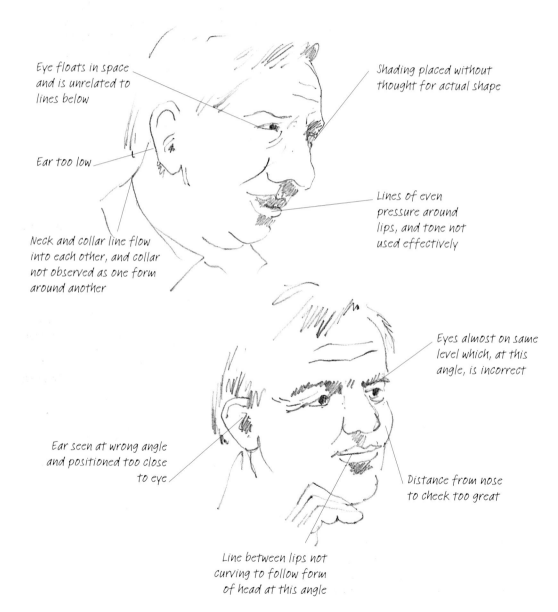

Eye floats in space and is unrelated to lines below

Shading placed without thought for actual shape

Ear too low

Lines of even pressure around lips, and tone not used effectively

Neck and collar line flow into each other, and collar not observed as one form around another

Eyes almost on same level which, at this angle, is incorrect

Ear seen at wrong angle and positioned too close to eye

Distance from nose to cheek too great

Line between lips not curving to follow form of head at this angle

Solutions

9B graphite pencil

Expressions are as a result of reactions.
The expression on this face is a reaction
to strong sunlight while deep in thought,
whereas below it is more that of interest
in a subject being observed:

Note dark shadow shapes

Shadow line

Lost line

Dark
behind

Shape
between

This is in a more free style than
the studies on pages 121 and 123,
for which I chose a much softer
pencil, as I wanted to accentuate
the darks

A slightly three-quarter view is more
interesting than a profile and offers a
chance to use shapes more effectively
when placing angle of nose, eyes and so on

Demonstration

I usually draw the guidelines and other areas emphasized here very lightly on my paper, as I feel my way into the portrait. I have made them dark on this page in order that you can see my thoughts on paper.

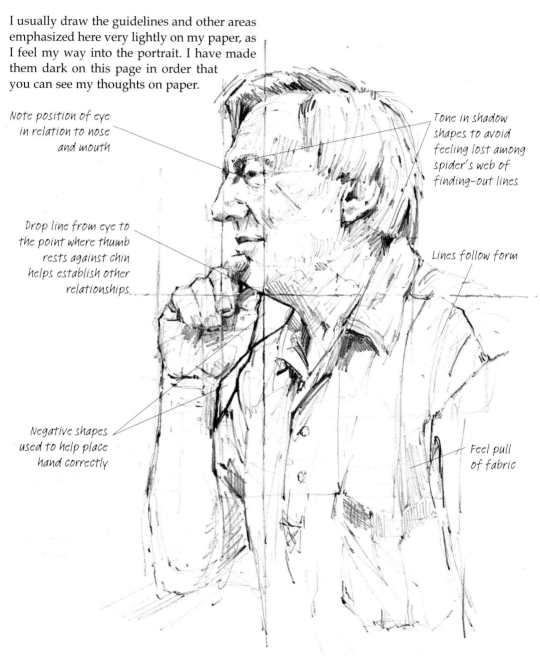

Note position of eye in relation to nose and mouth

Tone in shadow shapes to avoid feeling lost among spider's web of finding-out lines

Drop line from eye to the point where thumb rests against chin helps establish other relationships

Lines follow form

Negative shapes used to help place hand correctly

Feel pull of fabric

This demonstration contains wandering lines that follow form, darks behind, shapes between, negative shapes, lines of varied pressure, and the alternate use of chisel and pointed side of pencil.

Michael Pibworth

There is more chance of you achieving a likeness in your first portraits if you draw someone who is familiar to you. I asked my husband to pose for this study.

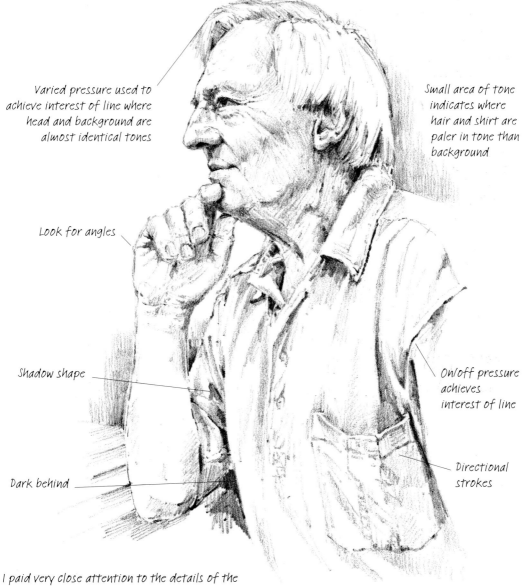

Varied pressure used to achieve interest of line where head and background are almost identical tones

Small area of tone indicates where hair and shirt are paler in tone than background

Look for angles

Shadow shape

On/off pressure achieves interest of line

Dark behind

Directional strokes

I paid very close attention to the details of the features and the folds of the collar, pocket and so on, allowing the pencil to travel more freely over other areas

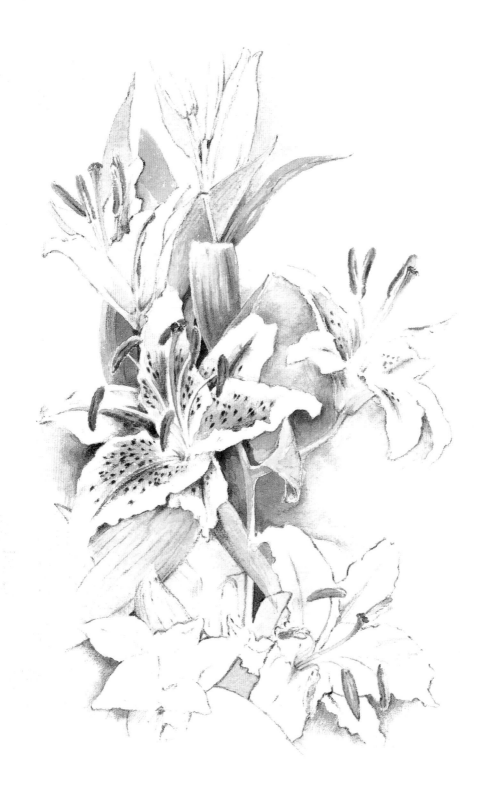

Watercolour

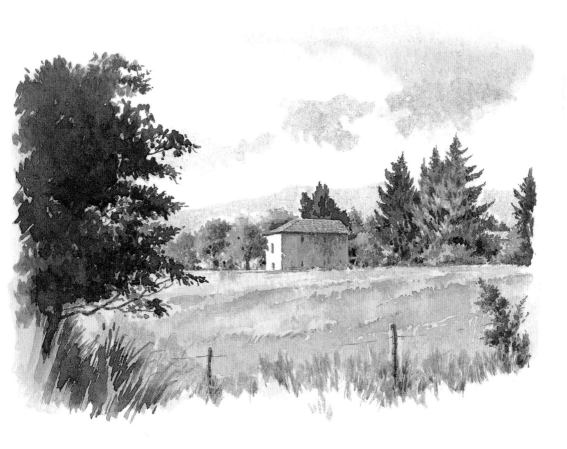

Introduction

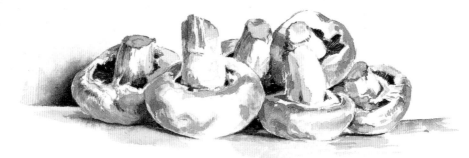

The aim of this section is to provide a learning experience that will help to guide you along an exciting path of self-discovery. If you have already embarked upon your own artistic journey, you may discover within these pages new ideas or variations to add to those you already use – enhancing and enriching your own ideas and methods. If you are a beginner or 'improver' in watercolour, this section is designed to show you the importance of understanding the basics and knowing how to use them as a firm foundation upon which to build both your drawings and paintings.

Sketching and drawing

In addition to being valuable in its own right, drawing is the most important basis for good paintings, and for this reason, each painting demonstration throughout the themed sections of this book is accompanied by a detailed drawing. Preliminary sketches enable you to look closely into your subject matter and familiarize yourself with all the intricate components before you embark upon any brushwork.

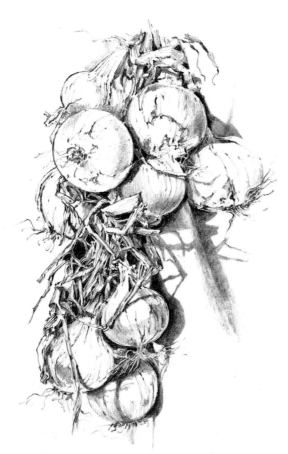

Try to think your way into all of your drawings and paintings – I call this 'putting your thoughts on paper'. As we have seen, the 'wandering line' is an approach to drawing where the pencil is allowed to wander lightly over the paper surface, following the form of objects freely as you observe and

depict the contours. Onions, with their many surface veins, are ideal subjects for observing contour lines, as shown on pages 202–203.

There is also a diagrammatic approach, where you can put your thoughts on paper

by using pencil guidelines and observing the 'shapes between' in your preliminary drawings, as demonstrated on pages 138 and 190. By drawing in a linear way and accentuating the parts where you want to reinforce your knowledge prior to painting, you can develop a deeper understanding of the subject and produce a convincing interpretation.

You can draw in a 'painterly' way; this is illustrated on page 196, where simple marks with a pencil, similar to brushmarks, are used to represent the background areas. And yet another way to put your thoughts on paper is to actually draw directional arrows on your sketches. In this way you are stating what you feel about what you see, and the arrows act as a reminder for brushstroke directions when you paint.

Brushstrokes

You should try to become involved with your subject and media in order to gain as much knowledge of them as possible. The best way is to start with brushstroke exercises, and for this reason each theme in this section commences with a 'Brushstrokes' spread – on one page you can see the basic strokes, and on the facing page how each of these can be used within the specific theme. Practising in this way will also help you to discover

which papers and brushes suit your own personal style. From these basic strokes you will discover many more of your own to incorporate within your watercolour paintings.

Once again, the importance of drawing comes to the fore here – even the simple brushstroke exercises on pages 144–147 require some basic knowledge of shape and form that is best obtained initially through close observation and drawing exercises, as shown in the first section of this book.

You do not need to be 'tight' in your general approach to painting, but I do believe that discipline leads to freedom – should you choose to eventually paint with freely applied brushstrokes in a loose style, you can experience nothing but benefit from going back to basics in your approach every now and then.

Learning from your mistakes

As with so many aspects of watercolour painting, it is practice that can help you steadily improve – providing, of course, that you learn from your mistakes. It is by trial and error that we learn our most lasting lessons, and only by facing problems head-on can we resolve them.

Mishaps do occur from time to time, and even when you feel you have mastered a particular technique things will occasionally go wrong. Alternatively, sometimes there can be 'happy accidents', when an unintentional effect actually enhances the painting – though it is not a good idea to expect these to happen.

I feel it is unwise to discard any paintings with mistakes – even when things do go disastrously wrong – until we have learned all we can from them and repaired them wherever possible, as shown on pages 158–163. This may involve a simple solution like redrawing, using another medium over the watercolour, or cutting out and mounting the idea that has been successful. Slight corrections can be made by scraping away the offending marks with the point of a sharp craft knife. Should a large part of the picture prove to be disappointing,

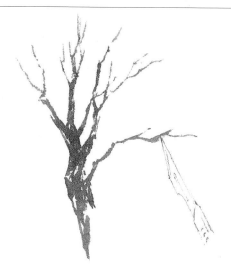

you can redraw and paint gouache over the entire painting. Using plenty of water with the pigments is one way of removing mistakes quickly, as described below.

Choosing and stretching paper

It is worth experimenting with papers of different weights and surface textures, which are examined in the first section of this book. Personally I prefer to work on paper that has been stretched beforehand – except when using a heavyweight paper. You may not wish to stretch a 300gsm (140lb) paper, nor may it always be necessary, but it is advisable to stretch anything below that weight.

To stretch paper you need a roll of gummed paper, scissors, a solid board that is slightly larger than the sheet of paper, a large container of water (a bath is ideal), a clean sponge and a clean paper kitchen towel. To start, cut the gummed paper into four strips to correspond with, and be slightly longer than, the sides of the paper, and leave them where they are easily to hand.

Wet the paper thoroughly – immersing it in water is best – and allow the excess moisture to drip off it before placing it on the board, with a margin of board showing around the edges, and gently smoothing it flat with the sponge. Moisten the gummed strips and apply

them with half the width on the paper and half on the board. Smooth out any air bubbles and blot gently with the paper kitchen towel.

Allow to dry flat at room temperature before using – if you tilt the board while the paper is drying, the excess moisture may accumulate along the lower edge, causing the gummed strip to lose adhesion and lift away when dry. Should the paper buckle or 'cockle' when drying, it may still dry flat eventually. If it is undulating when completely dry, simply remove it and repeat the process; you will soon learn with practice.

Working with water

It is wise to remember that watercolour painting means using plenty of water, and that when learning new techniques it is far safer to err on the side of too much water than too little. Without fluidity of your medium, the fluidity of your thoughts and ideas being interpreted in an exciting way is hampered.

To give you confidence in using a lot of water with pigments, mix a green or neutral brown in your palette to produce a rich hue, then add more water than you think

may be necessary while still retaining the pigmentation. Paint a simple shape using freely applied strokes, then immediately blot off with a paper kitchen towel until the paper is dry. If you have used enough water, you will see that only a pale stain remains on the paper, which means that if an image painted in this way does not appear as anticipated, you can remove almost all traces of it by blotting off immediately.

Becoming involved with your work

We all learn from each other and from our surroundings each day of our lives – for learning is a continuous and expanding process. Be aware of everything and keep your 'artist's eye' open to all possibilities. The best artwork comes from the commitment and involvement of the artist. The more you give of yourself to the creation of your work, the more successful you will feel it to be.

Try to avoid a superficial approach, and be sincere in what you are trying to express with your pencil and brush. Self-knowledge will develop if you remember the three P's – Practice, Patience and Perseverance.

Materials and Techniques

When drawing for painting, it is important that you understand how to use your materials to best effect, which ones work together and which suit your style and capabilities – it may also be that some of the problems you have experienced have arisen because you have combined pencil or brush with an unsuitable paper. Choose the best materials you can afford, treat them with care, and practise using them in exercises that help you develop your skills.

Choosing pencils

Graphite pencils for preliminary work for painting can be from the hard H range to F or, if a softer effect is required, from HB to the very soft 9B. As underdrawings for watercolours HB to 2B work well, because they are not too hard (because this might cause indentations) or too soft (because the marks might smear when water is applied).

Mass of dots (stippling)

Enlarge dots by pushing or pulling to suggest foliage

Basic line achieved by overlapping short strokes

Use the softness of the pencil to create thicker lines

Small crosses

Crosses massed at random

Crosses joined by lines to suggest branches and foliage

Pencil grades

Practise using a variety of pencil grades, and press gently or heavily on your pencil to create thick and thin lines as you work.

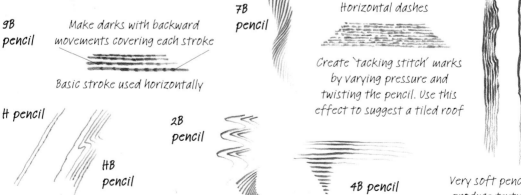

This grade is ideal for rich tonal blocks and line work

7B pencil

Horizontal dashes

9B pencil

9B pencil

Make darks with backward movements covering each stroke

Basic stroke used horizontally

Create `tacking stitch' marks by varying pressure and twisting the pencil. Use this effect to suggest a tiled roof

H pencil

HB pencil

2B pencil

4B pencil

Very soft pencils produce texture in lines

Fine lines create less intensity *Softer pencils create both fine lines and rich darks*

Brushes and their marks

Although many brush movements are the same as pencil movements, the element of water mixed with pigment allows shapes to merge and blend. A larger surface area can also be used with a brush – from the tip 'on your toes' position (see page 144) through to the full extent of the hairs laid horizontally (see page 147). It is this variety, and the many angles and pressures that can be applied, that adds excitement to brushwork.

Single dots merge when repeated and placed close together

Diagonal strokes begin to suggest leaf shapes

Applied in fan shape, massed strokes suggest a bush

Small crosses

Crosses massed at random

A few uneven 'flicks' at edges hide original crosses

Leave areas of white paper untouched

Draw branches and twigs through negative shape

Look for angles

Arrows demonstrate uneven application of paint

Delicate line on light side where there is no dark background

Arrows show movement downwards and across, using side of brush

Touch tip of brush to paper

Press as brush travels

Lift off gently

Travel Lift Reapply pressure

Use strokes to suggest ripples on water, similar to 'one-stroke' leaf shapes

Continuous on/off stroke, useful for tiled roof areas

Observation

Learning to look at your surroundings with an 'artist's eye' requires a special kind of observation. Try to look for different aspects of everyday objects and, as well as observing the positive forms in a group, also note the negative shapes between and around them.

Personal grid

To understand and use this method, place a tracing paper overlay over a still-life photograph. Look closely at the photograph, observing the points where one object touches or crosses another – the contact points. It is from these points that your grid lines may be drawn. Use only vertical and horizontal lines, as these are easy to check for accuracy with a set square.

From a point where one object comes into contact with another, draw horizontal and vertical lines on the tracing paper. Look along the these lines, and note where other parts of your subject(s) fall along them. In this case, at (a) the lines meet an angled area of stem, so you need to make sure that this point aligns with (b) – the initial contact point where the yellow pepper touches the shadow of the red one.

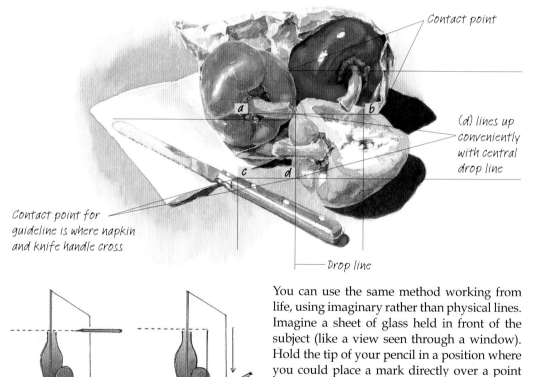

Contact point

(d) lines up conveniently with central drop line

Contact point for guideline is where napkin and knife handle cross

Drop line

You can use the same method working from life, using imaginary rather than physical lines. Imagine a sheet of glass held in front of the subject (like a view seen through a window). Hold the tip of your pencil in a position where you could place a mark directly over a point on the image behind. Run the pencil down – your 'drop line' – and see if the line meets any contact points. If it does, move your pencil horizontally, trying to meet another contact point and thus create your own personal grid.

Negative Shapes

Negative shapes are the shapes between the actual objects. They enable you to place your objects correctly in relation to each other when used in conjunction with your personal grid. As an exercise, draw some simple negative shapes as shapes only, not necessarily in context. With a pencil, tone within the outline you have drawn and create a solid block. Compare your shape with the one you see between the objects in front of you.

Choosing a starting negative shape

The group of three bell peppers and a knife below shows examples of small, medium and larger negative shapes. Practise starting a study of still life by drawing what you regard as the most important or relevant negative shape – the shape that, when it is drawn, will help you place the most objects accurately, in relation to each other. In the illustration here, this would be the medium shape, as it will lead naturally, with the use of guidelines, to being able to complete all three peppers.

Small

Medium

Large

Negative shapes

Larger negative shapes

The negative shapes between the sheep and lamb's legs are quite simple and easy to draw, and help you fix the proportions of the animals accurately.

Guidelines

Once you have established your personal grid of vertical and horizontal guidelines, and allied this to negative shapes, you will have a scaffolding upon which you can build your drawing. You now need to look for further 'shapes between' to help accurate placement.

Finding guidelines

The areas coloured in green show how to use a guideline to complete a 'shape between'. In this way you are creating more shapes to relate to each other and thus gain greater accuracy.

It is like a jigsaw puzzle, where the pieces fit together – or a spider's web. To avoid getting lost with an intricate grid, include solid tonal negative shapes and shadow shapes.

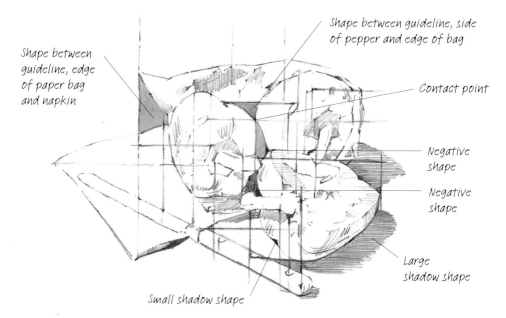

Shape between guideline, edge of paper bag and napkin

Shape between guideline, side of pepper and edge of bag

Contact point

Negative shape

Negative shape

Large shadow shape

Small shadow shape

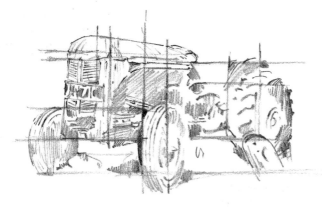

Composing with guidelines

This rough sketch of a tractor (refer to page 226 for the final drawing) shows how you can use guidelines to plot out your composition from the start.

Tone

Before you start watercolour painting, think of your subject in black and white – a black-and-white photo will help you understand the range of tones.

Toning for tone or toning for colour

Improving your awareness of tonal contrasts can help you establish tonal blocks (masses of light against dark and vice versa) that create the design of your pictorial composition. You can practise tonal blocks with pencil (as below) or one neutral watercolour. This tonal study of three bell peppers and a knife demonstrates how some tones suggest colour (toning for colour), while others relate to shadow areas (toning for tone).

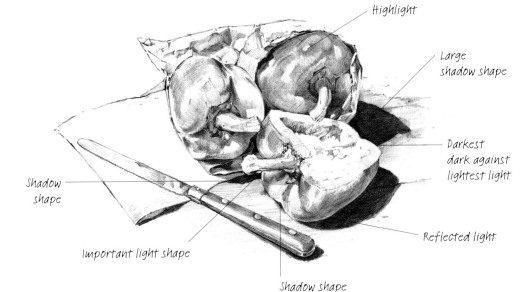

Highlight

Large shadow shape

Darkest dark against lightest light

Shadow shape

Reflected light

Important light shape

Shadow shape

Tonal blocks

Whether toning for tone or toning for colour, it is the variety of tones and contrasts that bring excitement to your pencil work. Make a series of eight tones to which to refer as your work progresses. Keep reminding yourself to look for the tonal contrasts within your subjects, and use as many different ones as possible.

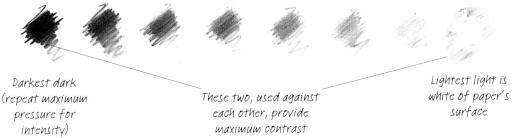

Darkest dark (repeat maximum pressure for intensity)

These two, used against each other, provide maximum contrast

Lightest light is white of paper's surface

Drawing within Shadows

Strong sunlight, with its resulting cast shadows, gives you an opportunity to use contrasts of light against dark. If you look closely within shadow areas you can see a further variety of tones, more closely related but at the same time still very clear.

Ways of adding shadows

Old buildings present a wealth of interest, and strong sunlight brings out exciting tonal contrasts. Using a smooth-surfaced white drawing paper, tone in an area to represent cast shadow and then draw within it, either in a linear way or with more tonal blocks. Alternatively, you can draw the objects prior to adding a tone that suggests a cast shadow over your drawing. This kind of drawing requires good pencil control.

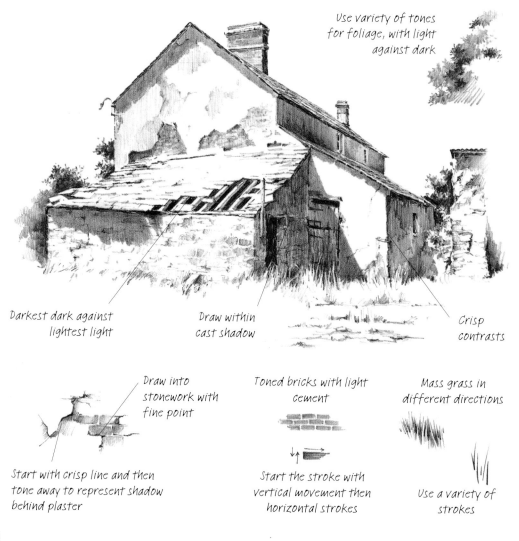

Use variety of tones for foliage, with light against dark

Darkest dark against lightest light

Draw within cast shadow

Crisp contrasts

Draw into stonework with fine point

Start with crisp line and then tone away to represent shadow behind plaster

Toned bricks with light cement

Start the stroke with vertical movement then horizontal strokes

Mass grass in different directions

Use a variety of strokes

Tonal watercolour exercise

Observe details within a shadowed area – pebbles on a beach within the shadow of a rock, for example – and paint them using one colour, then mix a neutral shadow tone and sweep the shadow shape over the pebbles. If you have used translucent washes for the pebbles and allowed the paint to dry thoroughly, you will see the image clearly through the shadow area. Do not mix too much pigment in your shadow colour.

Following form within shadow shapes

Study shadows closely, especially the way in which cast shadows curve and disappear behind light forms that cut across. This will help you understand how to create a three-dimensional impression of the subject. A simple example is when a cast shadow over grass causes dark shapes to cut into light (behind) and light into dark (foreground).

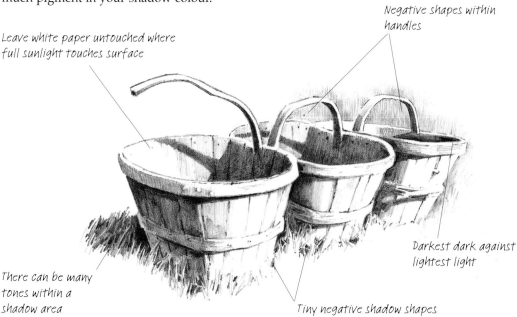

Negative shapes within handles

Leave white paper untouched where full sunlight touches surface

Darkest dark against lightest light

There can be many tones within a shadow area

Tiny negative shadow shapes

Use heavy pencil pressure to create shadow line over area of tone

Tone in same direction as first block to create shadow shape on top

Practising with tone

To render tone effectively in many situations you need to learn pencil control – use as many completely different subjects as you can to build this up.

Tone in Watercolour

These pages demonstrate the need for varied pressure and angles of the brush to make different movements. To achieve a diversity of tones you can either use a variety of diluted washes, building one upon the other, or blending the washes together.

Diluting paint

Lift a good reservoir of water into your palette – more than you might normally use – using a large brush. Wet a smaller brush and lift some pigment from the pan, adding it to the water until you have a pale tint. Brush this onto watercolour paper. Add more pigment and try the resulting mix again. Continue to do this until you have a range of tones. Even your darkest tones should be fluid.

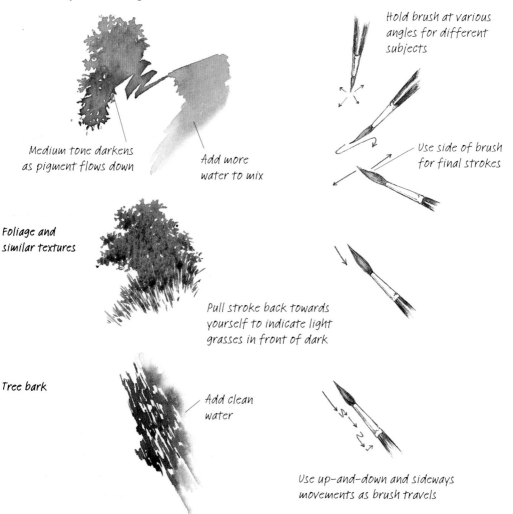

Medium tone darkens as pigment flows down

Add more water to mix

Foliage and similar textures

Tree bark

Add clean water

Pull stroke back towards yourself to indicate light grasses in front of dark

Hold brush at various angles for different subjects

Use side of brush for final strokes

Use up-and-down and sideways movements as brush travels

Blending to make curves

Not all tree bark has a rough texture, and the smoother surfaces of some tree trunks offer opportunities to blend from the dark side of the bark into the light.

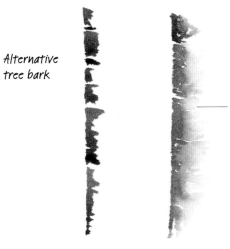

Alternative tree bark

Clean water for blending

Hold brush horizontally with full length of hairs on paper

Follow downward movement with sideways pull. Lift completely from paper at uneven intervals to add texture and highlights

Repetitive images

This exercise helps to develop the ability to work at speed when reproducing images like those of bricks, stones, blocks and other flat areas with repeated patterns or textures.

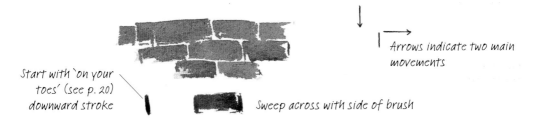

Arrows indicate two main movements

Start with 'on your toes' (see p. 20) downward stroke

Sweep across with side of brush

Moving images

These images are best achieved by swiftly applied strokes, so be prepared to practise painting at speed to achieve spontaneity.

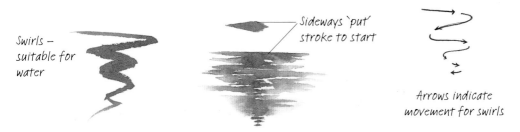

Swirls – suitable for water

Sideways 'put' stroke to start

Arrows indicate movement for swirls

Getting to Know Your Brushes

These one-stroke brush exercises are designed to help you develop confidence. If you practise them regularly you will soon find that you have more control over your brush and are able to vary the speed at which you work and the thickness of your strokes.

Brush positions

'On your toes' position with brush almost vertical

Angle brush for twist and lift off

Directional strokes
One-stroke leaf shapes may be executed both upwards from the stem stroke, or starting away from the stem and travelling towards a twiddle.

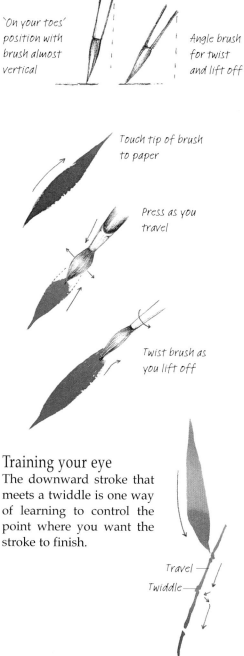

Touch tip of brush to paper

Press as you travel

Twist brush as you lift off

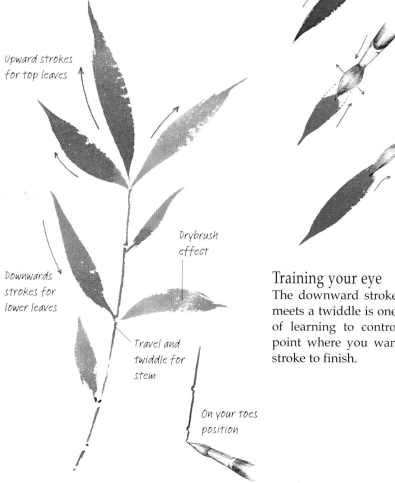

Upward strokes for top leaves

Drybrush effect

Downwards strokes for lower leaves

Travel and twiddle for stem

On your toes position

Training your eye
The downward stroke that meets a twiddle is one way of learning to control the point where you want the stroke to finish.

Travel

Twiddle

Combining long and short strokes

This exercise is an extension of the one shown opposite and demonstrates how to place short strokes alongside sweeping, extended shapes. The slender stem and 'tails' on the ears encourage concentration and control.

Basic 'put' stroke

This stroke places the whole length of the brush once upon the paper, lifting off immediately. It can be extended by placing and pulling downwards a little before lifting off.

Place and lift

Longer shape. Pull down a little as you lift off

Directional 'put' strokes

A series of 'put' strokes in formation can be executed by placing the stroke at one angle, lifting off, turning the brush to a different angle and placing another stroke, and so on.

Consider direction of strokes

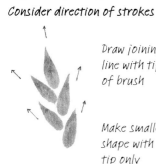

Draw joining line with tip of brush

Full brush pressure

Make smaller shape with tip only

Joining 'put' strokes

The series of 'put' strokes can then be joined by a curved or angled (stem) line to represent a recognizable image.

Draw brush line away from shape for highlight

Train your eye
A downward stroke that meets the tip of an image is one way of learning how to control the brush point at which you want the stroke to finish

Complete image

After having practised the exercises on these pages, you should be in a position to combine them and produce a complete image in the form of an ear of corn with a stem and long, tapering leaves.

Fine, delicate shadow lines

Start leaf stroke away from stem

1 Apply single upward stroke swiftly
2 Stop the stroke and lift brush before finishing stroke
3 Add finely drawn line to suggest edge of curve

Bring stroke down, adding firm pressure to create width

2 3

1

Lift pressure as leaf approaches stem

Place dark shape behind light edge to suggest underside of leaf in shadow

Draw fine lines over shape when dry to suggest veins

145

Combining tonal blocks and drawing

Here, we look at combining areas of tone and contrasting them with lines, drawn with the point of a brush, that follow the form of the object. Although the effects of coloured and tonal shapes are important in watercolour painting, it is also necessary to enhance images with the use of freely applied linear work at times – especially when the lines may suggest the presence of veins on the surface. When applied in a curve that follows the form of the subject, these lines help us to give the impression of a three-dimensional object. These exercises combine the 'on your toes' position of the brush with flat and angled strokes, the 'put' stroke and drawing.

Angles of application (1)

There are times, within a single brush stroke, where you may need to adjust the angle at which you hold your brush more than once.

Combining tone with line (2)

In this more complex image, based upon a seed pod, it is not only brush strokes that are considered but also relationships between tonal shapes and form finding lines.

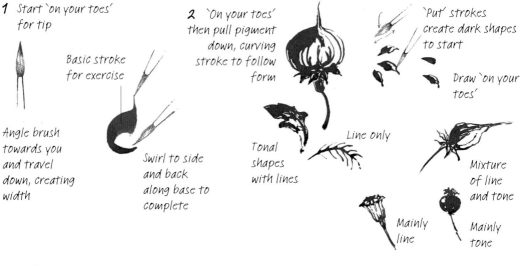

1 Start 'on your toes' for tip

Basic stroke for exercise

Angle brush towards you and travel down, creating width

Swirl to side and back along base to complete

2 'On your toes' then pull pigment down, curving stroke to follow form

'Put' strokes create dark shapes to start

Draw 'on your toes'

Tonal shapes with lines

Line only

Mixture of line and tone

Mainly line

Mainly tone

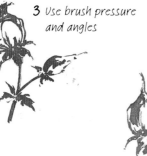

3 Use brush pressure and angles

4 Place dark shape behind light form

Flat tonal application (3)

The seed head, stem and leaves are brought together by working continuously from one into another to maintain even application. Use free-flowing pigment, diluted to achieve a pale hue, allowing it to be considered as an undercoat over which, when dry, further tonal shapes and drawing can be applied.

Using background images (4)

When images are grouped en masse, the lighter areas can be enhanced by what is placed beside or behind them. This exercise demonstrates the use of white paper to achieve this effect.

Blending

Blending, whether within the objects themselves or a background colour blended away from the objects to disappear into other colours or the white paper, is an exciting effect to achieve. The secret is to avoid adding too much water to the pigment already on the paper's surface – if you do, the point at which they meet may produce effects that are not the ones anticipated.

You can apply this blending technique to many subjects, including skies, where it can suggest the soft edges of clouds against the blue of the sky behind.

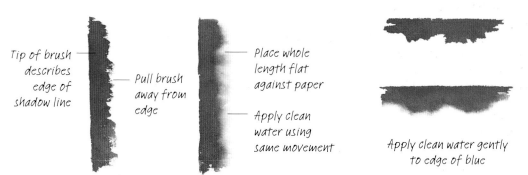

Tip of brush describes edge of shadow line

Pull brush away from edge

Place whole length flat against paper

Apply clean water using same movement

Apply clean water gently to edge of blue

Uses of blending

Blending can be used to great effect on both flat and curved surfaces. Consistency within a curve is important, and this is demonstrated in the subject of a tree trunk. The studies of foliage show the versatility of the misty and other effects that can be achieved by blending.

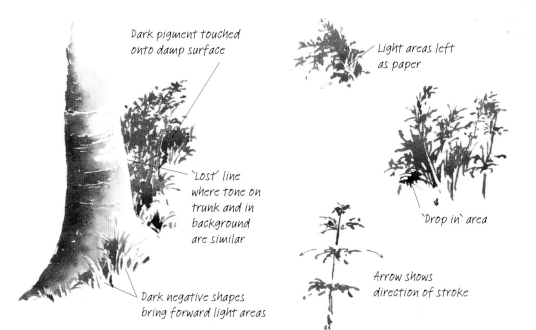

Dark pigment touched onto damp surface

Light areas left as paper

'Lost' line where tone on trunk and in background are similar

Dark negative shapes bring forward light areas

'Drop in' area

Arrow shows direction of stroke

Watercolour Techniques

Developing watercolour techniques through exercises can help to familiarize you with the amount of water you require to achieve certain effects. A common beginner's mistake is to add insufficient water to the pigment, or to not mix together enough in the palette to cover the intended area of paper – err on the side of too much, rather than too little, water.

Wet into wet

This technique, in which paint placed upon a damp surface spreads naturally, producing a diffusion of forms that find their own edges, helps to achieve a loose, soft effect. Used in the form of a muted background, it gives emphasis to more detailed work.

Painting wet into wet

The exercise below shows a basic wet-into-wet technique using one colour. Wet an area of paper evenly and hold the paper, angled, up to the light in order to observe the sheen and establish evenness.

Using a dilute mix of blue, commence drawing into areas of the damp surface with the tip of the brush. Watch the colour spread on contact. Work from side to side, and leave areas of white paper to suggest cloud shapes and formations.

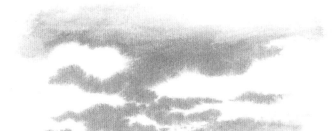

Darker areas can be placed over light

Single strokes applied at different angles

Test effect with single strokes on rough watercolour paper

Use side of brush to achieve effect of long grass

Drybrush

A drybrush effect is often created accidentally at the end of a stroke when paint on the brush is drying rapidly. In order to create this effect intentionally, to give the impression of texture or muted highlights, you will need less liquid than usual in your brush. Drag the brush across the paper, depositing pigment upon the raised areas of rough paper but leaving the 'troughs' free of paint. A flat brush was used for this example.

Washes

The secret of successful watercolour washes is to allow the first wash to dry thoroughly before the next is applied. You need to build only a few glazed washes to intensify tone.

Flat wash

Load the brush with plenty of paint and, starting from the top, work down the paper from side to side using sweeping horizontal strokes, across one way and back in the opposite direction. Keep loading your brush as you work, to avoid an area becoming too dry to accommodate the following stroke.

Gradated wash

To achieve a wash that progresses from a dark to light tone, add more clean water to the pigment for each successive stroke across the paper. To avoid creating a striped effect, experiment with the amount of water you add for each brush stroke line, and do not go back over a wash you have already laid.

Variegated wash

Choose two or three colours and blend one into the other as you work down the paper.

You can also create a wider band of the main colour and reduce the width for the second or third bands. When painting a sky, you can add clean water to the final strokes to suggest a light horizon.

Board angle

Support your paper – pinned or stretched upon a board – at an angle that will allow the brush strokes to flow into each other without causing dribbles.

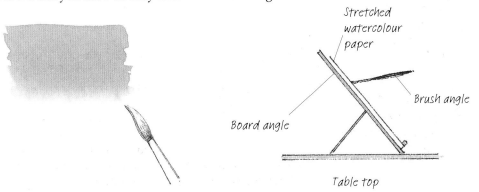

Stretched watercolour paper

Brush angle

Board angle

Table top

Highlights

Highlights are best depicted by the use of untouched white paper. Decide which areas are to remain white before you start to paint, and make preliminary sketches.

Painting around highlights

Sometimes pure white paper is not required for a painting, but a paler tone is. In this case, lifting off excess moisture and pigment is the answer, and the two techniques work well when used together.

This unfinished study of a prawn shows the underlying washes before subsequent layers of colour build up the intensity. Start by painting around the white area, as demonstrated in the study of peppers on page 136.

With no dark background, use a delicate line to bring the shape forward

Pull the paint away from the highlight and across the form

You can overlay pale washes after the initial shape has been defined

Removing excess moisture

Rinse brush in clean water, squeeze dry, then place tip onto wet surface to draw up moisture

Blotting Off

As long as you are using plenty of water mixed with pigment, if you make an error you can quickly blot the surface and significantly reduce the mark. Because watercolour lightens when it dries, the mark may be hardly noticeable and may be overpainted successfully.

Creating texture

The studies here show how blotting can be used to produce texture. Blotting produces subtle changes of tone with texture, and contrasts are essential for lively effects – gently drop darker pigment into damp textured areas. At all times keep the pigment fluid, paint onto a rough surface paper and blot gently. Be careful not to dry the blotted area too much, or the final stages may not take.

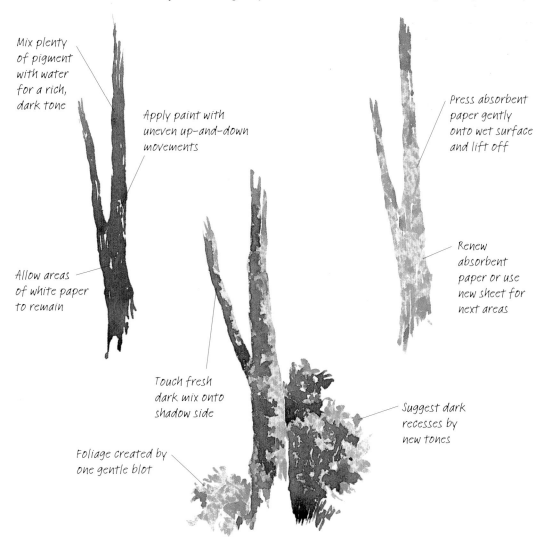

Mix plenty of pigment with water for a rich, dark tone

Apply paint with uneven up-and-down movements

Allow areas of white paper to remain

Touch fresh dark mix onto shadow side

Foliage created by one gentle blot

Press absorbent paper gently onto wet surface and lift off

Renew absorbent paper or use new sheet for next areas

Suggest dark recesses by new tones

Resists

A resist method is when part of the paper's surface is coated with a substance that prevents any overlaid washes of pigment reaching the paper underneath it.

Basic tree shape drawn using small brush dipped in masking fluid

Wash of colour applied over dry masking fluid

Masking fluid

This fluid is applied to the paper with a brush or pen. It dries to a rubbery film over the areas covered, thus preventing paint from marking the paper. You can then paint normally around (or across) the masking fluid in the knowledge that once it is removed, the areas it covered will appear as clean paper. When the painting is thoroughly dry, you need only gently rub the fluid with a finger or pull the rubbery substance from the surface.

Make mark with candle

Apply colour wash

Candle wax

Rub a white candle gently across the paper, then apply paint over the area and watch how the waxed area resists the paint upon its surface. The texture produced using this technique can be used to depict many different surfaces.

Rocks among grass

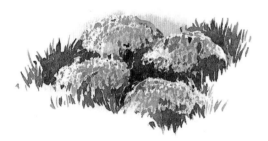

Draw shapes with the candle to represent smooth rocks, then sweep a wash of light colour over the waxed area. Any places where the wax did not touch the surface will take pigment in the usual way, as solid colour. Allow to dry before adding a darker tone to indicate shadow areas.

Creating Texture without Resists

Resists are not the only way to create texture in watercolour. Some techniques studied earlier, such as drybrush work and leaving highlights, can also be explored.

You can employ the surface of the watercolour paper to create texture – look at the texture of different brands of paper to see what it suggests.

Towelling, carpet and similar textures

Through this method, work 'on your toes' to follow the texture that can be observed on the surface of the paper.

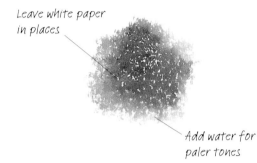

Leave white paper in places

Add water for paler tones

Wood grain

This overall textured effect is achieved by drawing a series of slightly uneven lines, one beside the other, using a brush.

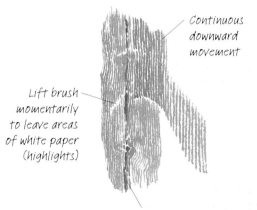

Continuous downward movement

Lift brush momentarily to leave areas of white paper (highlights)

Use darker tone to suggest recesses and shadow areas

Rusty iron

A rusty iron surface, with its cracks and indentations, can benefit from a stippling effect, for which you need to use the tip of your brush.

Apply base colour with swiftly applied angled brushstrokes

Cut in crisply to uneven areas with darker hue to suggest shadow recesses

Underside of leaf

This is a good example of how the surface of the paper can be used to great effect. Look closely at the paper's natural texture to note where the troughs occur. Apply the pigment in these 'pockets', leaving the raised areas as white paper.

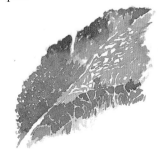

Understanding Colour

Colour enables you to create atmosphere in your paintings, and once you have mastered colour mixing you will be able to express moods better. By practising exercises you can learn which colours to use together and which combinations to avoid, and by experimenting you can understand all the ways in which you can make colour work for you.

Colour relationships

Colours affect each other – for example red and green, which are of equal intensity and are complementary colours, produce harmony when painted in equal proportions. By varying the proportions of these two colours within a painting you can create different effects. Paint a small square of green and surround it with a wide border of red. Compare this with a small square of red surrounded by a green border. Note how the green of the square appears lighter when surrounded by red, yet darker when green surrounds red.

The colour wheel

The basic colour wheel contains three primary colours, red, blue and yellow. Between them are the secondary colours, purple, green and orange. On more comprehensive colour wheels the intermediate colours are included – red-purple, blue-purple, blue-green, yellow-green, yellow-orange and red-orange – and the wheel can be subdivided again into further intermediates.

There is not actually a red, blue or yellow that is primary, as there are warm reds and cool reds. In the Winsor & Newton range an alizarin crimson or permanent rose is a cool red, whereas scarlet lake is a warm red; French ultramarine is a warm blue, and Winsor blue is a cool one; lemon yellow is cool, and cadmium yellow warm.

Tonal scale

As with the pencil scale in tone on page 139, we can also produce a tonal scale in colour. Paint the darkest value first then, adding a little more water to the pigment for each block, work through to the lightest tone.

Limited palette

Decorative stonework –in the form of a window frame or a statue – is a subject which lends itself to execution in a limited palette or in neutral colours. The stonework around the window to the right was painted using three colours – burnt sienna, yellow ochre and cobalt blue – mixed in varying quantities and strengths. The subject on pages 156–157 was also painted using the same palette, to show that a very few colours can be adapted for totally different subjects.

Neutral colours

When the three primary colours are mixed together in certain proportions they produce a neutral hue. A range of neutrals was used in this painting of an angel statue.

Concentrated mix produces very rich dark to enhance shadow areas

Understanding Colour

Most watercolour paintings are created through a number of distinct preliminary stages. Try to become aware of, and think your way through these stages in your work. This will ensure that you are in control as the painting develops.

Establishing composition

Once you have chosen your subject, make a preliminary sketch, consciously looking for areas of interest. In the sketch below, the sheep on the ground, in neutral colours, blended into their surroundings, so I chose to concentrate more on the strong shadows cast across the trees.

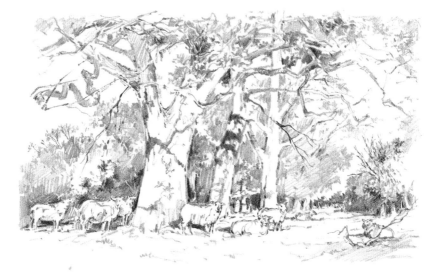

Drawing the tonal contrasts

A second sketch establishes the positions of negative and shadow shapes plus the areas of foliage mass. Once established, these basic shapes are then transferred onto watercolour paper as simple washes around the shapes of the trees.

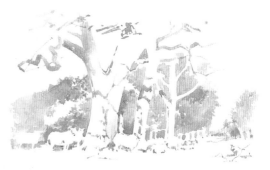

Painting the main areas

The palette is limited to three colours that, combined in varying quantities, also produce a range of subtle neutrals. The clear blue of the sky provides a cool contrast.

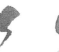

Burnt sienna Yellow ochre Cobalt blue Blended colours

Build up painting with freely applied blocks of colour and tone

Leave white paper to enhance contrasts

Blending

Crisp edges

Shapes between

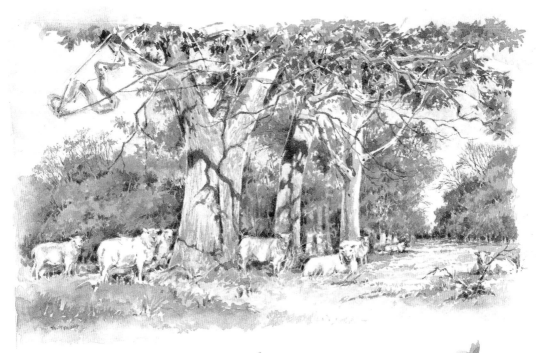

Build up painting with freely applied blocks of colour and tone

Leave white paper to enhance contrasts

To the Rescue

The disappointment felt when a promising painting goes wrong after hours of encouraging work can be reversed by the use of rescue techniques. The first thing to do is to assess the situation calmly and decide whether it is the drawing or paint application that is at fault. Excess paint can be washed off; images that have lost clarity can be redrawn over the watercolour using another medium, for example ink or charcoal pencil; gouache can be painted over watercolour to transform a weak painting; or a successful area of the artwork can be cut out of the whole and mounted separately.

Thick paint

If you have produced a painting where the paint has been applied too thickly, you can rescue it with a wash-off method. This method also helps when too much white is exposed within the painting, as it mutes the colours and enables you to build them up again, as well as giving you another chance to alter any drawing deficiencies.

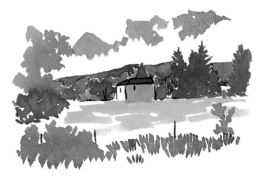

Back to drawing

Making a drawing helps you notice things that need to be corrected, so draw in a 'painterly' way, using tonal masses rather than outlines.

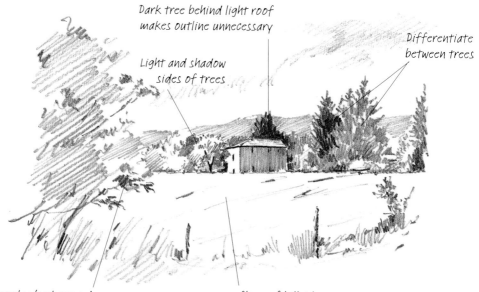

Dark tree behind light roof makes outline unnecessary

Differentiate between trees

Light and shadow sides of trees

Leaves overlay background

Slope of hillside

Washing paint off

Place your painting flat in a receptacle, and add clean running water. Gently stroke the surface with your finger, or brush or sponge off the pigment. Do this until there is no more pigment to be removed, only a residual tint staining the paper. Stretch the paper on a board and allow it to dry before continuing.

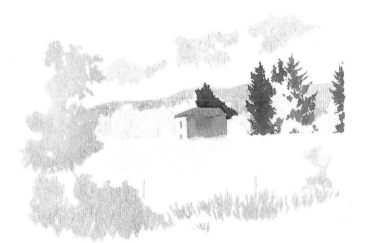

Cutting in and clarifying

Start by correcting the building, cutting in around the roof with a simple tree shape to give a dark colour behind and thus bring the image forward. Establish the shapes of the nearby trees.

Relating the foreground

Establish the relationship between the foreground and background by introducing the smaller trees on the other side of the building. This will enable the composition to become set.

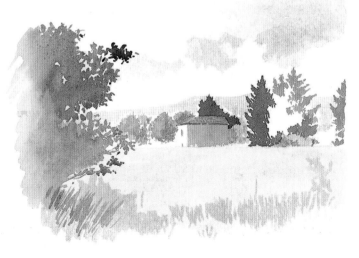

Final painting

Lightly apply washes to the grass area, to aid continuity. Build up the painting with washes in the foreground and background before adding the finishing details.

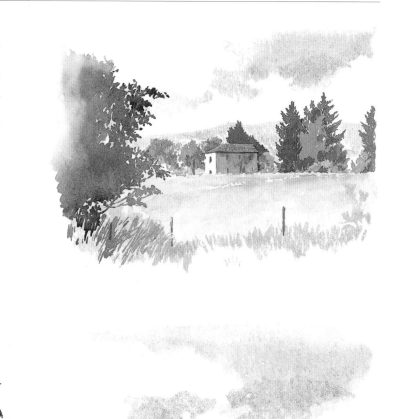

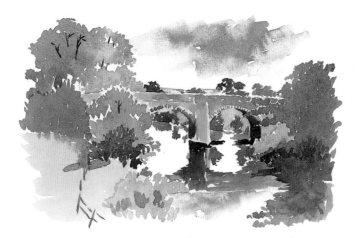

Using gouache

The problems with the painting above are the drawing (the right-hand side of the bridge slopes away too steeply), the greens (how to differentiate between them, and how much white paper to allow) and the muddled areas of shadow (the foreground area on the right-hand side is muddy and overworked, and lacks clarity within the shaded area). Gouache allows you to reintroduce drawing to correct and eradicate an unsuccessful sky. You can also use the advantage of working on a tinted ground to correct and to apply thicker paint to alter areas.

Establish areas of sky between redrawn branches and foliage

Lay warm (tint) wash over whole painting

Build up greens in relation to each other

Adjust tilt of picture and square off edges to lift bridge slightly, presenting more accurate perspective angle

Scraping off

When painting a snow scene, you may find you have coloured an area that you feel you would prefer to keep white. There may also be occasions where you wish to give the illusion of snowflakes, sea spray or sparkle upon a surface. In this instance, scraping off is part of the method to use; make sure that you use a sharp scalpel or craft-knife blade.

You may find you have painted an area which should have remained white

Twigs may be too heavy for distance

Use fine blade to gently scrape surface

Soften solid areas by scraping paint off

Rescuing scale and composition

If a painting's composition is becoming disjointed or you are having problems with relating the scale of one subject to another, you may find that excluding part of the picture is the answer. A simple method is to move a viewfinder around the picture until you find an area within the frame that presents a satisfactory composition, and then develop that area alone. If the painting was already completed and you were not satisfied with the overall effect, isolating a small area in this way can rescue hours of hard work.

Using mixed media

There are many examples of mixed media – watercolour and pastel, watercolour and charcoal, watercolour pencils and so on. One popular combination is watercolour and pen and ink, which is also an effective rescue technique because it allows you to clarify and re-establish the drawing aspect of your painting if this has been lost.

 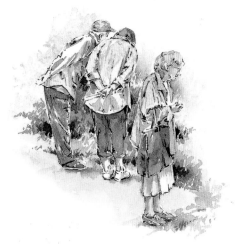

Skies and Water

Basic Brushstrokes

These exercises are designed to help you learn to interpret movement of water and clouds, allowing the surface of white watercolour paper to play as important a part as the paint itself. Also included here is a flat wash for when a tranquil sky or water surface is required.

Painting positions

The main brush positions for these examples are the normal painting angle (for flat brush-strokes) and one at a right angle to your hand (for the round brush image). Use a variety of angles for the cloud formation exercises shown below and opposite.

Flat brush exercise

Lift off completely in some areas and widen strokes in others

Note variety of thickness in strokes

'Drop in' dark reflection colour

Load flat brush with plenty of water and pigment and pass it across paper with erratic pressure from side to side

Round brush exercise

Hold brush at right angle to your body and touch, press as you travel and gently lift stroke

Make strokes narrower for distance, allowing to blend in places

Sky and water washes

Practise glazing with this simple exercise. Wash a block of pale blue onto your paper and allow it to dry. Mix a paler wash of a second colour, in this case raw sienna, and gently wash it over the blue to achieve a glazed surface.

Cumulus clouds

Apply pigment with curved strokes to describe the edge of a cloud (right), and paint out and away from the cloud (left).

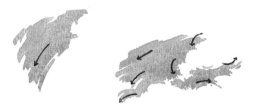

Flat wash.

Blended with clean water

A variety of brush positions and directional strokes helps to create interesting cloud shapes.

Developing Brushstrokes

These four exercises are developments of the strokes shown opposite. Remember to remain aware of the movement aspect when portraying water and skies, as well as employing the juxtapotion of crisp and blended edges.

Reflected image

The flat brush exercise opposite is useful for broken reflections in rippling water. You can set it up yourself by placing an object that reflects onto water.

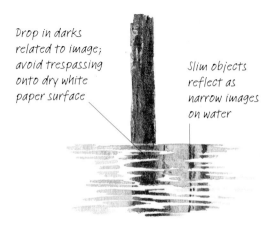

Drop in darks related to image; avoid trespassing onto dry white paper surface

Slim objects reflect as narrow images on water

Different viewing angles

Choosing a viewpoint near the surface of the water produces variations on how you portray the water and reflections on it.

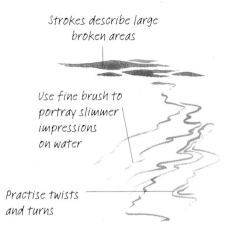

Strokes describe large broken areas

Use fine brush to portray slimmer impressions on water

Practise twists and turns

Blended wash

For painting tranquil skies you can create the desired effect by gradating a wash over another that has already dried (see page 149).

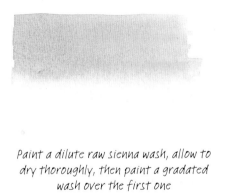

Paint a dilute raw sienna wash, allow to dry thoroughly, then paint a gradated wash over the first one

One-colour sky

You can practise painting cloud effects using only one colour. This is a development from the cumulus clouds exercise shown opposite.

'Pick up' pale blue from another area and paint slightly within light edge

Blend some clean water at cloud edges

Still Water: Typical Problems

To achieve spontaneity in your interpretation of water you need to restrict the number of washes applied. Without knowledge of the subject, however, adding washes at random cannot achieve satisfactory results – and nor can overpainting dark areas. You can see in the painting below how the background has been overworked.

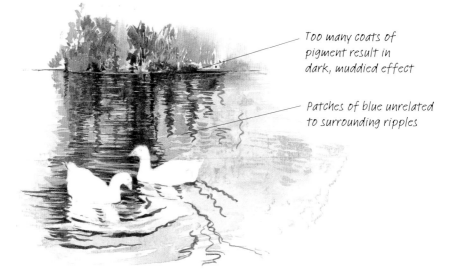

Too many coats of pigment result in dark, muddied effect

Patches of blue unrelated to surrounding ripples

Study detail using pencil

As water responds to its environment – stirred by a breeze or disturbed by birds, fish or amphibians, for example – it creates interesting patterns within reflections upon its surface. Start by observing and drawing these patterns on disturbed water.

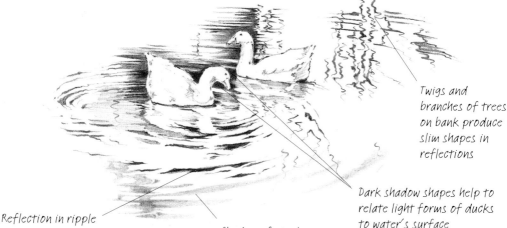

Twigs and branches of trees on bank produce slim shapes in reflections

Dark shadow shapes help to relate light forms of ducks to water's surface

Reflection in ripple

Shadow of ripple with no reflection

Solutions

An exercise in understanding

This exercise demonstrates wet-into-wet painting, representing distant reflections, and a controlled wet-on-dry interpretation for the close-up ripples.

Once you understand the subject and have interpreted it in this controlled way, you will be able to achieve spontaneity in your personal style.

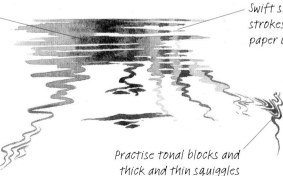

Paint around first pale wash

Apply masking fluid over duck images to allow sweeping strokes in background

Mask light images, allow to dry and apply washes freely

Paint in controlled way, following pencil shapes

While surface is still wet, 'drop in' dark reflection colour only on wet painted surface

Swift side-to-side strokes leave some white paper untouched

Practise tonal blocks and thick and thin squiggles

Moving Water: Typical Problems

The complexities of falling water against a backdrop of rocks, surrounded by ferns and other foliage, can be a daunting prospect for a beginner, as you are looking not only at an array of varying greens but also a vast variety of tonal contrasts. It is a good idea to separate one from the other and understand the importance of tonal relationships before moving into full colour – in this way it is possible to remove many of the problems that have arisen in the painting on the right.

Hard lines 'drawn' with black paint do not suggest shadow shapes between rocks

Drooping foliage does not appear convincing as negative shadow shapes are missing

Random squiggles on white paper do not suggest falling water

Dark behind does not 'cut in' sufficiently around ferns

An opportunity for closer observation

Start by finding a subject that has water dripping or falling a short distance – this will not appear as complicated as a longer fall, and you will be able to observe and draw the way it flattens, twists and bubbles. Pay particular attention to tonal variations.

Darks between plant stems produce rich, reflected ripples, at first solid and later broken

Place areas of rich dark tone either side of falling water to make fall come forward

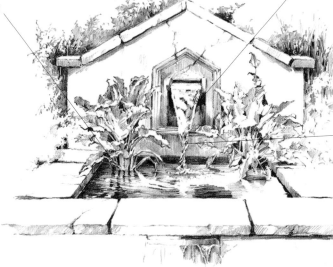

Note pattern of tone as water twists before meeting bubbling surface

Solutions

The magic of monochrome

Working in monochrome means that you put any problems of using colour to one side for the moment. This will allow you to take one learning step at a time. A number of points and methods mentioned in the Introduction have been used in this study, including applying masking fluid to retain light areas while allowing freedom of brush movements, using drybrush techniques for rough rock surfaces, enhancing dark negative shapes, and making full use of the tonal scale.

Making monochrome
Mix two colours together in plenty of water to create a pleasing neutral hue

Build up tone layer upon layer, allowing each to dry thoroughly

Lightly draw position of rocks and foliage masses in pencil

Block in foliage mass areas with masking fluid applied with small old brush, and allow to dry thoroughly

Gently remove masking fluid from all light areas and `cut in' a little with paint to reduce proportions

Paint on masking fluid in downward strokes to position waterfall

Use drybrush technique for textured areas

Cloudy Skies: Typical Problems

Whether working wet into wet or using a rough, dry surface to produce interesting cloud edges, it is swiftness of paint application that achieves the best results – this may not be as easy as it sounds, because this way of working does not allow time to consider the effects that are being achieved during application. In many cases panic sets in and a series of uneven white blobs results, as seen below left.

Alternatively, wet paint placed on a wet surface without knowledge of the subject produces a pleasant effect, but not necessarily an impression of cloud formation.

Series of white blobs within one-colour blue area

Random placing of colours without knowledge of cloud formations

Playing with paint

This exercise offers you the luxury of experimenting and pushing paint around without the concern of spoiling a painting. You will need a good-quality paper (see opposite). Choose your colours and mix each one separately, using plenty of clean water, in three separate palettes. Have other clean palettes ready for mixing colours together to create different hues.

Dampen the paper's surface with clean water. Either looking up at the sky, or at a photograph, paint the large shapes between the clouds. Make sure that the fluffy edges of the clouds that are to remain as white paper are interesting and appear natural. Mix some shadow colour and apply to the underside of the cloud formations.

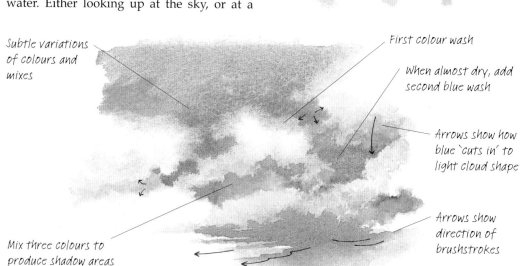

Subtle variations of colours and mixes

First colour wash

When almost dry, add second blue wash

Arrows show how blue 'cuts in' to light cloud shape

Arrows show direction of brushstrokes

Mix three colours to produce shadow areas

Solutions

Cumulus clouds

When cumulus clouds are nearer to you they appear fuller than those in the far distance. Note how the correct choice of paper helps you achieve desired effects – the surface of Saunders Waterford Rough 300gsm (140lb) paper is ideal to use for this technique, as the pigment settles into the hollows in the surface.

Pull first application of blue sky wash around white cloud shapes

Add washes of darker blues

Blue 'shapes between'

Shadow colours painted underneath clouds

Crisp, dry edges

Blending wet into wet

Calm and Clear Skies: Typical Problems

Painting open landscape, or a wide expanse of sand and sea combined with a calm arrangement of clouds, gives you an opportunity to practise gradated washes, as shown on page 149 Let your hand and arm move smoothly from side to side, and always use plenty of water in your washes. Avoid hard edges (as seen in the painting below) if you want your skies to flow and blend with white, fluffy clouds.

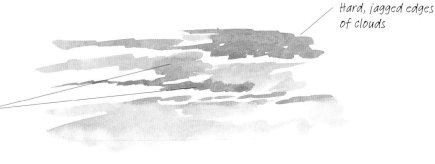

Hard, jagged edges of clouds

Not enough gradation in sky colours

A soft style of drawing

To get a feeling of space and tranquillity you need to practise a calm approach to your painting and incorporate gentle blending. Use a heavyweight quality cartridge paper and 2B pencil drawing to create this effect and achieve a strong sense of perspective.

Producing a drawing like this gives you time to consider ways of suggesting subtle tones with light application of pencil pressure as you define the soft edges of the clouds – this should carry you into your painting in the right frame of mind.

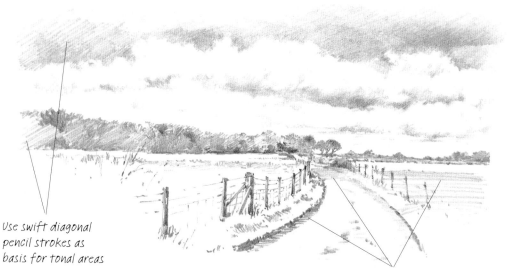

Use swift diagonal pencil strokes as basis for tonal areas

Use swift horizontal pencil strokes as basis for tonal areas

Solutions

Gradated sky

Subtle gradations of colour and tone are essential for capturing the essence of a clear or calm sky. Note that the gradated washes in these exercises are shown darker than in the painting below, for the purpose of clarity.

For the raw sienna wash invert your paper and work away from the horizon line.

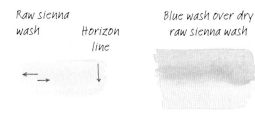

Raw sienna wash Horizon line Blue wash over dry raw sienna wash

With the paper the correct way up, start a blue sky wash and work down, adding more clean water as you approach the horizon.

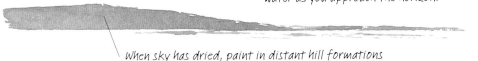

When sky has dried, paint in distant hill formations

Creating distance

In the painting below, the sky and distant coastline were painted first and allowed to dry. Darker foreground colours were then applied over the paler washes, and the sky was enhanced with cloud formations.

When dealing with painting styles that produce ragged edges, enclose the picture with a mount for a neater effect.

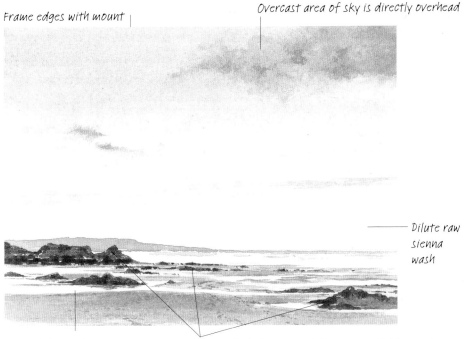

Frame edges with mount

Overcast area of sky is directly overhead

Dilute raw sienna wash

Water left as white paper

Paint dark foreground shapes over lighter washes

Trees and Foliage

Basic Brushstrokes

These exercises are designed to help you achieve a variety of brushstrokes that will enable you to depict different types of foliage and bark textures.

Creating a foliage mass

This shows you how to start a foliage mass, individual leaves and textured bark. Hold the brush vertically for this exercise.

Mix colours together to make green for foliage

Hookers green *Bright red*

Load brush with plenty of watery paint of rich colour

Place blob of paint on paper and push upwards using tip of brush

Directional leaf exercise

Hold the brush in a normal writing position for this exercise, but be prepared to vary the angle as you place individual strokes.

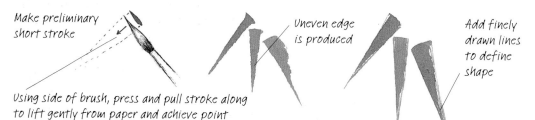

Make preliminary short stroke

Uneven edge is produced

Add finely drawn lines to define shape

Using side of brush, press and pull stroke along to lift gently from paper and achieve point

Bark effect exercises

The brush position varies for this exercise, using the positions shown above and combining them with other ones.

Hold brush vertically to start stroke

Angle brush as stroke is brought down

Back to vertical position to complete

Make series of strokes for textured bark effect

Basic bark stroke used horizontally

Repeat and curve to suggest dark delineations around tree trunk

Developing Brushstrokes

These four exercises are developments of the strokes shown opposite. Practise varying the pressure upon your brush and the angles at which you work, and you will quickly learn to achieve impressions of individual leaves and masses of foliage against tree barks.

Foliage mass for distant trees and bushes

An extension of the 'blob and push' exercise shown opposite, this exercise shows you how you can depict branches by pulling down individual strokes from a blob of paint.

Pull down individual strokes for branches

Make repetitive downward strokes for grass in front of low shrub

Bark

This extension of the textured bark effect opposite shows how you can create bark patterns on various trees, using shadow lines and shadow shapes. Use textured paper.

Establish basic texture with strokes demonstrated opposite

Draw with brush over raised areas and fill in tonal shapes to create pattern

Long-angled leaves

This is an extension of the directional leaf exercise shown opposite.

Paint negative shapes seen between leaves

Paint additional leaves in darker tones

Creating light veins

More extensions of the directional leaf exercise opposite, the second of these combines pencil and watercolour work.

Make single curved travelling stroke

Repeat strokes alongside, leaving white paper between

Draw centre vein and side veins in pencil.

Paint between pencilled veins, allow to dry and erase pencil

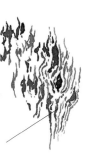

Add darker tones near central vein and at edge of leaf to create impression of highlight area

Distant Trees: Typical Problems

Distant trees often present a variety of problems for beginners as they try to depict massed foliage, individual branches and trunks of varying thickness. The latter, seen at a distance, may not be clearly visible and need to be understated rather than painted heavily. Remember that the colours of the leaves and trunks may not be as obvious when viewed from a distance as they are when placed in the middle ground or foreground.

1 *Interpreted as scribble of paint. Too narrow at base.*
2 *Diagonally applied strokes with no regard for form. Branches do not join trunk.*
3 *'Square' blob. Base too wide for narrow trunk.*
4 *Unrelated blobs of paint. Lacking in structure.*

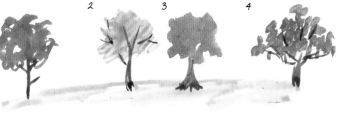

Sketchbook drawings

Use your sketchbook and make preliminary drawings to experiment with composition. In this drawing we see the view through an open-ing between bushes or hedgerows – almost as if the composition has a natural frame, that can be used in a painting.

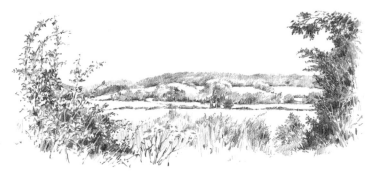

Open landscape

Although there is an indication in the fore-ground that we may be observing the distant view through sparse foliage, the composition is not contained and appears to stretch away without hindrance on either side, in contrast to the 'frame' in the drawing above.

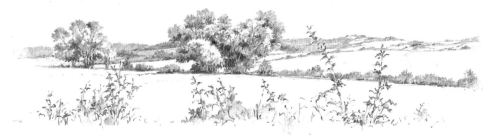

Solutions

Wet into wet

This technique uses the dampness of the paper surface to spread the first application of pigment. Make sure that you allow this to spread and dry enough to be able to control the later washes.

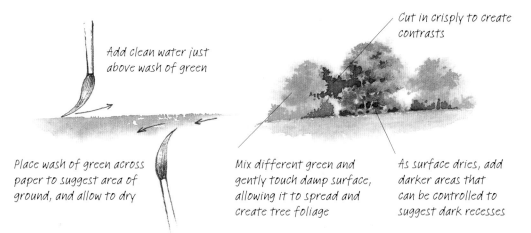

Add clean water just above wash of green

Cut in crisply to create contrasts

Place wash of green across paper to suggest area of ground, and allow to dry

Mix different green and gently touch damp surface, allowing it to spread and create tree foliage

As surface dries, add darker areas that can be controlled to suggest dark recesses

Blotting off

Taking up pigment and water with absorbent paper gives you a light base on which to drop in darker colours to produce a convincing impression of light and shade.

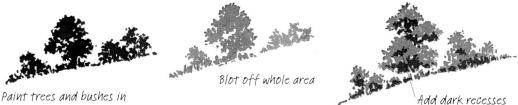

Paint trees and bushes in silhouette using dark, watery green

Blot off whole area

Add dark recesses and shadow areas

Building washes

After experimenting with the first two methods above you may feel more confident to tackle the method of building washes, one upon the other, allowing each to dry before the next is applied. This method can also incorporate the other two by blotting off in some areas if you feel this to be necessary, and by allowing some 'bleeding' of the paint (wet into wet).

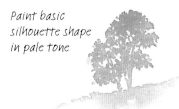

Paint basic silhouette shape in pale tone

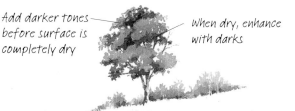

Add darker tones before surface is completely dry

When dry, enhance with darks

Masses of Foliage: Typical Problems

When painting masses of foliage, remember that you are not only trying to depict the prominent and obvious masses in the foreground but also those between and behind these masses. One of the most common problems experienced by beginners is of how to give the impression of density – too much white paper is often exposed, almost like a halo around some images. There are also problems with repetition – leaves in a mass are often placed one after the other, at identical angles and in a formal, unnatural arrangement – and lacking structure, where leaves do not appear to be anchored in any way. These problems may be seen in the painting below.

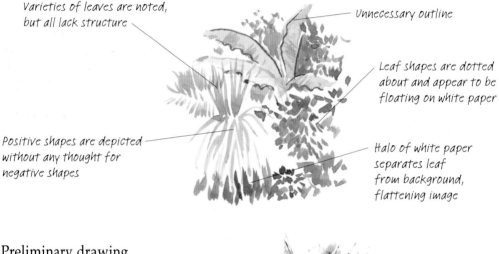

Varieties of leaves are noted, but all lack structure

Unnecessary outline

Leaf shapes are dotted about and appear to be floating on white paper

Positive shapes are depicted without any thought for negative shapes

Halo of white paper separates leaf from background, flattening image

Preliminary drawing

When observing a mass of foliage where different varieties are growing side by side, it is a good idea to concentrate on the largest, most obvious one first. Establish this then work away from the main mass, taking care to use any negative shapes between the leaves to place the leaves in correct relationship to each other. Note the amount of white paper – representing leaf shapes – that has been used in this study.

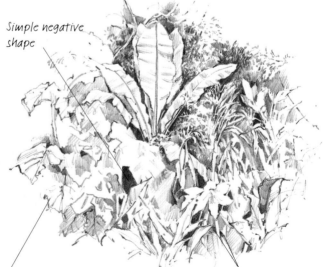

Simple negative shape

Start with loose drawing, tightening as you define shapes

Look for small negative shapes either side of stem

Solutions

Establishing the negative shapes

From closely observing where darker tones for the negative shapes between leaves and masses are depicted in the drawing, you will be able to create a medium-toned arrangement of these shapes. Practise a little study of one section to help you understand how this process works.

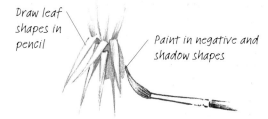

Draw leaf shapes in pencil

Paint in negative and shadow shapes

Developing the painting

The left-hand side of this study shows the 'undercoat' upon which the top layers are built. This comprises a series of negatives of various shapes and sizes, all in the same medium tone. Make sure that you colour-match the greens before you start painting, rather than midway through, as you are unlikely to make a match in the later stages.

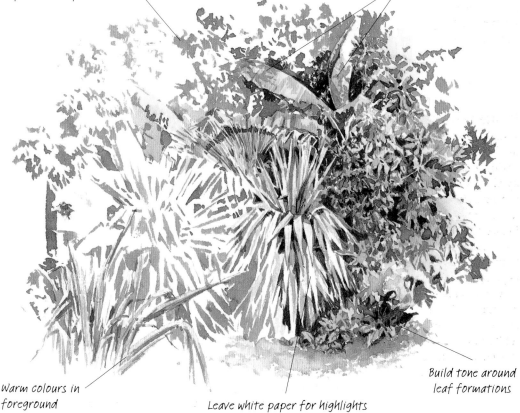

Paint in negative shapes, allow to dry and erase pencil marks

Paint in cast shadows

Warm colours in foreground

Leave white paper for highlights

Build tone around leaf formations

Individual Trees: Typical Problems

Beginners sometimes experience problems when trying to depict the structure of a single tree, especially when large areas of trunk and branches may be partially hidden by foliage masses. The structure then appears disjointed. Another problem is that of 'anchoring' the structure – the base of the trunk may be depicted as far too wide to give the correct proportions, or too narrow to support the structure above. Problems with treatment of the foliage occur when little thought is given to the direction of growth, resulting in a random placing of blobs of paint that do not represent leaves.

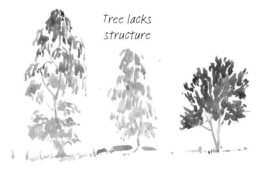

Tree lacks structure

Trailing leaves depicted with squiggle, not regarded as a mass

Foliage represented by blobs of paint

Using drawings to analyse problems

When you look at a painting and realise that something is wrong with the way that you have interpreted the subject, try to analyse the problem. Look at the edges of the tree silhouette and draw these as a flat pattern to start, then look within the mass and try to work out which areas appear light and which

dark. Study the structure and leaf formations and determine the basic shape (silhouette) and growth pattern to familiarize yourself with the subject before starting to draw and paint.

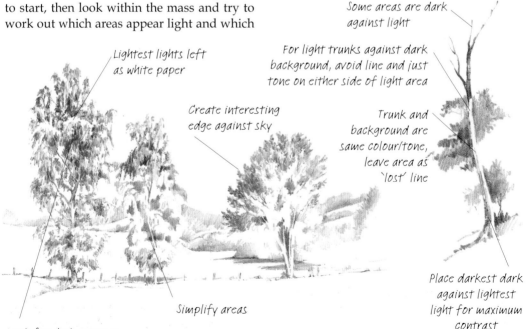

Lightest lights left as white paper

Create interesting edge against sky

Some areas are dark against light

For light trunks against dark background, avoid line and just tone on either side of light area

Trunk and background are same colour/tone, leave area as 'lost' line

Place darkest dark against lightest light for maximum contrast

Simplify areas

Look for dark recesses

Solutions

Working diagrammatically

You will be well on the way to solving many of your tree painting problems if you approach some of your drawings in a diagrammatic way, and when you start painting, do so in stages, as this will enable you to be in control every step of the way. Remember that drawing in a 'painterly' way and painting in watercolour are very similar in approach.

You need to use the white paper as part of the drawing/painting, so plan in advance which areas you intend to leave white or as light tones.

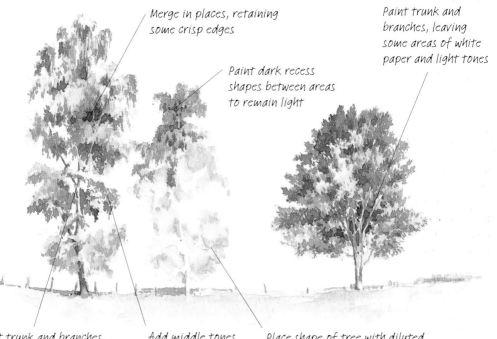

Merge in places, retaining some crisp edges

Paint dark recess shapes between areas to remain light

Paint trunk and branches, leaving some areas of white paper and light tones

Paint trunk and branches, leaving some areas of white paper and light tones

Add middle tones between darks and lights

Place shape of tree with diluted pigment, leaving white paper where sky and trunk show

Basic stages

Here, the method shown above is simplified to two basic stages. Look at a tree with a similar foliage mass silhouette to the first study and close your eyes a little, trying to see where dark masses show within the shape, as in the second study. The pale wash areas represent leaf masses touched by sunlight, and the dark shapes represent masses within shadow areas.

Paint first pale colour as silhouette block, and allow to dry

Paint in dark recesses and shadow areas

Leaf Shapes and Textures: Typical Problems

Whether you want to paint in a free or tight, detailed style, what can help achieve a feeling of confidence is the ability to create detailed impressions – you can always loosen up later. It is through a detailed approach that you can learn to really look at subjects and be fully aware of their unique structure and form. Because drawing and painting are so closely related, this spread shows how to combine the two within one study. In the same way,

you can combine watercolour pencils with watercolour for this way of working.

Fine foliage detail

One of the problems experienced by beginners with regard to detailed interpretations is that they may be too heavy-handed and this is not helped by the fact that often the pencil used is not sharp enough, or the brush does not have a sharp enough point for delicacy.

Colour applied evenly with no consideration for shadow areas

Light area depicting vein is too wide

No suggestion of other leaves in background

Variety of greens used, rather than tonal variety of specific greens

Drawing into paint

This illustration shows leaves in relation to fruit, contrasting the busy interpretation of the leaves with the simple, smooth surface that is found on apples.

You can see pencilwork on its own and areas of pure paint, but it is also interesting to carry one into the other and draw over your watercolour to add fine detail.

Pencil and watercolour

Erase initial pencil drawing after first colour washes are in place

Cast shadows help define form

Delicate hue of sky provides unobtrusive background

Warmer colours where leaf damage has occurred

Leaf in shadow provides interesting shadow shape to simplify area

Solutions

Complementary combinations

This study combines watercolour pencil and watercolour, with the former dissolving into the latter and becoming lost as the watercolour washes take over. For this type of detailed work, a smoother surface paper is more suitable than some of the textured or rough varieties.

Draw leaves and twigs using watercolour pencils

Fill in `shapes between' with watercolour wash

Paint first light colour wash on leaves

Drybrush for textured effect

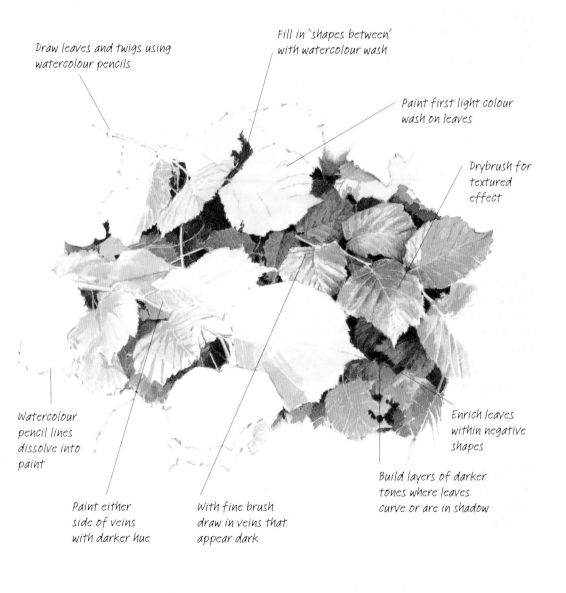

Watercolour pencil lines dissolve into paint

Enrich leaves within negative shapes

Paint either side of veins with darker hue

With fine brush draw in veins that appear dark

Build layers of darker tones where leaves curve or are in shadow

Bark Texture: Typical Problems

The two obvious basic directions for bark texture – horizontal around the form, and vertical marks – have numerous variations (depending on the tree species) and can also play host to other textures. When painting light trunks it is a common beginner's mistake to draw outlines on both sides of the trunk. This, with horizontal strokes between edges, often results in a flat-pattern effect. The interesting contrasts of rough bark texture against smoother surfaced growths within a recess, provide opportunities for the inclusion of rich darks, resulting in full use of the tonal scale. One beginner's problem is how to use tones to full advantage – and an abundance of white paper, with a few dark blocks and squiggles, can be the result.

Dark recess shapes not included

Bark pattern does not follow form of trunk

Shadow area placed without regard to contours of trunk

Darks appear as superficial marks rather than shadow areas

Put your thoughts on paper

It is helpful to approach these problems diagrammatically, by putting your thoughts on paper. For example, if you look at an area of tree bark directly in front of you and determine which texture line is exactly horizontal (on your eye level), you will notice that when you raise your eyes slightly (above your eye level) the bark texture lines curve downwards. Alternatively, when you lower your gaze they sweep upwards. This observation can be drawn onto the paper as an arrow or, as below right, a series of arrows.

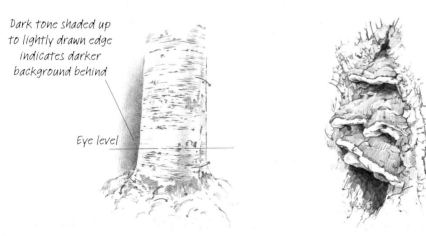

Dark tone shaded up to lightly drawn edge indicates darker background behind

Eye level

Thought arrows show directions in which to apply tone to follow form

Solutions

Contrasting bark textures

Here, a detailed, botanical-style illustration – where precision is of great importance – is contrasted with a looser style, used to depict a rough-textured bark with fungal growths.

This detailed style of drawing and painting encourages close observation and is best used to make precise marks depicting a species that should not be mistaken for another.

Note curve of bark texture above eye level

Indicate subtle shadows with swift downward brushstrokes

Texture of bark follows form of root

Note horizontal texture line at eye level

Pull down brushstrokes to encourage feel of direction

Sweep pigment mixed with plenty of water across areas of lichen growth

Using a loose approach

Rough-textured bark with interesting fungal growths can be depicted with a loose style of painting. This does not mean that it should be any less carefully observed, however, rather that observation should take in the fact that this surface possesses deep recesses with growths coming towards us.

Establish the darker recess, and the areas that are to remain as white paper, by painting around the shapes in medium tone. Slowly build up the intensity of tone and colour, wash upon wash, enhancing the fine details by enriching tonal contrasts (darkening the darks against much lighter areas) and drawing shadow lines with the brush.

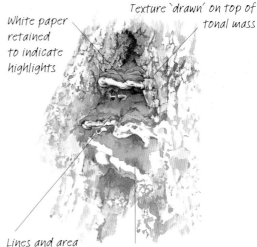

White paper retained to indicate highlights

Texture 'drawn' on top of tonal mass

Lines and area of tone follow form

Blending wet into wet

Flowers

Basic Brushstrokes

These exercises are designed to help you place leaf, petal and stem strokes with confidence – whether on detailed specimens or in a freely painted group. On this page the basic strokes in isolation are shown, and on the opposite page, you can see how they can be developed within a painting.

Mix and match

Mix the three primary colours in different proportions to achieve a variety of subtle colours and neutral hues.

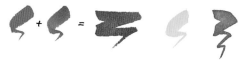

One-stroke shape

This is the basic 'touch, press as you travel, lift and twist' stroke seen on page 144. The first stroke is upwards, the second downwards.

Touch tip of brush vertical to paper and angle end away from you

Pigment accumulates at end of stroke away from starting point

In normal painting position, place brush tip on paper and pull stroke down towards you

Short, curved strokes

A series of curved strokes, indicated by arrows, follows one after the other. Load the brush with plenty of water and pigment.

With brush position a little more vertical than normal, describe strokes using directional application

Positive and negative silhouettes

Use the normal painting position for these three exercises.

Touch tip of brush placed vertical to paper and angle end away from you

One stroke 'press and lift' line

Use a standard working position to make a 'touch/ travel, press to expand, then lift' stroke.

Place another stroke below, leaving thin strip of untouched paper between

Draw around similar shape using very fluid pigment

While still wet, add clean water to blend pigment away from original outline

Developing Brushstrokes

These four exercise variations are developments of the brushstrokes shown opposite. All were painted on a Rough-surface paper, upon which you should be able to achieve fine lines if you use a good-quality brush that enables you to work with a fine point.

Leafy stem
This is an extension of the 'touch, press as you travel and twist as you lift' stroke.

Fine pattern lines can be carefully superimposed over basic shape when dry

One-stroke blending
This is an extension of the one-stroke 'press and lift' exercise. Note that a darker hue has been touched against a still wet area to produce a darker blended area.

Add clean water for pale colour blending

Mass of petals
This is an extension of the short, curved strokes exercise opposite. Remember the basic flower shape as you work.

Work quickly, placing strokes in directional way

Retain some white paper within stroke for this effect

Basic backgrounds
This is an extension of the positive and negative silhouettes exercise.

Leave white paper to intrude at base of leaf shape for edges of flower petals

Add shapes to suggest foliage/stems once blended area has dried

Solid silhouette shapes can be helpful for certain effects

Flower image to be painted here

Paint negative shapes only and blend away edges with clean water

Simple Shapes: Typical Problems

The strong delicacy of lilies, where crisp crinkled edges of tapering petals can be clearly seen against the rich dark leaf shapes, provides a contrast to the more fragile rose on page 190.

Here, simple trumpet shapes burst open to display their array of stamen around the central pistil, but it is this very arrangement that can prove to be problematic for beginners.

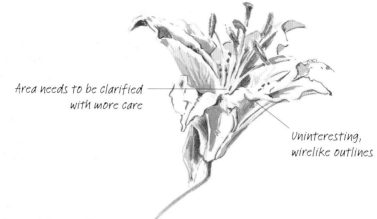

Area needs to be clarified with more care

Uninteresting, wirelike outlines

Beginning with a bud

This detailed drawing of a lily bud demonstrates how close observation can teach you much about structure and relationships. By drawing a single bud first you can begin to understand how the petals eventually open up to reveal the glory within.

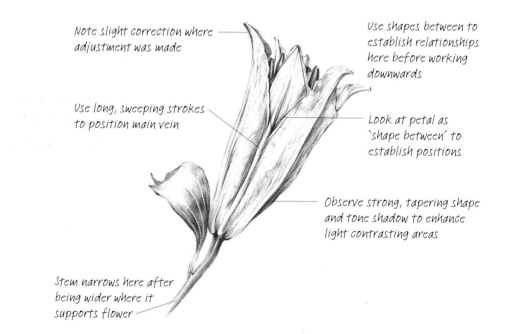

Note slight correction where adjustment was made

Use shapes between to establish relationships here before working downwards

Use long, sweeping strokes to position main vein

Look at petal as 'shape between' to establish positions

Observe strong, tapering shape and tone shadow to enhance light contrasting areas

Stem narrows here after being wider where it supports flower

Solutions

From drawing to painting

The main shapes in this study were drawn in both graphite and watercolour pencils on a Rough-surface paper before watercolour was added. The combination works well and enhances blending techniques.

Note that the lower area demonstrates the first stages of the painting, where more emphasis is placed upon the background (negative) shapes to provide form to the lighter flowers.

Tiny negative (shadow) shapes on either side of stem automatically place bud or leaf in correct position

Note scale of stamens in relation to petals

Important negative shapes place two sets of flower heads correctly in relation to each other

Central components 'burst out' like fireworks

'Cut in' crisply with neutral background colour to bring white petal images forward

More Complex Shapes: Typical Problems

Delicate flowers can be painted in a free style, but they will still rely on close observation and drawing ability if your paintings are to be convincing. When painting pale colours, beginners often resort to outlining petals or placing contrasting colours behind the image.

Both of these methods are acceptable when they are used correctly, but they need to be applied carefully. In the painting below, the artist has been rather heavy-handed for such a delicate subject – a miniature rose with fine, detailed leaves and petals.

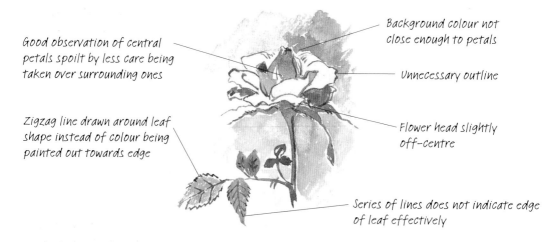

Good observation of central petals spoilt by less care being taken over surrounding ones

Zigzag line drawn around leaf shape instead of colour being painted out towards edge

Background colour not close enough to petals

Unnecessary outline

Flower head slightly off-centre

Series of lines does not indicate edge of leaf effectively

Diagrammatic drawing

This sketch of a rose is not intended as a finished drawing but rather as a finding-out exercise. The lines around the edges have been enhanced more than usual, to help you understand the shapes and reinforce your knowledge prior to painting.

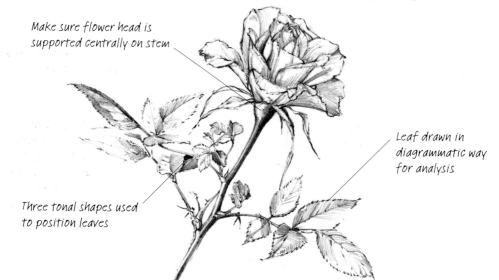

Make sure flower head is supported centrally on stem

Three tonal shapes used to position leaves

Leaf drawn in diagrammatic way for analysis

Solutions

Colour and form

Saunders Waterford 300gsm (140lb) Not paper was used for this subject, as it encourages free application while allowing fine detail to be achieved. In addition, gentle blending of background colours, that 'cut in' to describe the form, can help you to capture the essence of a rose.

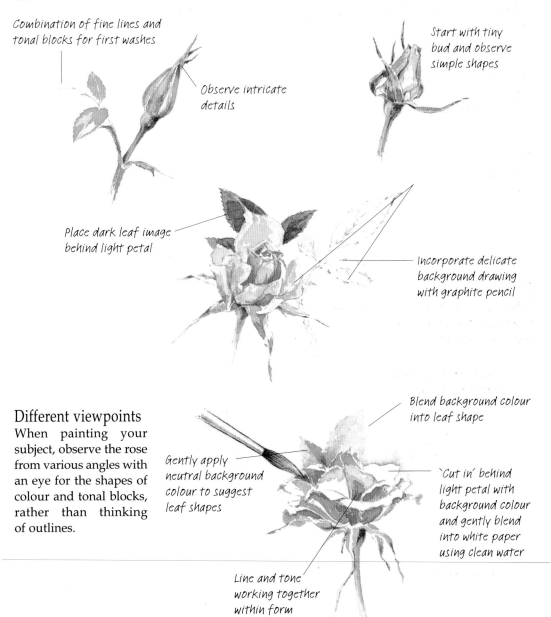

Combination of fine lines and tonal blocks for first washes

Observe intricate details

Start with tiny bud and observe simple shapes

Place dark leaf image behind light petal

Incorporate delicate background drawing with graphite pencil

Different viewpoints

When painting your subject, observe the rose from various angles with an eye for the shapes of colour and tonal blocks, rather than thinking of outlines.

Gently apply neutral background colour to suggest leaf shapes

Blend background colour into leaf shape

'Cut in' behind light petal with background colour and gently blend into white paper using clean water

Line and tone working together within form

Palm and Bamboo Types: Typical Problems

The smooth surface of long, tapered leaves, particularly those of palms or bamboo types, comes as a contrast to the freely applied brushstrokes on the previous pages. Tradescantia leaves, although shorter, require similar treatment – long, sweeping brushstrokes from tip to base or vice versa. The studies on this page have been treated in a tighter, more controlled way, as it is the long slender lines that are important.

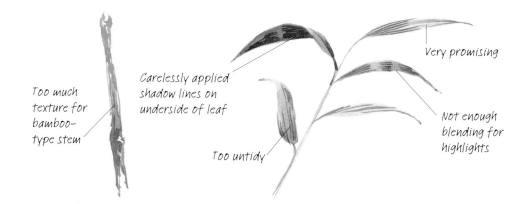

Too much texture for bamboo-type stem

Carelessly applied shadow lines on underside of leaf

Too untidy

Very promising

Not enough blending for highlights

Varied pressure drawing

Random, long leaf exercises give you the opportunity to practise 'press and lift' strokes with your pencil prior to starting brushstroke work, helping you learn how to create highlights.

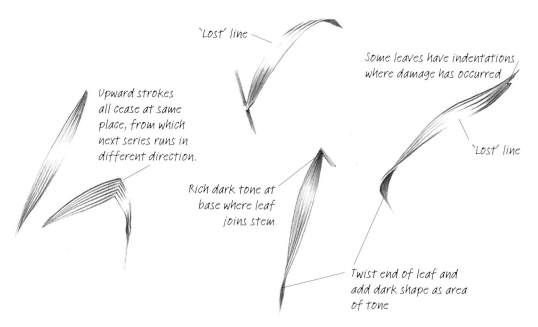

'Lost' line

Some leaves have indentations where damage has occurred

Upward strokes all cease at same place, from which next series runs in different direction.

'Lost' line

Rich dark tone at base where leaf joins stem

Twist end of leaf and add dark shape as area of tone

Solutions

Lines on leaves

Tinted Bockingford paper is ideal for the basic sweeping strokes and thin lines of pattern in the leaves' surface – the paint flows on easily for the wider leaf shape, yet narrow lines can be just as successfully achieved upon this versatile surface, using a fine brush for the delicate points on long, tapering leaves. The surface of this paper also responds well to blending and, because it is tinted, background washes merge successfully into the tint.

Yellow underpainting

Lightly draw basic leaf shape in pencil before applying first colour wash

Paint small leaves using one-stroke method (see p. 20)

Building around negatives
This little study of dense foliage started with the depiction of one negative shape, and the surrounding leaves were then related to this shape. You can work outwards in this way, observing the way leaves overlap and creating more negatives on the way

Draw second shape positive

Dark behind light form

Leave area of tinted paper for highlight

Stem and offshoots
The one-stroke `press and lift' line and blending exercises at the beginning of this theme can help you achieve the smooth effect required to depict bamboo stem

Leave tinted paper untouched

First negative shape, with different tones within it

Bouquets: Typical Problems

A floral bouquet supplies a profusion of brightly coloured flower heads set against rich greenery. Light forms are thrown forward, creating crisp contrasts that rely upon a juxtaposition of interesting shapes to create the composition, and masses of stems and leaves behind the main flower heads provide contrasts of colour, tone and form. Beginners are often unsure how to depict this greenery, as well as the intricate petals of the blooms.

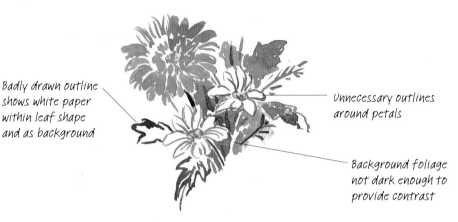

Badly drawn outline shows white paper within leaf shape and as background

Unnecessary outlines around petals

Background foliage not dark enough to provide contrast

Drawing the details

It is a good idea to familiarize yourself with the structure of the flower heads – this can be achieved by drawing details in order to analyse the forms. You can choose to draw the individual leaves and petals, or one or two in relation to each other.

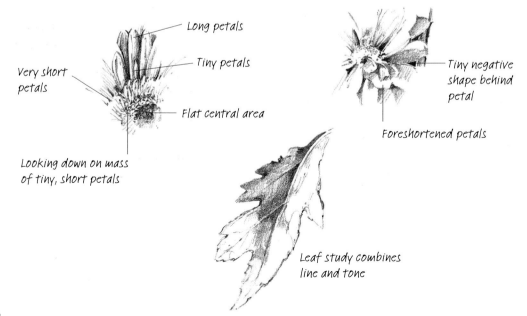

Long petals

Tiny petals

Very short petals

Flat central area

Looking down on mass of tiny, short petals

Tiny negative shape behind petal

Foreshortened petals

Leaf study combines line and tone

Solutions

Working from within

An exercise that encourages close observation is that of working from within a group of flowers, rather than arranging the composition as shapes around a central area or drawing them at random. Start with a single flower head and relate another to it. Add dark leaves and shadow shapes behind, and continue to work outwards and away from the initial shapes. Saunders Waterford 300gsm (140lb) Not paper is ideal for this gentle blending technique.

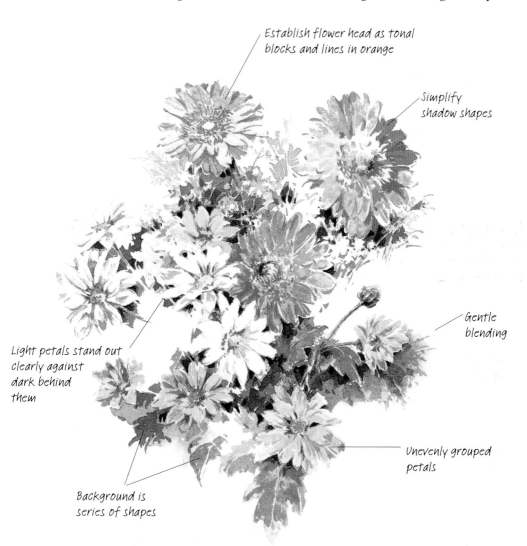

Establish flower head as tonal blocks and lines in orange

Simplify shadow shapes

Gentle blending

Light petals stand out clearly against dark behind them

Unevenly grouped petals

Background is series of shapes

Garden Scenes: Typical Problems and Solutions

A garden scene, with flowers and foliage creating a 'busy' painting, can benefit from the introduction of animal life. However, having decided to introduce an animal, some beginners then face the problem of where to place it and what colour to paint it. It is also important to consider both the composition of the painting and how to make the animal clearly visible amongst the foliage. These problems have arisen in the painting below, where the grey tabby cat is 'lost' and not an obvious focal point as intended.

Grey of tabby and stone wall are of similar, undifferentiated hue

Shutter, cat and edge of wall all appear in line and cut picture in two

All foliage similar and appears disjointed

Considering the cat

By changing the animal's stance within the composition you can break the line from the shutter downwards. You can also increase the shadow area behind the cat to bring its form forwards.

Include more intense shadow shapes to create strong background

Leave part of cat as white fur to simplify and make form more obvious

Draw in painterly way, with random directional marks suggesting background

Solutions

Improving the pictorial composition

You can make amendments throughout the picture, but often just one or two small changes can make all the difference. Here, deciding to change the cat's colour to ginger and white, added to its new, animated and therefore more lively position, immediately improves both the composition and clarity of the painting.

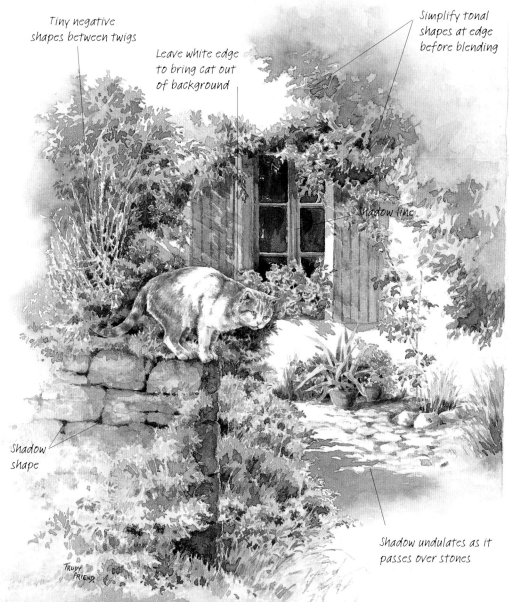

Tiny negative shapes between twigs

Leave white edge to bring cat out of background

Simplify tonal shapes at edge before blending

Shadow line

Shadow shape

Shadow undulates as it passes over stones

TRUDY FRIEND.

Fruit and Vegetables

Basic Brushstrokes

The following exercises will help you to create textured effects for fruit and vegetables, with repetitive strokes for close texture and sweeping strokes for smoother surfaces.

When used on a Rough-surface paper, some sweep and curve strokes automatically leave areas of white paper that suggest highlights, such as on the surfaces of citrus fruits.

'On your toes' painting position

This stroke pushes paint outwards unevenly and is good for depicting the uneven, rough texture of citrus fruit skins.

Make uneven blob and push paint outwards, using texture of paper as guide

Warm red Green

Mix to create versatile colour

Add water to edges to blend and place tiny dots for indentations before blended area has fully dried

Place, sweep and curve stroke

This stroke, with the brush held at less of an angle, is suitable for depicting curved surfaces where shadow sides and highlights are required, for example on root vegetables such as carrots and parsnips. Note that some areas are solid colour, with white paper cutting in. White (highlight) areas have contour lines drawn with a brush.

Make basic stroke following direction of arrow

Repeat stroke along form

Standard writing position

This looped stroke is suitable for depicting the fleshy, teardrop-shaped components of citrus fruit segments.

Make stroke following direction of arrow

Repeat and mass for citrus fruit segments

Repeat, flattening strokes, to suggest inside surface of pepper

Developing Brushstrokes

Here, you can see how the brushstrokes shown opposite have been developed and adapted to create the textures used in the fruit and vegetable theme overleaf.

Always study your subject closely before starting to paint, as in this way you will establish brushstroke direction by following form and texture.

Citrus fruit skin
The curved surface of citrus fruit requires areas of highlight and shadow to give the impression of a three-dimensional form. This is an extension of the 'on your toes' exercise opposite. The edge of the fruit has been added, as well as the position of the highlights and blending to dot in recesses.

Leave white paper for highlights

Add dots for indentations

Highlights on internal segments
These repetitive, looped strokes form a mass to represent areas of highlight and shadow on a cut, flat surface or side of a separated citrus segment, as well as the internal texture of a pepper. This is a more delicate interpretation of the place, sweep and curve stroke, and can be tightly looped.

Draw fine lines rather than wide strokes

Add clean water to blend in places

Carrots and other root vegetables
The main texture of these vegetables can be created easily within the sweep of the brushstrokes as they travel down the form, where white paper shows through pigment in places. This is an extension of the place, sweep and curve stroke.

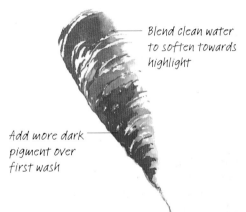

Blend clean water to soften towards highlight

Add more dark pigment over first wash

Texture inside casing
The inside casing of certain fruits, vegetables and in many cases nuts can receive the same treatment as demonstrated in the pepper example below. This is another adaptation of the basic looped stroke.

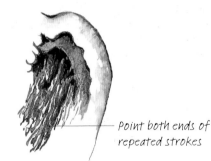

Point both ends of repeated strokes

Cross-Sections: Typical Problems

A solution to many drawing and painting problems is to develop a deeper understanding and knowledge of your subject. For example, when observing the outer casing of a fruit or vegetable, it is sometimes difficult to imagine what lies within. Discovery leads to enlightenment, and you can build up self-confidence by drawing and painting cross-sections – these will present you with exciting, and sometimes surprising, patterns and textures.

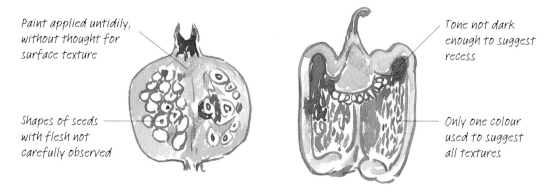

Paint applied untidily, without thought for surface texture

Shapes of seeds with flesh not carefully observed

Tone not dark enough to suggest recess

Only one colour used to suggest all textures

Drawing the details

First draw a segment of a vegetable or fruit – such as the pomegranate on the left or the bell pepper (capsicum) on the right – and then note how the seeds are contained.

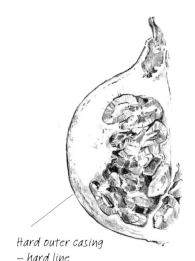

Hard outer casing – hard line

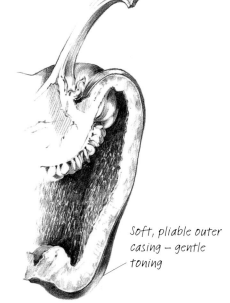

Soft, pliable outer casing – gentle toning

Solutions

Pattern with texture – pomegranate

Be guided by weight before cutting fruit in half. The solid feel of a pomegranate will suggest the contents – numerous seeds encased by flesh. The individual shapes are dictated by the close proximity of the neighbouring ones, making interesting patterns and textures. Note how the two halves of this cross-section are different in content and arrangement.

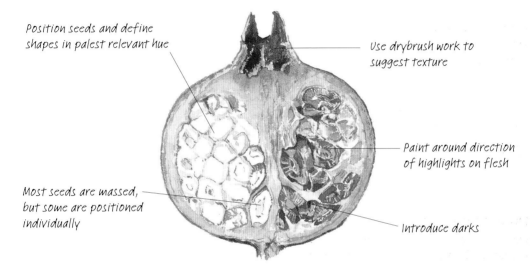

Position seeds and define shapes in palest relevant hue

Use drybrush work to suggest texture

Paint around direction of highlights on flesh

Most seeds are massed, but some are positioned individually

Introduce darks

Bell pepper

The lighter weight of a bell pepper suggests a hollow interior. The uniformly shaped seeds cling to the fleshy area at the base of the stem and are surrounded by space.

Use dark areas to enhance clarity and shape of seeds

Make up textured area by building up 'dry' tonal washes

Rough-surfaced paper plays important part in creating white highlights

Pull and curve brushstrokes to follow form

Three Dimensions: Typical Problems

As the images shown below demonstrate, the most common problem encountered by beginners in drawing and painting fruit and vegetables is creating something that looks three-dimensional. Although you are inevitably working with a limited palette, you also need to be sure you look for subtle colour variations to achieve a realistic rendition.

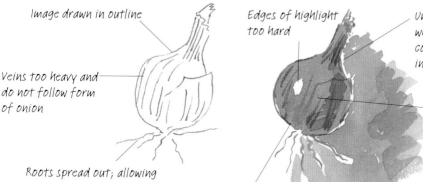

Image drawn in outline

Veins too heavy and do not follow form of onion

Roots spread out; allowing strands to overlap would look more natural

Edges of highlight too hard

Unintentional halo of white – background colour should 'tuck in' more closely

Flat colour would benefit from subtle blending

Veins have 'bled' because paint was applied before underlying wash had dried

Subtly drawn three-dimensional forms

Look at this drawing to see how some of the problems shown above have been rectified.

Negative shape between three objects allows you to place each one correctly in relation to others

Softened highlights and tonal variations create three-dimensional image

Contrast busy area with one that 'rests the eye'

Draw roots as light images against dark and dark against light background

Make use of shadows cast across area of background

Shadows follow form upon which they are cast

Solutions

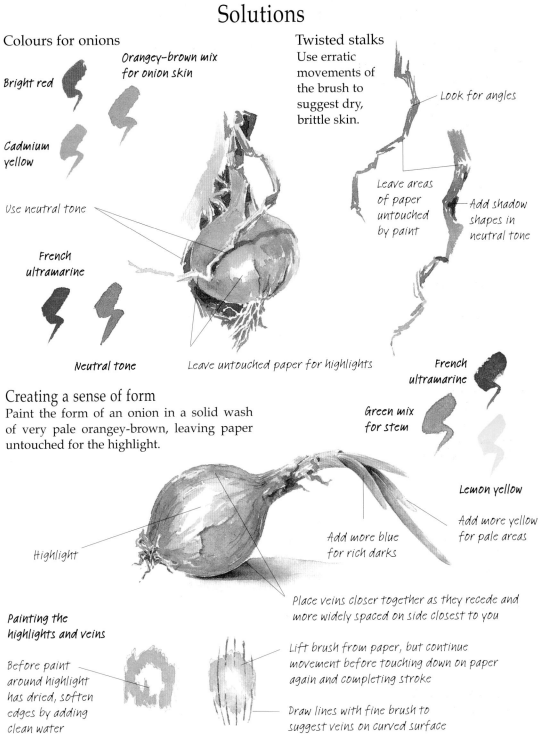

Colours for onions

Bright red

Orangey-brown mix
for onion skin

Cadmium
yellow

Use neutral tone

French
ultramarine

Neutral tone

Leave untouched paper for highlights

Twisted stalks

Use erratic
movements of
the brush to
suggest dry,
brittle skin.

Look for angles

Leave areas
of paper
untouched
by paint

Add shadow
shapes in
neutral tone

French
ultramarine

Green mix
for stem

Creating a sense of form

Paint the form of an onion in a solid wash
of very pale orangey-brown, leaving paper
untouched for the highlight.

Highlight

Add more blue
for rich darks

Lemon yellow

Add more yellow
for pale areas

Place veins closer together as they recede and
more widely spaced on side closest to you

Painting the
highlights and veins

Before paint
around highlight
has dried, soften
edges by adding
clean water

Lift brush from paper, but continue
movement before touching down on paper
again and completing stroke

Draw lines with fine brush to
suggest veins on curved surface

203

Shapes and Textures: Typical Problems

The surface textures of some root vegetables are very similar to others; this occurs with the similarities between a parsnip and a carrot. In these instances, in order to differentiate between the two other than just with colour, you need to be aware of the feel of the vegetable when holding it. Note the bands that curve around the form – their irregularities, indentations and protrusions – as these are the textures you should endeavour to portray.

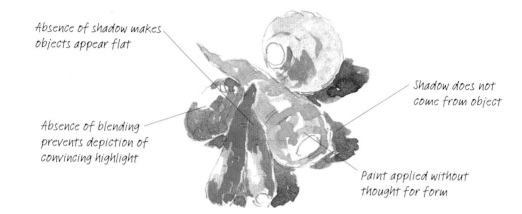

Absence of shadow makes objects appear flat

Absence of blending prevents depiction of convincing highlight

Shadow does not come from object

Paint applied without thought for form

Drawing to observe shape and form

It is important to see and depict the shape and form correctly, as the texture will need to 'follow the form'. Like anything else with drawing, this requires practice.

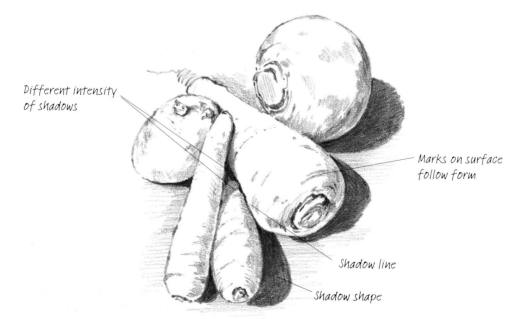

Different intensity of shadows

Marks on surface follow form

Shadow line

Shadow shape

Solutions

Blending textures

Crisp edges, where shadows overlap or cut in behind light forms, provide an interesting contrast to the subtle blending used on the surface of the potato here, and the gentle 'bleeding' required to paint the swede.

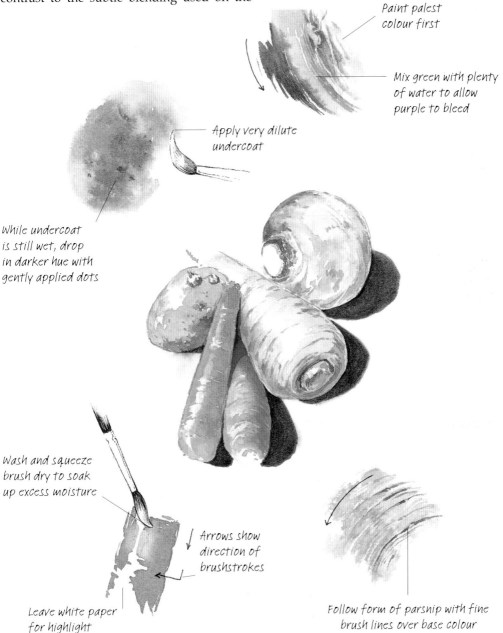

Paint palest colour first

Mix green with plenty of water to allow purple to bleed

Apply very dilute undercoat

While undercoat is still wet, drop in darker hue with gently applied dots

Wash and squeeze brush dry to soak up excess moisture

Arrows show direction of brushstrokes

Leave white paper for highlight

Follow form of parsnip with fine brush lines over base colour

Colour: Typical Problems

The vibrant colours of citrus fruit and contrasting highlights can sometimes prove to be a problem – if the colours are too dull or the highlights are positioned incorrectly, you may end up with a flat, patterned image instead of a three-dimensional impression of form. Where the fruit has been cut and a flat image is required, look closely at the exposed texture, where highlights also play an important part. Keep your colours fresh and unmuddied by limiting the number you use, mixing only one or two together and trying them out on a separate sheet of paper before applying them as translucent washes.

Contrast too marked, and needs subtle blending

Paint applied without sufficient thought for indentations on surface texture

Dark outline unnecessary, as pale pigments easily seen against white paper

No thought given to relationship between each component

Drawing with watercolour pencils

You can remain aware of the colours while working on your drawing by using watercolour pencils, either dry or with water added to solidify the colour.

Using clean water, blend gently into highlights

Note reflected light

Important negative shape relates all segments of study

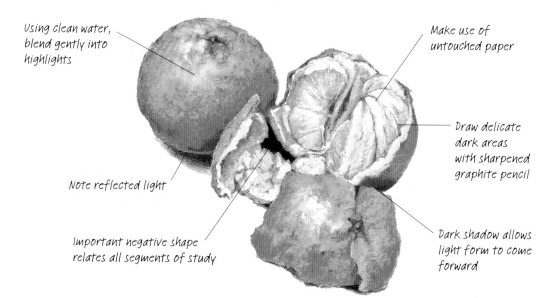

Make use of untouched paper

Draw delicate dark areas with sharpened graphite pencil

Dark shadow allows light form to come forward

Solutions

Single study

Painting a study of a single fruit allows you to concentrate fully on the colour of an individual specimen. The texture on the surface of this lime was achieved by working wet pigment onto a damp surface and allowing it to bleed.

Work around highlight

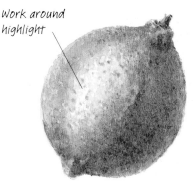

Citrus group

In a group of similar-shaped and coloured citrus fruits, you need to consider perspective and angles in addition to textures.

Apply pale wash over whole segment except highlight

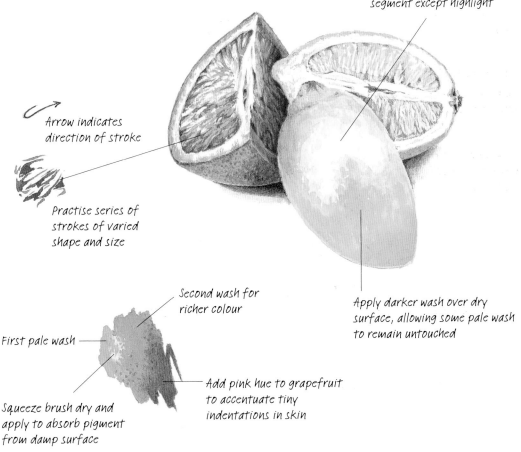

Arrow indicates direction of stroke

Practise series of strokes of varied shape and size

Second wash for richer colour

First pale wash

Apply darker wash over dry surface, allowing some pale wash to remain untouched

Squeeze brush dry and apply to absorb pigment from damp surface

Add pink hue to grapefruit to accentuate tiny indentations in skin

Tones in Monochrome: Problems

When an object lacks colour we have an opportunity to become fully aware of tonal variations. Mushrooms, with their interesting forms and rich contrasts of tone, from surface light to gill recesses, and their rich darks encourage you to consider the tonal scale. Beginners often experience problems with a tonal scale and limit their range of tones to such an extent that the subsequent painting appears dull and uninteresting. They also find it difficult to rely solely on tone to create the forms, and resort to unnecessary and uninteresting wirelike outlines to differentiate one form from another.

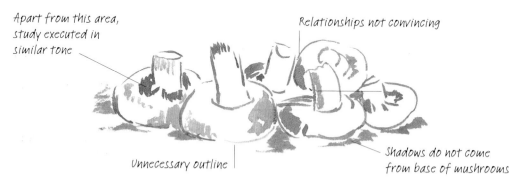

Apart from this area, study executed in similar tone

Relationships not convincing

Unnecessary outline

Shadows do not come from base of mushrooms

Limiting outlines in drawing

Try to use an area of dark tone against a light form without resorting to an outline. Find opportunities to 'lose' these lines.

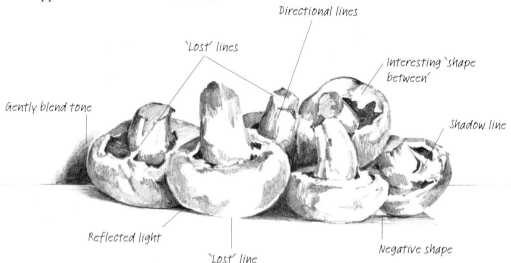

Directional lines

'Lost' lines

Interesting 'shape between'

Gently blend tone

Shadow line

Reflected light

'Lost' line

Negative shape

Solutions

Tonal scale

A good exercise to help understand the tonal scale is to use one colour only – in this example, sepia – diluting the pigment little by little as you paint tonal blocks. In this way you can produce a variety of tones, ranging from intense to weak.

Placing dark behind

Placing a dark tone against a light area produces an exciting tonal contrast. These contrasts are very important within a painting to add interest and bring work to life. Enrich the dark areas (the negative shapes and shadows) to allow untouched white paper (from the other end of the tonal scale) to be used to full advantage and produce strong contrasts.

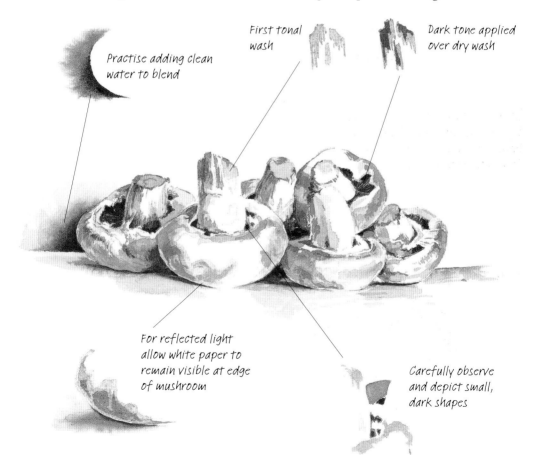

Practise adding clean water to blend

First tonal wash

Dark tone applied over dry wash

For reflected light allow white paper to remain visible at edge of mushroom

Carefully observe and depict small, dark shapes

Animals

Basic Brushstrokes

The following exercises are designed to help you develop an understanding of how to create different textures of animal fur. This page shows the basic brushstrokes in isolation, while the facing page demonstrates how to develop them further in the context of an animal painting.

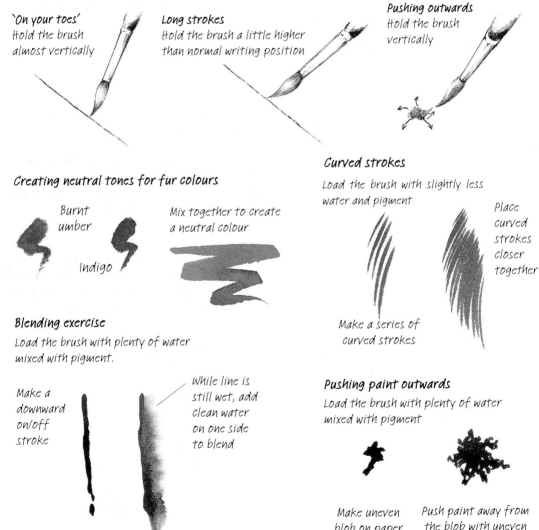

Three painting positions

'On your toes'
Hold the brush almost vertically

Long strokes
Hold the brush a little higher than normal writing position

Pushing outwards
Hold the brush vertically

Curved strokes

Load the brush with slightly less water and pigment

Place curved strokes closer together

Make a series of curved strokes

Creating neutral tones for fur colours

Burnt umber

Indigo

Mix together to create a neutral colour

Blending exercise

Load the brush with plenty of water mixed with pigment.

Make a downward on/off stroke

While line is still wet, add clean water on one side to blend

Pushing paint outwards

Load the brush with plenty of water mixed with pigment

Make uneven blob on paper

Push paint away from the blob with uneven movements

Developing Brushstrokes

These four exercises are developments of the strokes shown opposite. You can very quickly learn how to use them to create the texture of hair or fur. The key to success – which comes with practice – is knowing when to apply clean water to achieve the desired effect.

Glossy, smooth-haired animals
An extension of the blending exercise opposite, this wet-into-wet effect can be used to depict the sheen on an animal's coat.

Make series of joined, angled lines

Where build-up of pigment occurs at angle, add clean water to blend away from line

Leave slight gap of white paper between

'Pull' resulting wash down to run beside lines

Pigment from line spreads across into wash where one touches another

Woolly coats
Push paint outwards, as shown opposite, to develop shapes from a blob – a useful way of depicting woolly-coated animals such as sheep and some breeds of cattle and dogs.

Initial shapes

Lighten tone by adding water so dark areas suggest shadows

Dense hair or fur
An extension of the curved strokes exercise opposite. Paint initial strokes in one direction, for the undercoat. Once dry, add darker tones to suggest long, dense hair or fur.

Join curved strokes together to form a mass

When dry, add further strokes of a different colour or tone to suggest the texture of hair

Highlights
A variation on the curved strokes, showing how to leave white paper untouched to suggest highlights by 'cutting in' with the darker tones. It is suitable for use on tails and manes.

Pull hair strokes in different directions

Cut in with dark tone against light

Introducing Ink: Typical Problems

Pen and ink used with watercolour washes is a popular choice, and it is a good idea to practise this combination using a limited palette rather than a wide range of colours. By doing this you are in a position to control the tonal values, as you will not have too many colours to think about at the same time. One animal that possesses neutral or subtle hues naturally is a pig; place the animal in a setting where the same range of colours may be adapted for the background, and enhance the study in a controlled way with the addition of pen and ink.

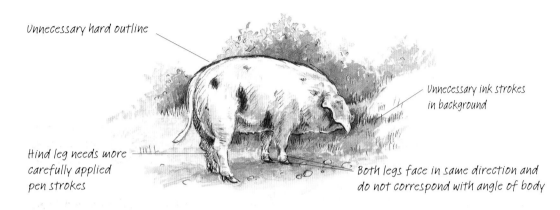

Unnecessary hard outline

Unnecessary ink strokes in background

Hind leg needs more carefully applied pen strokes

Both legs face in same direction and do not correspond with angle of body

From pencil into ink

A preliminary drawing in pencil using guidelines establishes the scale and position of the subject. Draw the same image alongside in ink, omitting your guidelines and positional marks but being careful to achieve the right proportions. You can use a tracing for this.

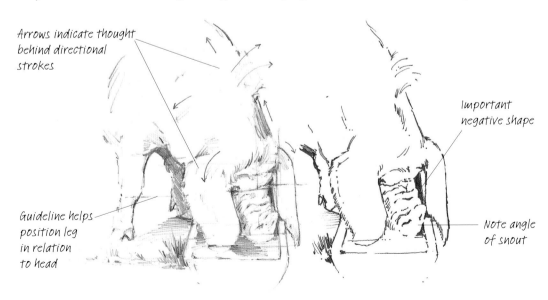

Arrows indicate thought behind directional strokes

Important negative shape

Guideline helps position leg in relation to head

Note angle of snout

Solutions

Working with a limited palette

Before choosing colours for a limited palette, it is a good idea to practise your colour-mixing proportions. By adding a little more of one colour than the other, a monochrome hue can move from the warm range into the cool, and vice versa.

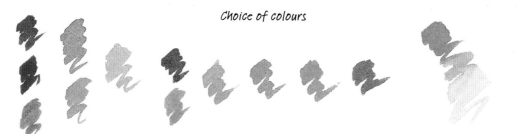

Choice of colours

French ultramarine, Indian red and raw sienna

Ultramarine and raw sienna create a variety of subtle greens

Adding a small amount of Indian red produces a pleasant, neutral hue

Ink over watercolour

Executing a watercolour painting on Rough-surfaced paper enables you to drag your pen lightly across the surface and achieve delicate lines that do not overpower the painting.

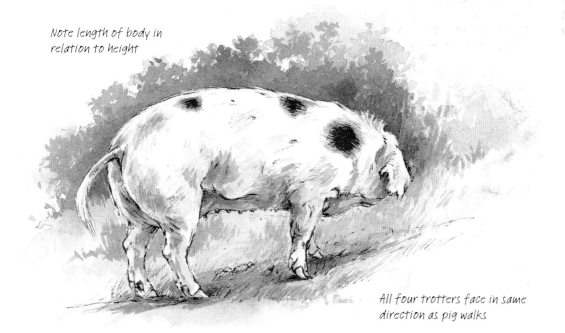

Note length of body in relation to height

All four trotters face in same direction as pig walks

Contexts: Typical Problems

If you do not have the opportunity to observe animals from life, study photographs and watch their movement when they are shown on television. It is very important, when painting animals that spend time outdoors, such as ponies and cattle or sheep, that you include some of the background or context. Very often the contrast between the hair of the animal and the foliage of a landscape, or farm building, can enhance a painting.

Paint application too dry, preventing creation of subtle tones

Pony and background merge together without differentiation

Area of white paper too wide

Preliminary drawing to establish proportions

Include the background in your preliminary drawing, as this will make it easier to ensure that the scale and proportion are correct within the pony. Also, try to take as much care of shadow and negative shapes as you do over the positives. Think of it as a jigsaw – fit one piece into another until the content of the whole drawing is placed correctly.

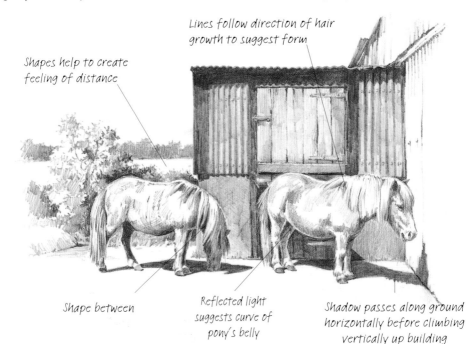

Lines follow direction of hair growth to suggest form

Shapes help to create feeling of distance

Shape between

Reflected light suggests curve of pony's belly

Shadow passes along ground horizontally before climbing vertically up building

Solutions

Placing your subject in context
Clearly differentiate your subject from its background through careful consideration of the tones – light against dark, dark next to light and so on.

Burnt sienna *Raw sienna* *Cobalt* *Cerulean blue*

Dampen the paper, load your brush with a mix of cobalt and cerulean blue, and drop colour onto the surface, leaving some areas white to suggest clouds

Dark washes added to dry initial wash where shadow shapes suggest curve of animal's body

When sky is dry, paint simple silhouette shapes to suggest foliage

Dark foliage behind light edge of tail

Up-and-down movements suggest direction of growth for grass

Shadow shape on far leg makes nearer one stand forward

Fine detail
This study demonstrates how, by building darker tones one upon the other and using delicate, 'directional' brushstrokes, you can create a three-dimensional impression.

Small, but essential, shadow shapes suggest form

Angle of eye neither straight line nor circle

Light tones and areas of white paper suggest highlights

Directional Strokes: Typical Problems

A common problem experienced when painting horned animals is that of how to relate the horn growth to the animal's head. This also applies to the depiction of hooves, whether it be the round hoof of a pony or that of a cloven-footed animal. The most important thing to remember with all of these is the direction involved of both the growth rings on horns and hooves and the hair growth, which itself can cause problems.

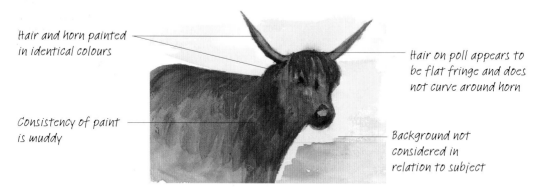

Hair and horn painted in identical colours

Consistency of paint is muddy

Hair on poll appears to be flat fringe and does not curve around horn

Background not considered in relation to subject

Detail studies

Studies of detail may be made in your sketch-book. One method is to stand by an animal and look down at the feet to draw them singly, in relation to a small area of ground.

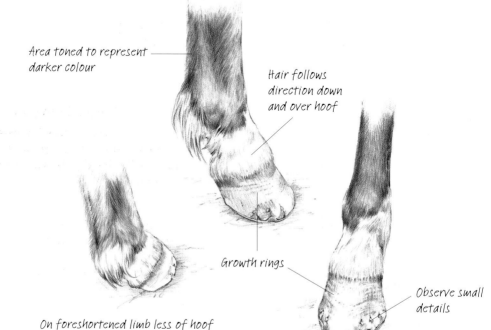

Area toned to represent darker colour

Hair follows direction down and over hoof

Growth rings

Observe small details

On foreshortened limb less of hoof is visible, and shoe cannot be seen

Solutions

Concentrating on hair

For safety reasons, some farm animals are de-horned. In this study there are no horns, so the focus is on hair growth direction over the strong bone structure of the head.

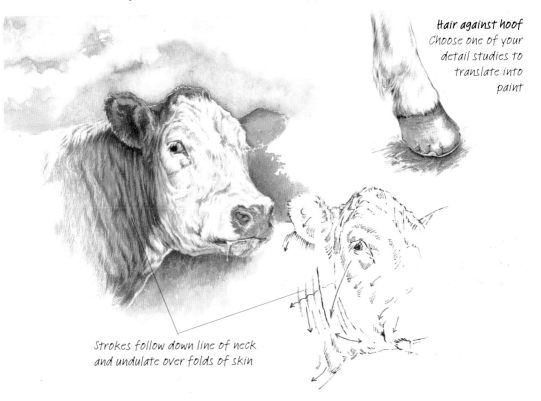

Hair against hoof
Choose one of your detail studies to translate into paint

Strokes follow down line of neck and undulate over folds of skin

Tinted background enhances clarity of image

Disproportionate horn growth

The magnificent curved horns of some varieties of sheep twist and turn, with highlights accentuating the direction.

Working in monochrome enables you to concentrate more on structure of indentations of growth lines

Use richest tone you can mix in darkest shadow recesses

Woolly Textures: Typical Problems

The dense texture of thick wool is a problem for some beginners to depict for a number of reasons. In the drawing and painting below, the problems are clearly visible, both in the drawing of the subject, where the neck has been elongated and the back legs placed unconvincingly, as well as with the texture of the animal's coat.

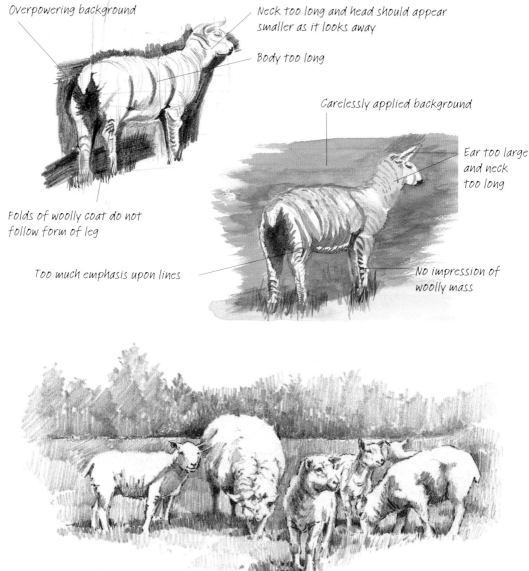

Overpowering background

Neck too long and head should appear smaller as it looks away

Body too long

Carelessly applied background

Ear too large and neck too long

Folds of woolly coat do not follow form of leg

Too much emphasis upon lines

No impression of woolly mass

Grouping subjects
Sheep are usually seen as a flock, so the darks of shadows behind and between their forms allow white paper to play an important role

Solutions

Drawing wool

Animals seen at a distance appear as light shapes against a darker background. For this reason, when drawing wool avoid filling in the image with too much pencil work. Remember that what you leave out is just as important as what is put into a drawing or painting.

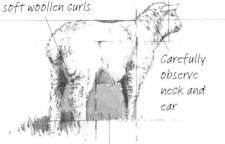

Use rounded marks for soft woollen curls

Carefully observe neck and ear

Negative shape gives correct length of body

Pull green paint down with individual strokes at base to indicate that light grasses are 'cutting in' in front of darker grass

Painting exercise
Transfer the image onto watercolour paper with gentle pressure on your pencil strokes, then place a watery wash of olive green around the drawing

Use neutral hue to suggest texture of wool and shadow areas

Blend in clean water to soften edges

Building up the washes

This little study was painted in stages. After the drawing had been transferred lightly onto watercolour paper a wash of green was painted around the subjects to represent the grass and distant bushes. Care was taken to leave areas of white paper to suggest sunlight upon the sheep, and the shadow sides were painted in textured washes.

Olive green *Cobalt blue* *Raw umber* *Magenta*

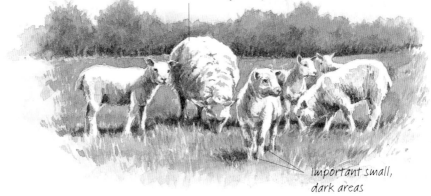

Retain light edge

Important small, dark areas

Still Lifes in the Landscape

Basic Brushstrokes

These exercises are designed to help you understand brush movements and pressures related to the methods used in this theme. For instance, superimposing lines to suggest grain on a wooden surface and painting the grille of an old car incorporate very similar techniques; in the same way, curved brushstrokes of uneven pressure help to give the impression of tread on tyres and overlapping planks on a boat. Sideways sweeps of the brush depict flat panels, sheets of glass and so on, and you can adapt them to indicate curved panels with dark recesses behind.

Colours for neutral

Cool red

Hookers green

A mix of these colours provides a useful neutral hue

Superimposing grain

For this exercise, hold the brush sideways against the paper in a horizontal position.

Load brush with plenty of paint, sweep wide stroke down and allow to dry

Draw lines over tonal block with similar pointed brush

Curved lines

A normal writing position is the best one to adopt for this exercise.

Draw series of curved lines with No. 6 or 8 pointed brush

Use smaller brush to draw series of fine lines

Sideways sweeping strokes

For this exercise, hold the brush at less of an angle to the paper than for the previous one.

Contrast wide with narrow strokes

With swift movements, make series of diagonal, sweeping strokes

Curved metal surfaces

To suggest highlight areas, enhance controlled sweeps of the brush by adding fine lines.

Cut in closely with dark tones, leaving very fine white edges between tones

Developing Brushstrokes

The exercises here are developments of the strokes shown opposite. They demonstrate varied pressure on the brush, angles of application and superimposed marks, and are designed to help you become aware of the importance of following the form of an object in order to create a three-dimensional impression of your subject.

Wood grain

This is an extension of the superimposing grain exercise opposite. You can also use it to suggest the grille on a car, but the strokes will need to be straighter.

Paint grain using small brush, and include curved and textured lines

Strokes depict shadow shapes on grille of car

Sweeping strokes

Use sideways sweeping strokes to suggest a flat metal panel on the side of a trailer, for example, or glass in the windows of a vehicle or a boat.

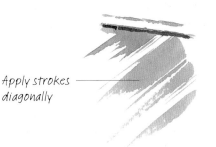

Apply strokes diagonally

Curved strokes following form

Overlapping planks on boat and tyre treads follow the form of the object. This is an extension of the curved lines exercise opposite.

Draw light pencil line to define shape of boat

Curve strokes to describe shape

Stroke with more texture, achieved by on/off pressure, suggests tyre tread

Strokes for curved metal surfaces

These exercises are extensions of the sweeping strokes shown opposite. When applied swiftly, or at varying angles and of different lengths, you can quickly indicate curved metal areas like those seen on the bonnet of a motor vehicle.

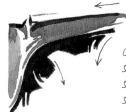

Cut in with dark shadow shapes to suggest engine in shadow

Garden Benches: Typical Problems

It is only by making comparisons with certain subjects/objects that we can develop a deeper understanding of methods. For instance, the fencing in a landscape is made up of both vertical and horizontal posts and rails – by observing the elongated shapes between these you can achieve scale, proportion and perspective accurately.

When drawing a bench, beginners often experience problems with perspective and proportions when they consider only the positive shapes, as seen below.

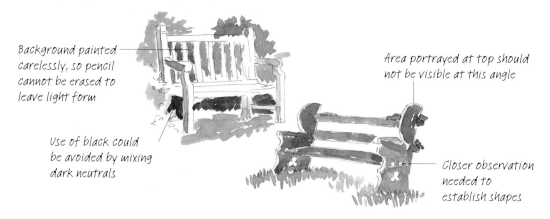

Background painted carelessly, so pencil cannot be erased to leave light form

Use of black could be avoided by mixing dark neutrals

Area portrayed at top should not be visible at this angle

Closer observation needed to establish shapes

Sketchbook composites

The freedom of using a sketchbook allows you to place objects of varying scale, seen at different angles of perspective, in close proximity to each other. You can draw the object against a relevant background, or portray it simply as the object. In both cases it is most important to relate it to the ground – in other words, anchor it.

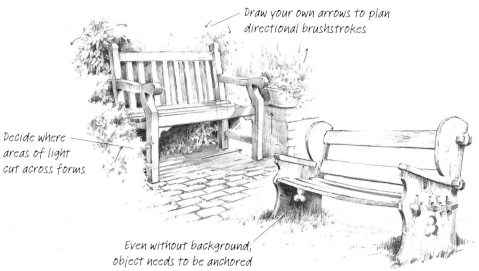

Draw your own arrows to plan directional brushstrokes

Decide where areas of light cut across forms

Even without background, object needs to be anchored

Solutions

Learning from comparisons

An important comparison is that of the presented with the background playing an integral part, and a study where no background is included. The upper painting demonstrates how crucial it is to consider the background and paint around the form when you decide to paint your subject in a setting. The lower bench is made of darker wood and can be presented as a study without background.

Both studies demonstrate how observing and drawing the negative shapes between the vertical and horizontal slats leads to accurate placing of the positive shapes.

Work along top of bench and lift colour upwards

Work down side of bench and pull colour away

Paint down leg and move colour into brickwork

Use small directional movements to indicate foliage

With brush flat against paper, sweep stroke sideways to suggest ground

Paint whole image in palest neutral tone within pencil lines, allow to dry and erase pencil

Build areas of tone in washes

Anchor by relating object to grass

When dry, use fine brush to suggest texture of wood surface

Half-hidden Objects: Typical Problems

The painting below suffers from the typical beginners' difficulty of knowing how to mix colours effectively, leading to the unnatural hues on display. It also shows how a lack of understanding and knowledge regarding the use of negative shapes leads to a flat and patterned effect rather than the desired three-dimensional impression.

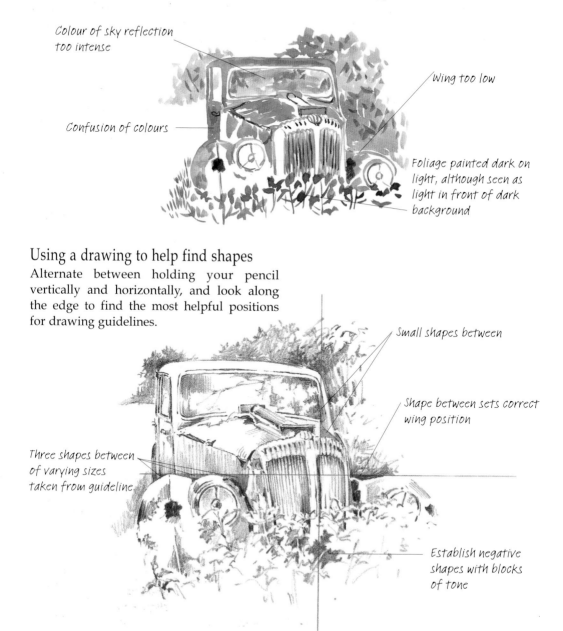

Colour of sky reflection too intense

Wing too low

Confusion of colours

Foliage painted dark on light, although seen as light in front of dark background

Using a drawing to help find shapes

Alternate between holding your pencil vertically and horizontally, and look along the edge to find the most helpful positions for drawing guidelines.

Small shapes between

Shape between sets correct wing position

Three shapes between of varying sizes taken from guideline

Establish negative shapes with blocks of tone

Solutions

Using a few colours effectively

It is a challenge to work with a limited palette of three colours that may not be a natural choice for the subject, as it encourages you to consider the proportions of pigment in your colour mixes. In addition, in order to use dark negative shapes to full advantage (so that they provide rich contrasts to light areas) you need to experiment with colour intensity. The nature of the pigments here means that you are likely to discover some separation of colour in your mixes. This provides added interest and can create some exciting effects.

Colour mixing

Practise mixing these three colours in different proportions until you have a variety of hues in your palette wells.

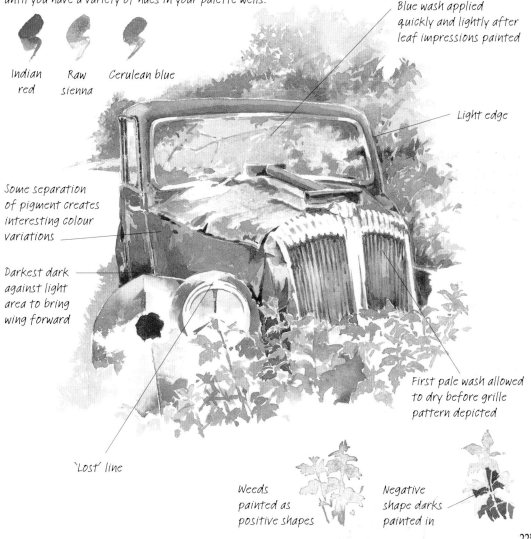

Indian red

Raw sienna

Cerulean blue

Blue wash applied quickly and lightly after leaf impressions painted

Light edge

Some separation of pigment creates interesting colour variations

Darkest dark against light area to bring wing forward

First pale wash allowed to dry before grille pattern depicted

'Lost' line

Weeds painted as positive shapes

Negative shape darks painted in

225

Vehicles with Rounded Shapes: Typical Problems

An old farm machine such as a tractor abandoned in a field can provide the artist with interesting subject matter, as it offers a variety of colour (against the greens), the texture of damaged metal, tonal contrasts (engine in shadow) and various curves and contours. Beginners who are unaware of a guideline method of drawing may experience problems with perspective (as shown below) as well as their interpretation of the subject in paint.

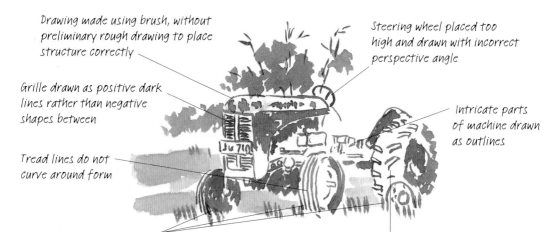

Drawing made using brush, without preliminary rough drawing to place structure correctly

Grille drawn as positive dark lines rather than negative shapes between

Tread lines do not curve around form

Steering wheel placed too high and drawn with incorrect perspective angle

Intricate parts of machine drawn as outlines

Visible wheels placed at same level with no thought for perspective

Outlines rather than blocks of tone

Drawing correct contours

There are many curves to be found in this subject – the steering wheel and below the bonnet and wheel arch, as well as the tyres, where the front wheels are angled slightly. Practise finding these contours on a preliminary reference drawing.

Observe negative shapes between wheel arches

Series of curves needs close observation

Solutions

Building washes

Although strong contrasts are an important part of this study, they are not painted dark initially. Instead, pale colours are applied to the lightly drawn pencil work and are allowed to dry before the pencil is erased and a gradual building of washes is undertaken.

Shadow shapes help to describe form

Rich darks behind light form instead of outline

Negative shape

Arrows show direction of brushstrokes.

Arrow shows direction of brushstroke for shadow area under wheel arch. First shadow wash allowed to dry before darker tone applied

Use light wash for foliage mass, then add dark

Paint shapes as blocks of tone

Shadow lines between treads curve to follow form

Brushstrokes travel in different directions to describe form

Grass mass painted in light tone and allowed to dry

Darker tone added and other colours and tones dropped in while still wet

Straight-sided Vehicle: Typical Problems

An old trailer tilted at an angle in a field offers the opportunity to make a perspective study using guidelines to establish the correct angle. In the painting below, problems arose with the treatment of side panels and tyres as well as with the perspective and the angles in the composition. It may be that the subject itself is complex and could be simplified (without losing its identity) to provide a valuable exercise.

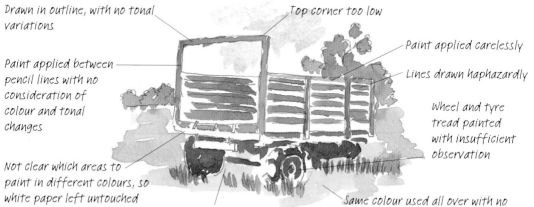

Drawn in outline, with no tonal variations

Top corner too low

Paint applied carelessly

Lines drawn haphazardly

Paint applied between pencil lines with no consideration of colour and tonal changes

Wheel and tyre tread painted with insufficient observation

Not clear which areas to paint in different colours, so white paper left untouched

Shadow area beneath trailer not painted in

Same colour used all over with no attempt to suggest distance by varying tones

Drawing what you see

This drawing shows exactly how the trailer appeared – with corrugated sides and heavy tyre treads. A sense of recession is suggested by the angles of the top and base lines.

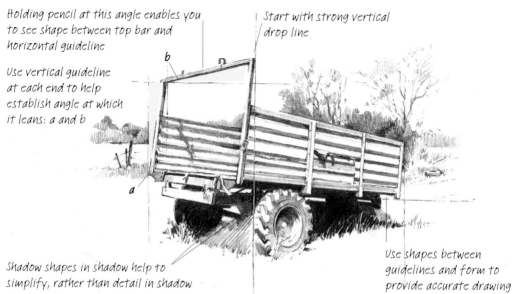

Holding pencil at this angle enables you to see shape between top bar and horizontal guideline

Start with strong vertical drop line

b

Use vertical guideline at each end to help establish angle at which it leans: a and b

a

Shadow shapes in shadow help to simplify, rather than detail in shadow

Use shapes between guidelines and form to provide accurate drawing

Solutions

Finding the basic shape

A flat surface has been substituted for the corrugated sides, and the tyres are now smooth. A couple of sacks were added to provide interest within the interior.

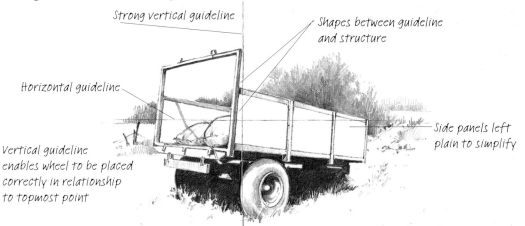

Strong vertical guideline

Shapes between guideline and structure

Horizontal guideline

Side panels left plain to simplify

Vertical guideline enables wheel to be placed correctly in relationship to topmost point

Painting simple shapes

For some simple shapes, it is useful to practise swift brushstrokes. For others, such as the tyres, just suggest the tread rather than going into detail. To create a little incidental texture on the plain panels, Saunders Waterford 300gsm (140lb) Rough paper was used.

Simplify foliage by following light green with darker overlay

Quick directional strokes in neutral colour suggest solid panels

Painting dark behind light edge of the trailer means no outline needed

Dark shadow beneath trailer painted in light tones and allowed to dry before next application

Arrow shows direction of brushstrokes to follow form

Uneven downward dark tones allow white paper to remain before green added in front

229

Boats on Sand: Typical Problems

When the background is stronger than the objects it surrounds, beginners sometimes treat it in a way that overpowers foreground subjects, as can be seen in the painting below – the band of dark concrete behind these boats, plus a tree-covered bank above, vie for attention with the boats in the foreground. A simple solution to this problem is to choose a tinted paper to unify the study by blending or using the natural tint of the surface.

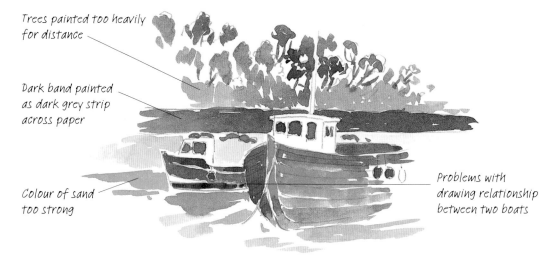

Trees painted too heavily
for distance

Dark band painted
as dark grey strip
across paper

Colour of sand
too strong

Problems with
drawing relationship
between two boats

Establishing a relationship between the main subjects

Use a drawing to make sure that the subjects in your composition relate convincingly both to each other and to the surroundings.

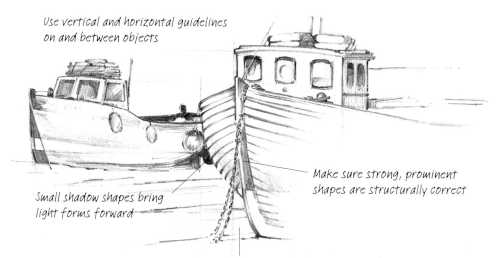

Use vertical and horizontal guidelines
on and between objects

Small shadow shapes bring
light forms forward

Make sure strong, prominent
shapes are structurally correct

Shape between bow of boat, surface of sand and chain is important

Solutions

Blending on tinted paper

Cream-tinted Bockingford 300gsm (140lb) watercolour paper was chosen for this study, where the predominating colour is that of sand. The tint works well under a blended green to suggest a tree-clad hillside in the background, and allows a little Chinese white to be added to the painted surfaces of the boats in order to lift these areas out of the middle ground.

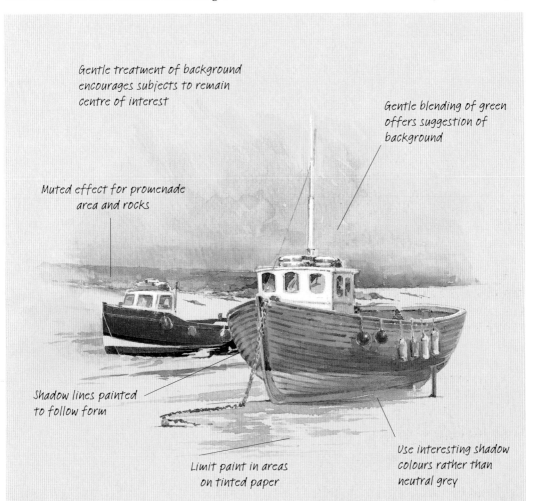

Gentle treatment of background encourages subjects to remain centre of interest

Gentle blending of green offers suggestion of background

Muted effect for promenade area and rocks

Shadow lines painted to follow form

Limit paint in areas on tinted paper

Use interesting shadow colours rather than neutral grey

Still-Life Materials

Basic Brushstrokes

These exercises are designed to help you understand how to depict highlights on smooth surfaces such as copper, porcelain and glass. There is also an exercise to help you paint folds within fabric, which is often used as a background in still-life paintings. The basic brushstrokes are shown below, while on the opposite page they are incorporated within some of the still-life objects that are covered in this theme.

Choosing colours

Once you start to observe and paint man-made objects for still-life pictures, you need to consider an alternative set of colours to the natural ones found outdoors, in nature.

Colour for green glass

Colour for copper

Yellow glaze for reflections and highlights

Windsor & Newton Quinacridone yellow for glaze

Blue mixture for fabric

Fine lines for crisp edges

A natural painting/writing position was used for these exercises. These lines are basic on/off pressure strokes, as used in the other brushstroke exercises (on pages 164, 174, 186, 198 and 210).

For very delicate, fine lines, use a No. 0 pure sable brush

Using a larger No. 8 pointed synthetic brush, apply gentle pressure for fine lines and increase pressure for wider tapering strokes

For delicate lines with more weight, a No. 2 pure Kolinsky sable brush is ideal

Curves and squiggles

Mirrored images, especially those found on curved or uneven surfaces such as copper containers, require a feeling of movement in the brushstrokes.

Paint applied over dry image

Create squiggles and curved strokes that suggest movement, similar to those used to interpret water

Cutting in and contours

Curve the edges of tonal blocks and incorporate fine lines – either as dark lines on light paper or as a white line created by toning either side.

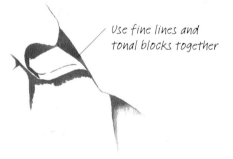

Use fine lines and tonal blocks together

Developing Brushstrokes

These four developments of the strokes shown opposite incorporate crisp edges (as seen on glass, copper and mirrored images in other smooth surfaces), strong contrasts (useful in all subjects), and gentle blending (shown to advantage in fabric folds and highlights).

By practising these exercises you will learn how to retain white paper when indicating highlights by painting around these areas, and how to subsequently blend away from the highlighted areas and dark contrasted shadow shapes.

Bottles and other glass object

This is an extension of the fine line exercises shown opposite. These two exercises show how to work around the area to be high-lighted, using rich colour.

Use a variety of curved strokes, straight lines and squiggle

Small shapes, dots and dashes are useful

Introduce other colours by gentle blending

Mirrored images on copper

This is an extension of the curves and squiggles exercise opposite. First, paint the shapes of the reflections you see within the surface, allow them to dry, then swiftly sweep the yellow glaze over the area where no white paper is to remain.

Fabric folds

This is an extension of the cutting in and contours exercise on the opposite page. Note the crisp light edges brought forward by the dark tones that suggest areas of recess.

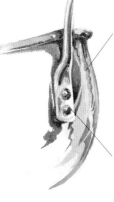

Squiggles occur on uneven surface when reflections are seen

Take advantage of opportunities to make use of strong contrasts

Paint dark area, allow to dry, then paint darker still in corners

Pull dark pigment away from dark of recess, blending with clean water if necessary

Glass: Typical Problems

Although glass objects may be uniform in colour, remember that because of the way light shines through them, the density of colour will vary. Highlights where the light bounces off the surface are also critical in making the object appear three-dimensional. Objects reflected in glass are distorted in shape, and clear, colourless, glass often picks up colours from objects nearby. Accurate drawing of a bottle or glass can often be a problem, even before you start to paint. Once you have mastered this, your observation will still have to be precise in order to position the reflections accurately, especially when another object is placed alongside.

In the study to the right there is no beneficial relationship between the bottle and glass. The bottle has not been given a translucent appearance because too much strong colour has been used in a careless manner, and as a flat wash over a pale wash. There is only one highlight area, when many more could have been observed.

Top of bottle too heavy

This area is starting to work well, but surrounding areas lose credibility

Glass appears to be floating in space – placing it in relationship to bottle would anchor it

Drawing subjects closer

Place the glass in front of the bottle and see how perspective affects scale. The top of the glass and bottle are slightly above eye level and curve in the opposite direction to their bases.

Series of guidelines produces small shapes that help to position objects

Label of bottle produces pattern within stem of glass

Dark base of bottle is seen through glass as abstract shape

Use guidelines to help achieve correct proportions

Solutions

Separating objects to show distortions

If you pull the glass a little away from the bottle, you can see how the distortions become more apparent – as if the colourless glass is absorbing colour to enhance its own image.

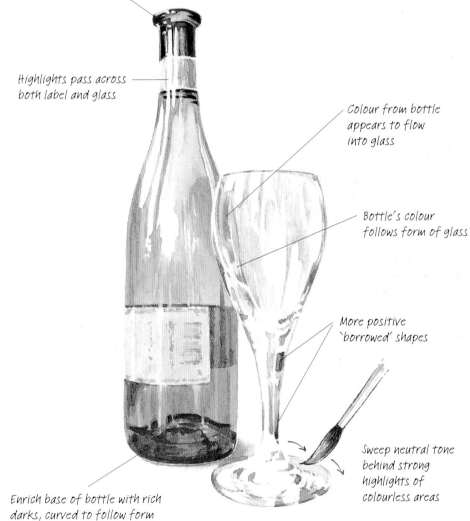

Look closely at reflections in busy area to enhance your interpretation

Highlights pass across both label and glass

Colour from bottle appears to flow into glass

Bottle's colour follows form of glass

More positive 'borrowed' shapes

Enrich base of bottle with rich darks, curved to follow form

Sweep neutral tone behind strong highlights of colourless areas

Ceramics: Typical Problems

Objects made of fine china lend themselves to being painted in a very delicate style, especially if the porcelain is white. In this case the existence of a pattern on the surface adds interest, and because it follows the form of the surface, it can help to achieve a three-dimensional impression. In the study below right the artist has painted the pattern to follow the form of the vase, but in the left-hand painting it appears flat and disjointed.

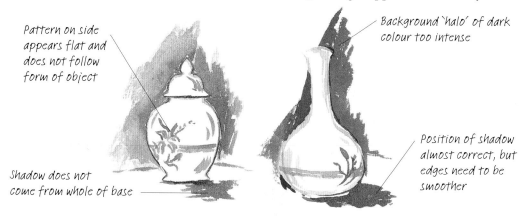

Pattern on side appears flat and does not follow form of object

Shadow does not come from whole of base

Background 'halo' of dark colour too intense

Position of shadow almost correct, but edges need to be smoother

Drawing upon knowledge

Even if you eventually want to paint each object individually, placing them as a group in relation to each other helps you gain knowledge of their shape and form.

Look at the objects from a different angle, and separate the object itself if possible (in this case a lid was removed) in order to draw and understand ellipses.

Place dark background behind form to bring pot forward

Rich dark within rim to accentuate light edge

Extreme curve of pattern band as vase is viewed from above eye level but seen as below eye level

Negative shapes between objects establish correct relationship

Solutions

Depicting white

Most depictions of porcelain rely on the use of white paper as the objects themselves are white. With a shadow side, a neutral colour is used, both to work around the areas to be left white and to accentuate any highlights on the surface of the porcelain.

Place blue cloth behind image to allow white and contrasting colours to stand forward

Build pattern carefully to follow form of surface

Large area of white paper indicates porcelain is white

Leave these areas white to suggest highlights

Note curve at top of vase when viewed from below eye level

Building washes

Here, delicate washes are overlaid on the white vase to indicate a shadow at its base. This example shows how the shadow shapes are established before the colour and tone are built up.

'Lost' line

Metals: Typical Problems

Some metals reflect their surroundings in the same way as water and a mirrored image. A curved copper surface reflects and distorts the contents of a room within its area. It can, therefore, appear to be a very busy image, showing the colours of surrounding objects to a limited extent, which are always influenced by the copper colour. In the painting below you can see some typical drawing problems regarding scale, proportion and perspective, as well as the problem of how to deal with distorted mirror images.

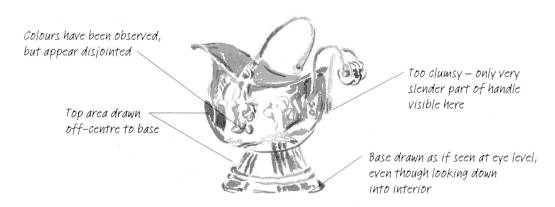

Colours have been observed, but appear disjointed

Top area drawn off-centre to base

Too clumsy – only very slender part of handle visible here

Base drawn as if seen at eye level, even though looking down into interior

Drawing from a different viewpoint

To help you become familiar with this, or any other subject, draw it from a different angle.

Note the ellipse that appears as you look down into the receptacle, and also at the base.

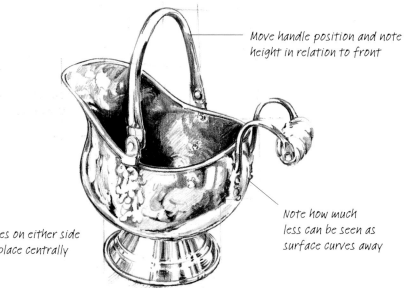

Move handle position and note height in relation to front

Note how much less can be seen as surface curves away

Guidelines on either side help to place centrally

Solutions

Colours and contours

Before you start painting, select a limited range of colours to suit the subject – in this case copper. Remember the importance of leaving white paper for highlights.

You need to have good brush control in order to depict curves and contours, so at the base of the page there is a little exercise demonstration for you to practise sweeping, curved strokes.

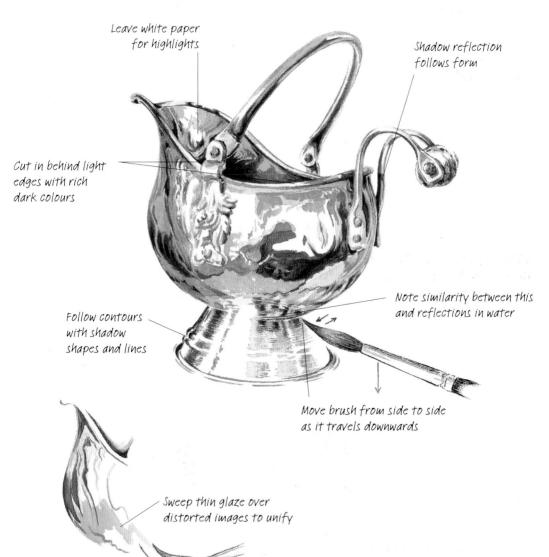

Leave white paper for highlights

Shadow reflection follows form

Cut in behind light edges with rich dark colours

Note similarity between this and reflections in water

Follow contours with shadow shapes and lines

Move brush from side to side as it travels downwards

Sweep thin glaze over distorted images to unify

Fabric: Typical Problems

Fabric is often used as a background for still-life groups, as the folds help you to form a relationship between the objects. Used as a cover, fabric follows the form of the object beneath, for example a cushion cover or an item of clothing being worn. A hung or draped shirt or blouse provides you with an interesting array of folds, as well as other related components like pockets, buttons and the attached sleeves. For many beginners it is these folds that cause problems, as in the study to the right.

Drawing to describe folds

Using a very sharp pencil, gently tone layer upon layer to build the darks. Follow the form, curving around contours and cutting in behind light areas to suggest undulations of folded material. Leave the white paper for highlights.

Random lines are superficial and do not give impression of recess

Same blue used throughout, more intense within folds, rather than effective shadow colour

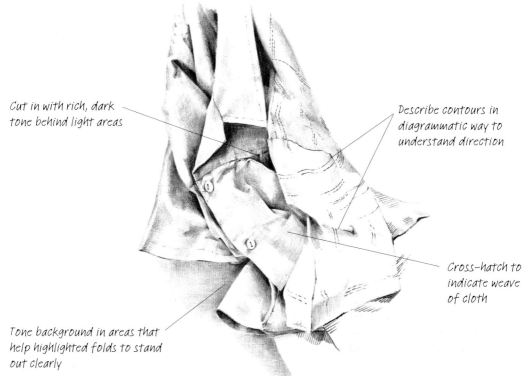

Cut in with rich, dark tone behind light areas

Describe contours in diagrammatic way to understand direction

Cross-hatch to indicate weave of cloth

Tone background in areas that help highlighted folds to stand out clearly

Solutions

The 'ins and outs' of folded material

For this exercise, imagine an insect wandering in and out of the folds of a garment – when the insect is at the highest level, it is probably standing on a highlighted area.

Leave these highest areas as white paper and apply your tones, in varying degrees, behind it, working from the lightest to the very darkest tones.

Small shadow shapes add interest to shadow line

Hint of red incorporated with blue within shadow tone areas

Untouched white paper

Where rich dark suggests shadow recess, add clean water carefully at edge and blend with swift brushstrokes

Lower part of garment shows first pale colour washes

Buildings

Basic Brushstrokes

The exercises on this page are designed to help you become aware of the importance of the varied and directional brushstrokes required to depict the textured effects used when painting buildings. On the opposite page you can see how they may be developed within this context.

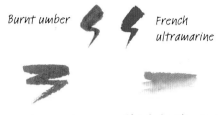

Burnt umber

French ultramarine

Mixed to produce brown hue.

Blended with water for pale tones.

Angled, varied pressure strokes

Use the normal painting position for these strokes. Note the effect that can be achieved by just varying the pressure on Rough-textured paper.

Lift brush from paper occasionally

Repeat strokes closer together with fine brush

Partial drybrush effect

This is suitable as a base texture for many surfaces. Hold the brush horizontal to the paper, letting the whole length of hairs remain in contact throughout the stroke. Note how the Rough surface of the paper robs the brush swiftly of its pigment.

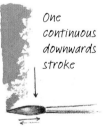

One continuous downwards stroke

Block and lift strokes

Hold the brush a little more vertically for this solid one-stroke impression. Place another stroke immediately alongside.

Only half length of hair is in contact with paper

Narrow lines, wide bands

Use the normal painting position for this variety of stroke, where the aim is to depict gentle undulations.

Wide shape, narrow shape

Use the normal painting position for the first part of the stroke, angled towards the paper to complete the stroke as you pull down or along. Use the tip of the brush.

Make undulating, wide bands with single block stroke, or paint in with smaller strokes

Developing Brushstrokes

The five exercises on this page are developments of those shown opposite. Four of the exercises are influenced by the Rough-textured Saunders Waterford paper, which was chosen in order to enhance these effects.

It is important that you discover how the paper you choose to work on may affect the impressions you create – you can do this by experimenting before you start to paint your pictures.

Varied pressure strokes

This extension of the exercise shown opposite is designed to suggest a tiled roof.

Short, slightly angled, downward lines join disjointed lines

When dry, wash different colour across whole surface

One-block stroke

An extension of the block and lift stroke shown opposite, this exercise shows you how the blotting-off method (see page 151) works on a brick or stone image.

Basic (wet) stroke

Blot off and drop in more pigment before image has dried

Drybrush overlay

To depict textured surfaces of walls or timber, apply a further stroke of the brush over the initial partial dry-brush stroke shown on the opposite page.

Narrow lines and wide bands

This exercise shows you how the one opposite can be used for a mirrored image on glass-fronted buildings. This image is best suited to a smooth-surfaced paper, but, as you can see here, it can also be painted onto Rough texture and still achieve a smooth effect.

Wide shape, narrow line stroke

An extension of the wide shape, narrow shape stroke, this shows how the two may be joined. Use this stroke to depict smooth stone walls – remember to enhance the negative 'shapes between' with a rich, dark hue to suggest recesses.

Basic image

Blot off/drop in for shadow textures

Timber: Typical Problems

A timber building in a neutral hue can offer a pleasing contrast to its surroundings. However, many beginners, in their quest for colour, fail to take advantage of the subtle neutrals and paint a variety of browns, as seen in the picture below. This painting has lost harmony, and the numerous lines, drawn without regard for tone and texture, are overpowering. Do not be afraid to take advantage of a monochrome effect for certain subjects – greens in the background can almost be a monochrome study in themselves – as there are occasions when understatement has its own charm.

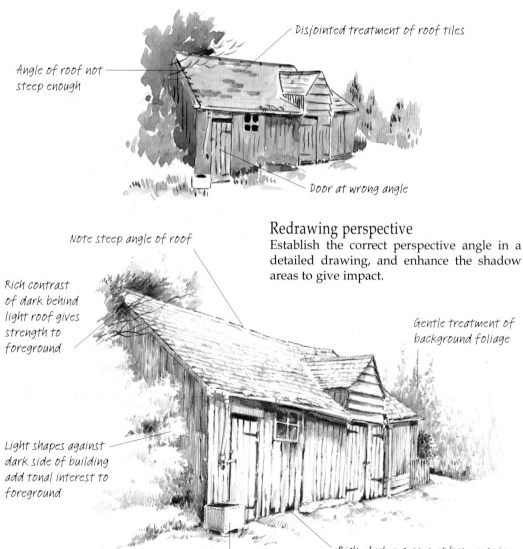

Disjointed treatment of roof tiles

Angle of roof not steep enough

Door at wrong angle

Note steep angle of roof

Redrawing perspective
Establish the correct perspective angle in a detailed drawing, and enhance the shadow areas to give impact.

Rich contrast of dark behind light roof gives strength to foreground

Gentle treatment of background foliage

Light shapes against dark side of building add tonal interest to foreground

Small objects drawn carefully

Rich, dark recesses at base require crisp edges

Solutions

Working in monochrome

This painting is limited to two almost mono-chrome areas – the neutrals of the timber building and the greens of the foliage in the foreground and background.

This monochromatic approach enables you to concentrate upon the importance of tonal contrasts rather than hue. The only additional colour is in the blue sky.

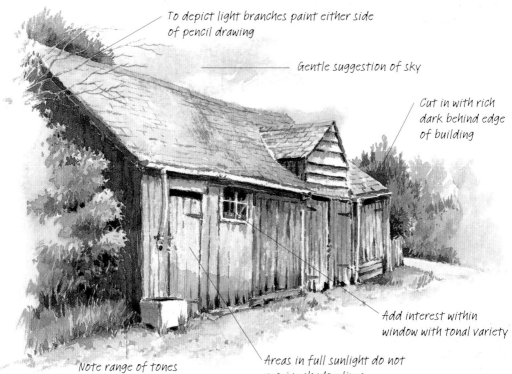

To depict light branches paint either side of pencil drawing

Gentle suggestion of sky

Cut in with rich dark behind edge of building

Add interest within window with tonal variety

Note range of tones within shadow areas

Areas in full sunlight do not receive shadow lines

Ways to create textures on timber

Here are a couple of exercises to help you discover ways of creating a textured surface effect.

Rough texture with drybrush technique

Drag paint across surface in direction of wooden planks

Draw in dark shadow shapes between planks with fine point of brush and stronger pigment

Describing darks

Establish position of planks

Apply slightly darker tone than first wash using drybrush technique

Paint in dark shadow shapes and shadow lines

Corrugated Iron and Stone: Typical Problems

Old or derelict buildings may be made up of many different materials, and can thus supply the artist with numerous textured surfaces to depict in paint. On this neglected building an old corrugated iron roof over stonework contrasts with timber doors and peeling hard- board panels, and is softened by the foliage. With so much to observe, it is not surprising that some beginners simplify everything to such an extent that the essence of the building and its setting are lost in a mass of conflicting colours and patterns.

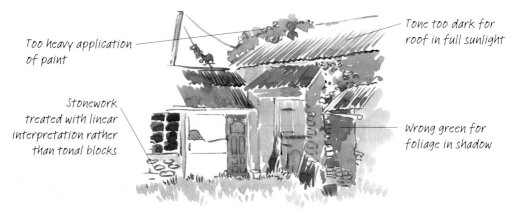

Too heavy application of paint

Tone too dark for roof in full sunlight

Stonework treated with linear interpretation rather than tonal blocks

Wrong green for foliage in shadow

Correcting perspective

The (1) and (2) 'shapes' are below the guideline, and (3) and (4) are positioned above the guideline. In this way the correct perspective angles of roofs can be established.

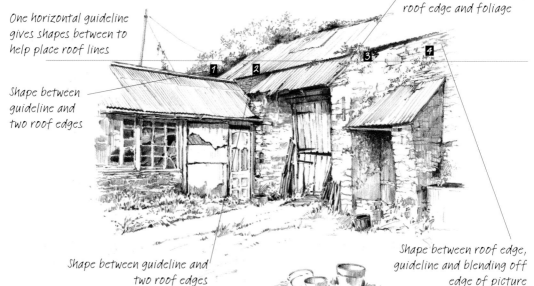

One horizontal guideline gives shapes between to help place roof lines

Shape between guideline, roof edge and foliage

Shape between guideline and two roof edges

Shape between guideline and two roof edges

Shape between roof edge, guideline and blending off edge of picture

Solutions

Tackling textures

This study required many brush angles and pressures to achieve the effects of a variety of textured surfaces. It shows the various stages of underpainting used, and also how the subsequent washes were built up gradually until the right colour and depth were achieved.

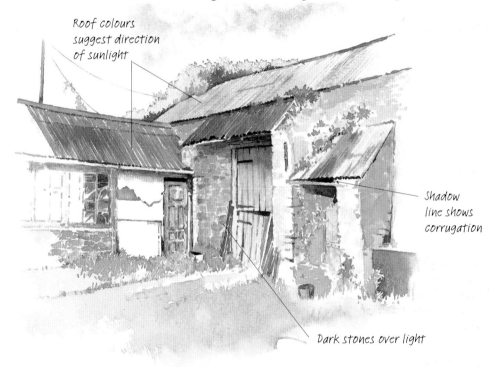

Roof colours suggest direction of sunlight

Shadow line shows corrugation

Dark stones over light

Depicting details

These three exercises show how you can practise details before incorporating the techniques into the painting.

Up-and-down brush movement

Straight shadow line beneath

Place first wash of pale green using side-to-side strokes

Pull brush strokes down over dry surface, using darker green mixed with plenty of water

Dark stones over light

Side-to-side brush movements

Light stones with dark recesses

Pull down and across

Street Scenes: Typical Problems

A variety of buildings within a street setting will be viewed at different angles. Perspective problems may be overcome using the 'guide-lines' method – aligning parts of one building with another. Any awareness of scale can be helped by the inclusion of a figure, but this needs to be treated with care. It is far better to draw/paint a figure slightly too small than too large – as seen in the painting below, which also shows how a too heavy-handed treatment of background areas can overpower the foreground.

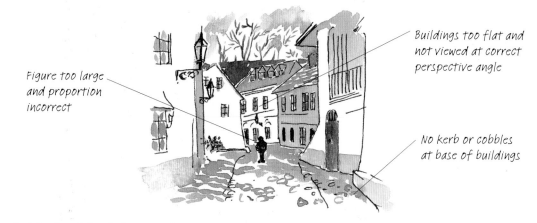

Figure too large and proportion incorrect

Buildings too flat and not viewed at correct perspective angle

No kerb or cobbles at base of buildings

Quick sketchbook impression

Here, a fine-nibbed pen was drawn over the surface of textured paper to establish a wide view of the scene, before moving in close to the centre of interest.

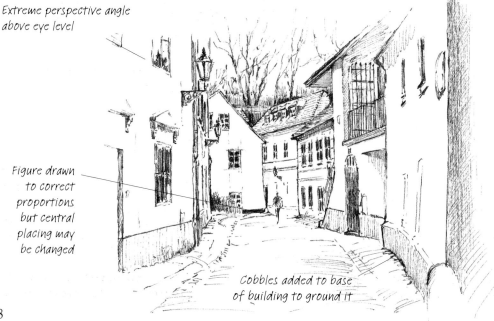

Extreme perspective angle above eye level

Figure drawn to correct proportions but central placing may be changed

Cobbles added to base of building to ground it

Solutions

Drawing and tinting

For this exercise, draw the entire scene in pen and ink on textured watercolour paper, using a thick-nibbed pen for the wider lines.

Vary the pressure on the pen to encourage it to create interesting lines, then work with the texture of the paper to enhance these effects.

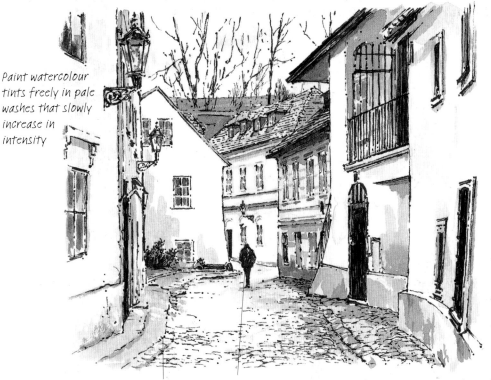

Paint watercolour tints freely in pale washes that slowly increase in intensity

Lines along kerb guide eye into picture

Figure slightly off-centre because we now see less of left-hand wall than in sketch

Drawing with a pen

Here are four exercises to use as a warm-up as you practise penwork prior to starting the final drawing.

Squiggles and lines of varied pressure plus tonal blocks give effect of quick impression

Draw right angle first, then curves and pattern shapes

Vary pressure on lines that differentiate buildings

Avoid drawing wirelike line around each cobblestone – lift off and then re-apply pressure

Arrows show side-to-side movement to depict cobbles seen in perspective

Glass-Fronted Buildings: Typical Problems

Glass-fronted buildings that reflect their surroundings produce images reminiscent of surrealist paintings. As an artist you may feel that the interest lies not in the overall shape of the building, but in the reflected images distorted by slight undulations of flat glass panels – but the maze of vertical, horizontal and distorted lines are difficult for a beginner to view, let alone draw and paint with accuracy.

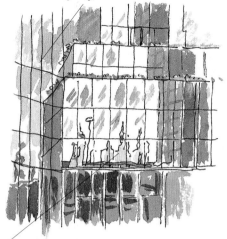

Bars painted carelessly and too heavily, as well as at wrong angle

Drawing distortion

Close observation of the scale and perspective in the scene are the primary considerations. Once these are noted you can consider how they have been altered through distortion. Here, there is a helpful grid of vertical and horizontal bars, so that you can concentrate on one section at a time.

Loose 'squiggles' with same colour in each one do not give impression of range of buildings

Variety of tones and rich darks contrast with white of paper

Where glass pane is angled, some areas are not reflected

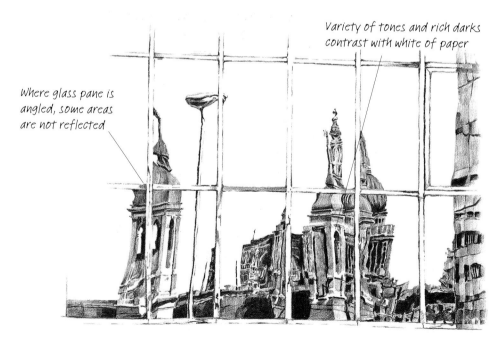

Solutions

Quick impression

The quick sketchbook impression to the right establishes the building as a whole before selecting an area for detailed interpretation. Drawing on-site, where you can establish basic proportions and perspective angles, can be regarded as a warm-up exercise. There is no need to draw precise details if it is your pre-liminary interpretation prior to a more detailed drawing and painting of a small area.

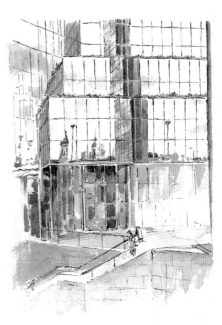

Building a mirrored image

Place the grid and consider the content of each section in its own right, as well as regarding the picture as a whole. Show some of the external glass side-panelled wall of the building in order to retain identity, and then start by painting everything as an undercoat of pale washes.

Retain identity of building by portraying part of one side

Paint reflects blue sky to enhance white (paper) images of glazing bars

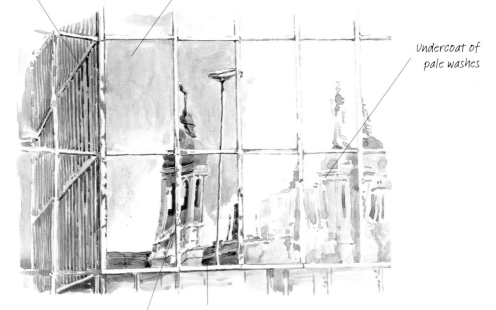

Undercoat of pale washes

Enrich dark areas in final washes

Note undulations of reflected shadow lines

Index

Index